S0-AYR-884

CAPE COD WIDE

ARTHUR P. RICHMOND

4880 Lower Valley Road Atglen, Pennsylvania 19310

Copyright © 2007 by Arthur P. Richmond
Library of Congress Control Number: 2007926813

All rights reserved. No part of this work may be reproduced or used
in any form or by any means—graphic, electronic, or mechanical,
including photocopying or information storage and retrieval sys-
tems—without written permission from the publisher.
The scanning, uploading and distribution of this book or any part
thereof via the Internet or via any other means without the permis-
sion of the publisher is illegal and punishable by law. Please pur-
chase only authorized editions and do not participate in or encour-
age the electronic piracy of copyrighted materials.
"Schiffer," "Schiffer Publishing Ltd. & Design," and the "Design of pen
and ink well" are registered trademarks of Schiffer Publishing Ltd.

Designed by Doug Congdon-Martin
Type set in Americana XBd BT/Zurich BT
ISBN: 978-0-7643-2776-6
Printed in China

Published by Schiffer Publishing Ltd.
4880 Lower Valley Road
Atglen, PA 19310
Phone: (610) 593-1777; Fax: (610) 593-2002
E-mail: Info@schifferbooks.com

For the largest selection of fine reference books on this and related
subjects, please visit our web site at **www.schifferbooks.com**
We are always looking for people to write books on new and related
subjects. If you have an idea for a book please contact us at the
above address.

This book may be purchased from the publisher.
Include $3.95 for shipping.
Please try your bookstore first.
You may write for a free catalog.

In Europe, Schiffer books are distributed by
Bushwood Books
6 Marksbury Ave.
Kew Gardens
Surrey TW9 4JF England
Phone: 44 (0) 20 8392-8585; Fax: 44 (0) 20 8392-9876
E-mail: info@bushwoodbooks.co.uk
Website: www.bushwoodbooks.co.uk
Free postage in the U.K., Europe; air mail at cost.

Above: Charter boats at Rock Harbor.

Title page: Newcomb Hollow Beach in the winter.

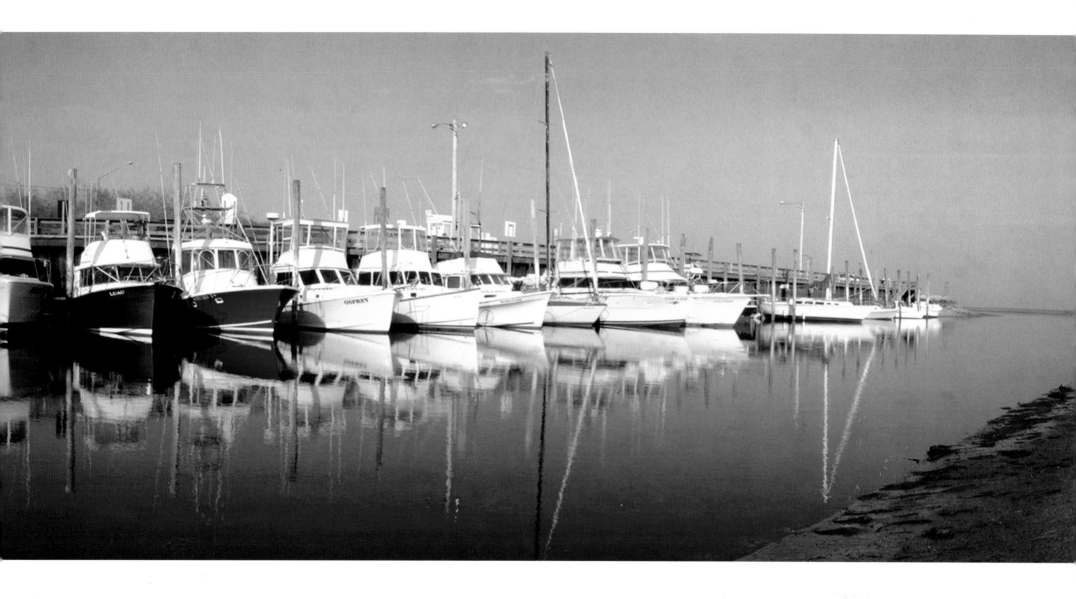

CONTENTS

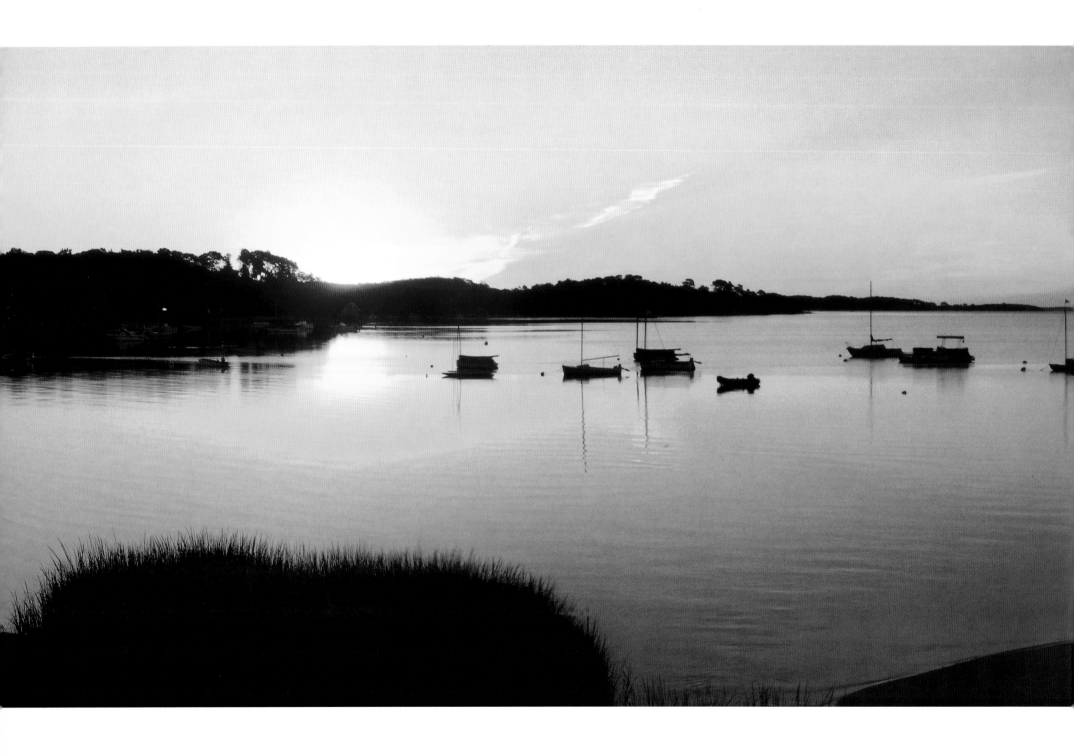

Pleasant Bay, Orleans, just after sunrise.

INTRODUCTION

Cape Cod has been a popular destination for travelers and visitors wishing to experience the charm of this quaint old land and, perhaps, to capture it in word or image. Many have written of their encounters, leaving a legacy of excellent literature that is still popular today. In the mid-1850s, Henry David Thoreau made four excursions to the Cape and wrote of experiences of walking and exploring this seaside realm. Thanks to the Cape Cod National Seashore and the preservation of these outer lands, it is still possible to enjoy the same vistas that Thoreau saw more than 150 years ago. More recently, Henry Beston in 1928 wrote what he called "a year on the Great Beach of Cape Cod." This book, *The Outermost House,* is an environmental classic and was one of the factors motivating the establishment of the National Seashore.

Visualists have also sought the Cape to create outstanding images. Photographers and painters looking for that exceptional and ephemeral light so common to the Cape are variously rewarded for their efforts. Many visitors arrive with their cameras and seek to capture that special scene.

As a photographer for over forty years, I have tried to capture that light that provides the impact for many of the following photographs. However, I was looking for more. Many of the Cape's vistas offer a field of view greater than could normally be captured with a camera using a standard focal length lens. Without the breadth of view, something was lost. So, through the marvels of modern digital technology, I have created these wide-angle panoramas. They consist of three or more sequential images, stitched together using a computer and photo-editing software.

Panoramic photography traces its beginnings to the birth of picture making. Now with a quality digital camera, patience at a desired location, and practice with the computer, panoramas can be created by those who are seriously interested. The settings of these panoramas are typical of the scenery of Cape Cod. They are accessible, easily reached, and waiting for their expansive beauty to be captured on film.

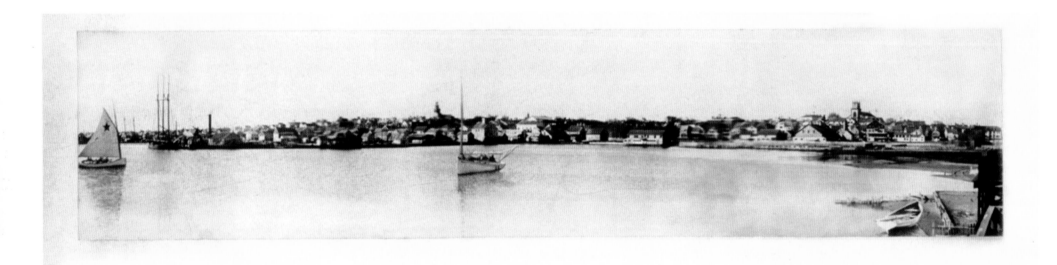

Nantucket from Brant Point, 1895.

"Nantucket from Brant Point 1895," by Henry Sherman Wyer.
Courtesy Library of Congress- pan 199300606/PP.

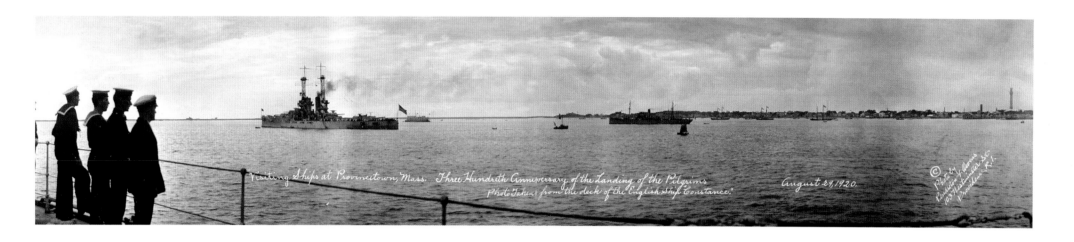

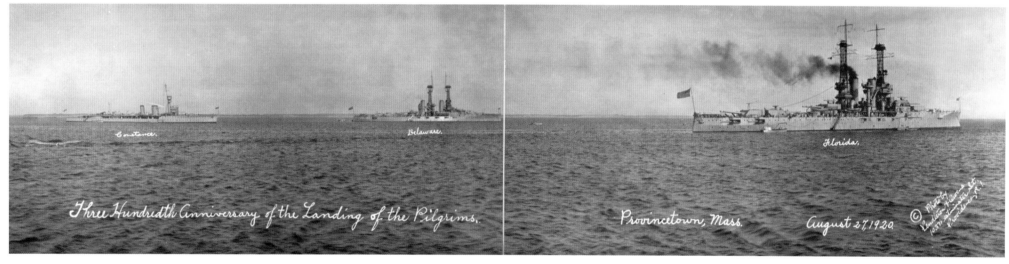

These images were taken in August 1920, by Pendleton & Owens of Providence, R. I. on August 29, 1920.

Top: "Visiting ships at Provincetown, Ma, Three Hundredth Anniversary of the Landing of the Pilgrims; photo taken from the English ship 'Constance', August 29, 1920." *Courtesy Library of Congress-pan 1993003921/PP.*

Bottom: Three Hundredth Anniversary of the Landing of the Pilgrims." *Courtesy of Library of Congress pan-1993003920/PP.*

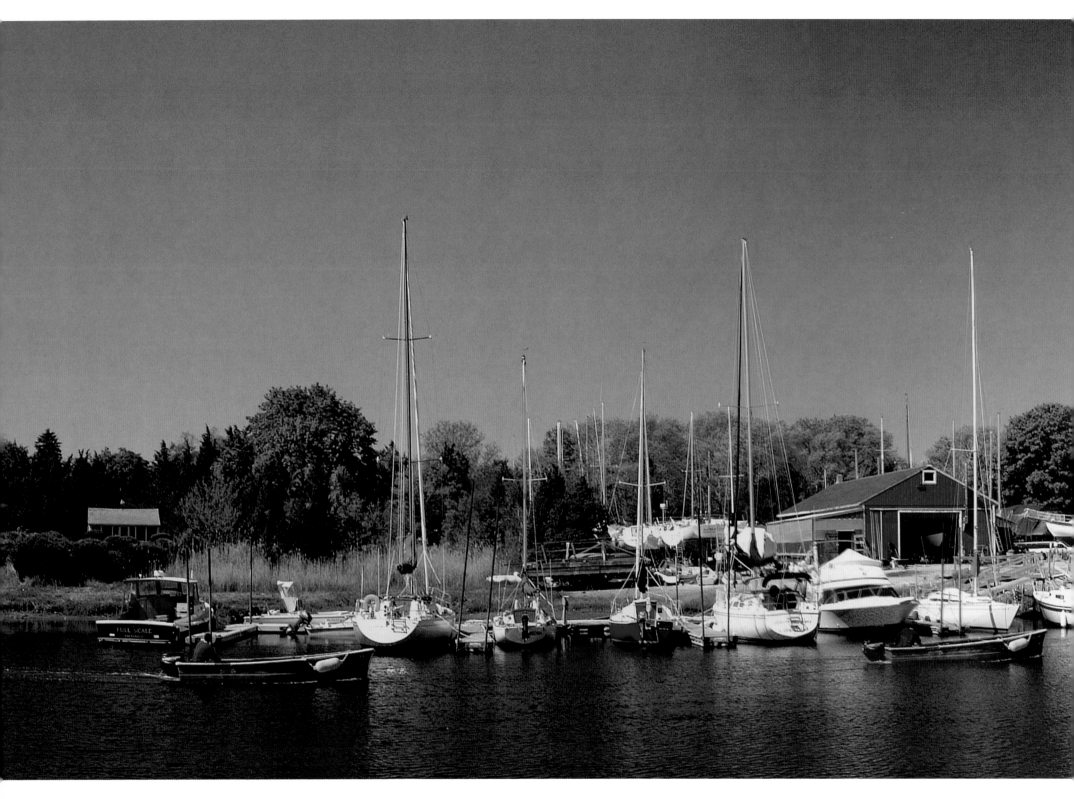

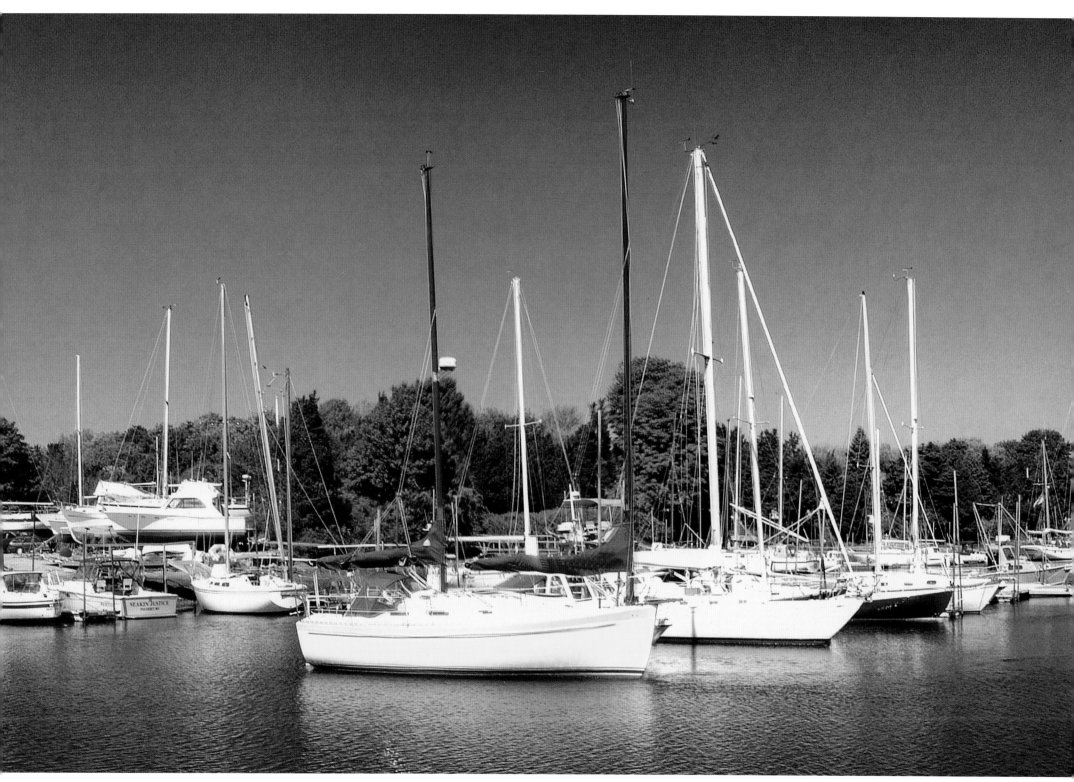

Bucky's Boatyard on the Pocasset River.

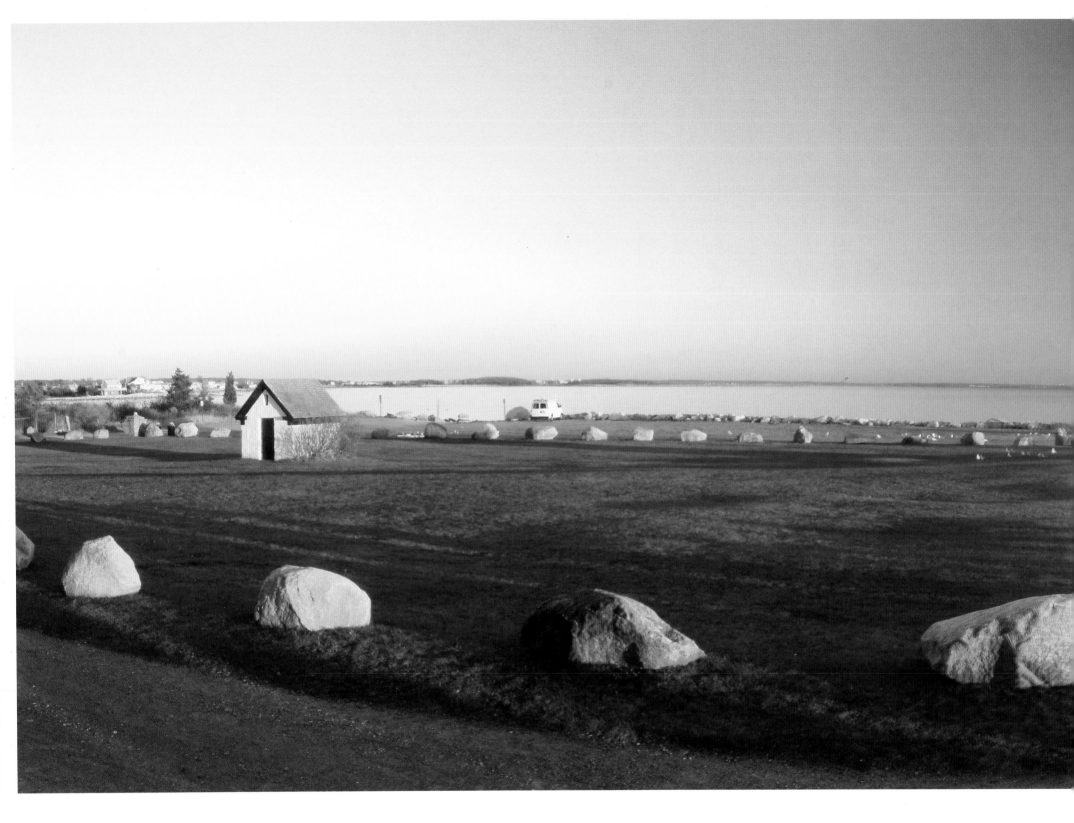

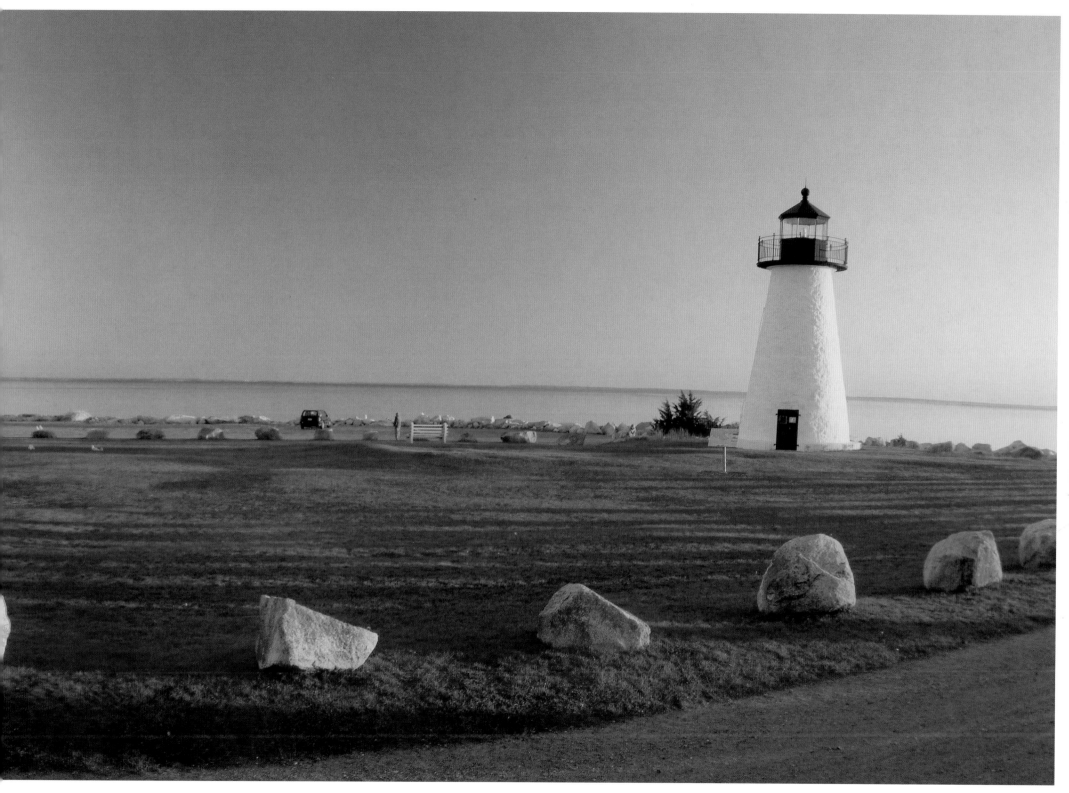

Ned's Point Lighthouse in Mattapoisett in mid afternoon

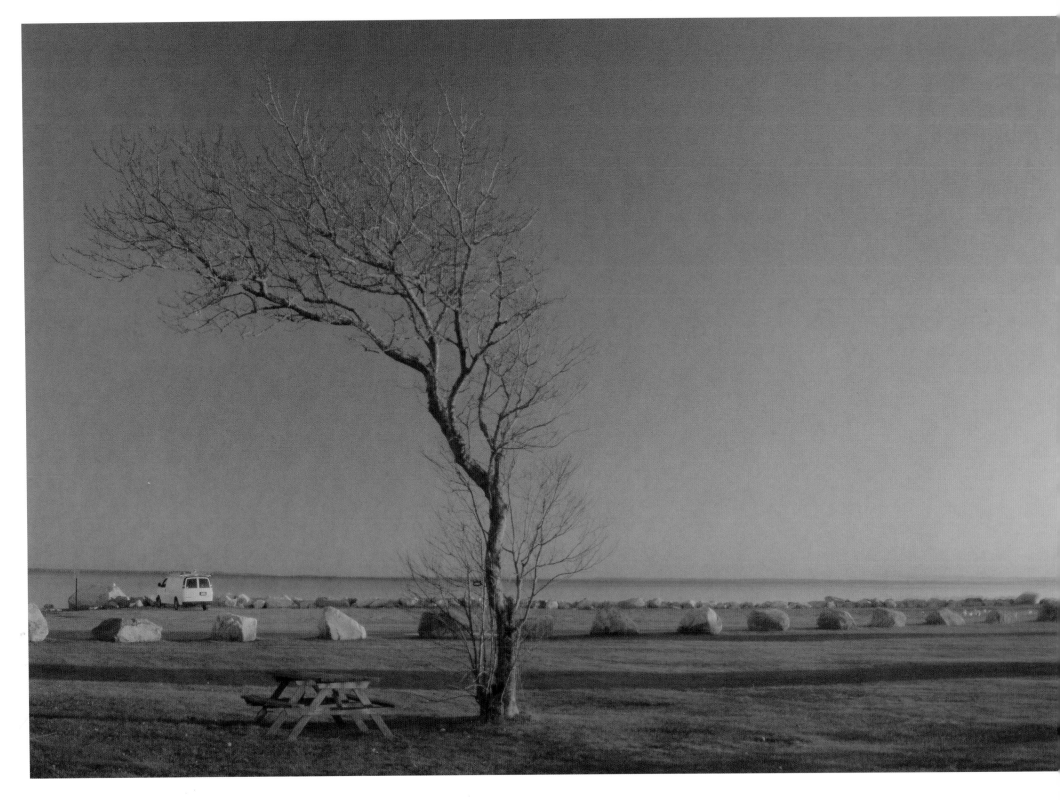

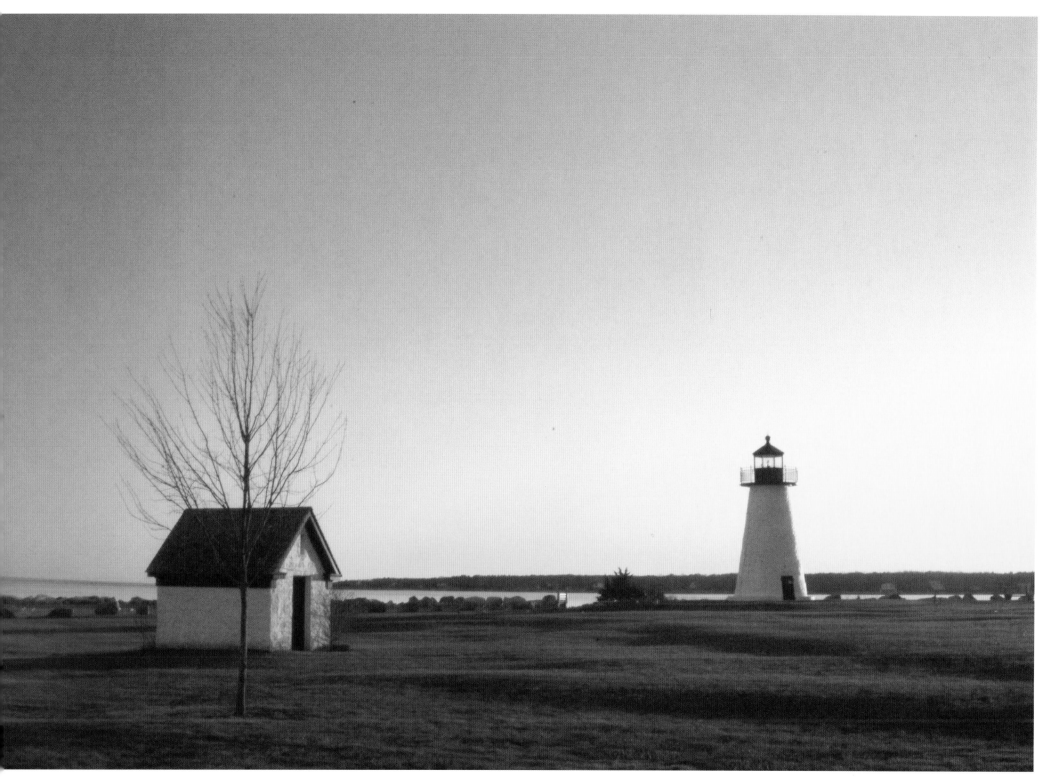

Ned's Point lighthouse was built in 1888 and with a height of 39 feet. This view was taken just before sunset.

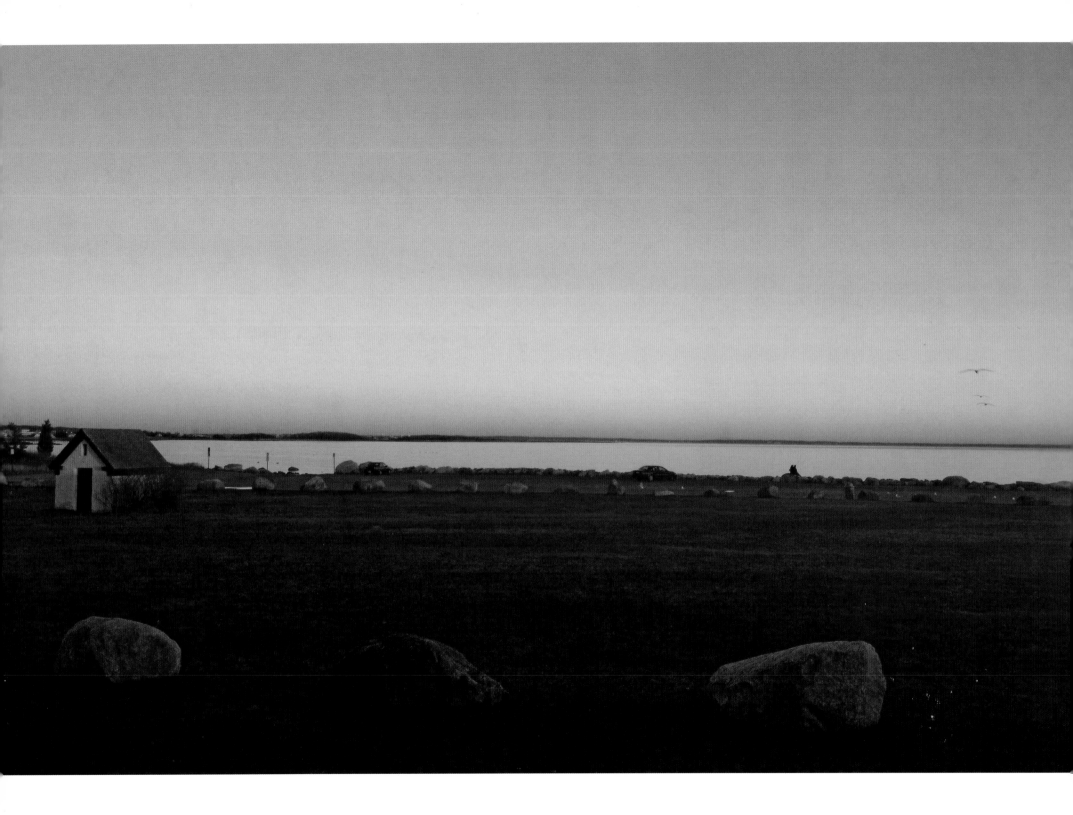

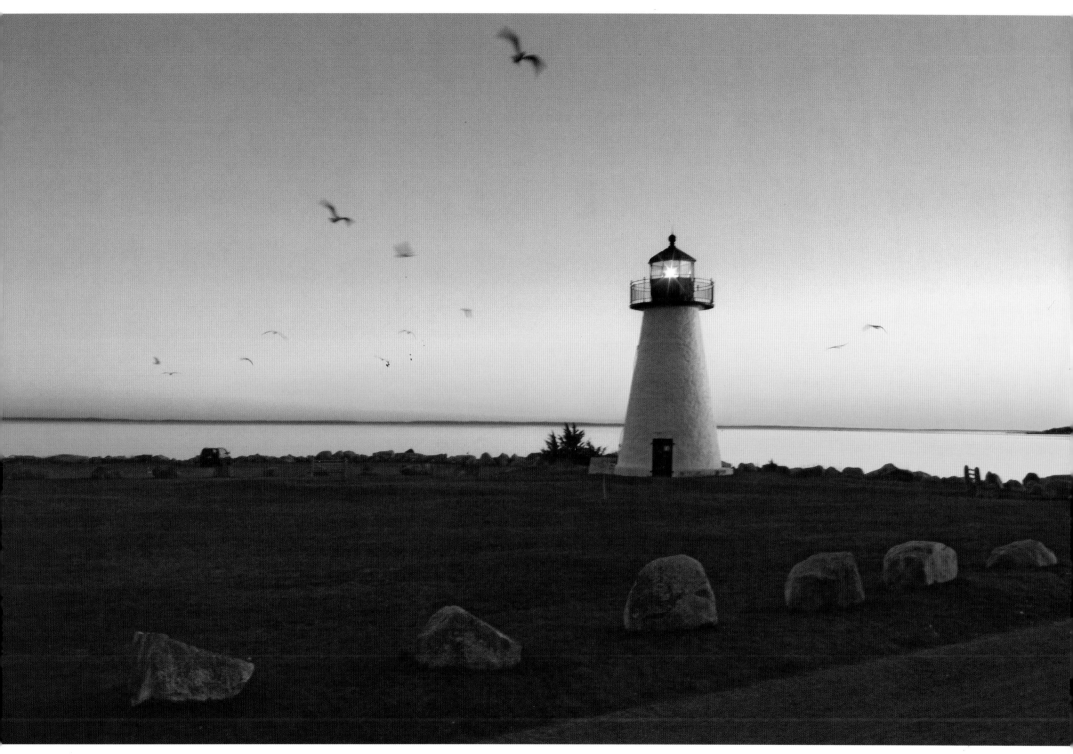

Ned's Point lighthouse in the last rays of sunlight.

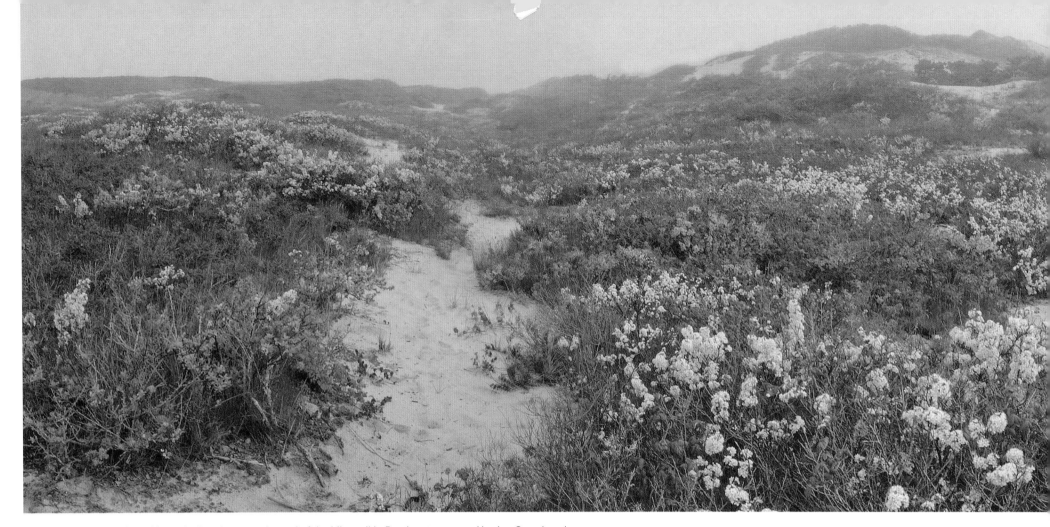

In late spring, beach plums bloom in the dunes, at the end of the bike trail in Provincetown near Herring Cove beach.

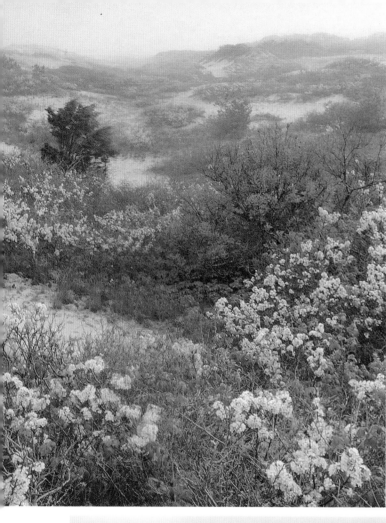

Also blooming in the spring, is scotch broom with its small yellow flowers. The dunes here extend to Race Point light and beyond to Massachusetts Bay.

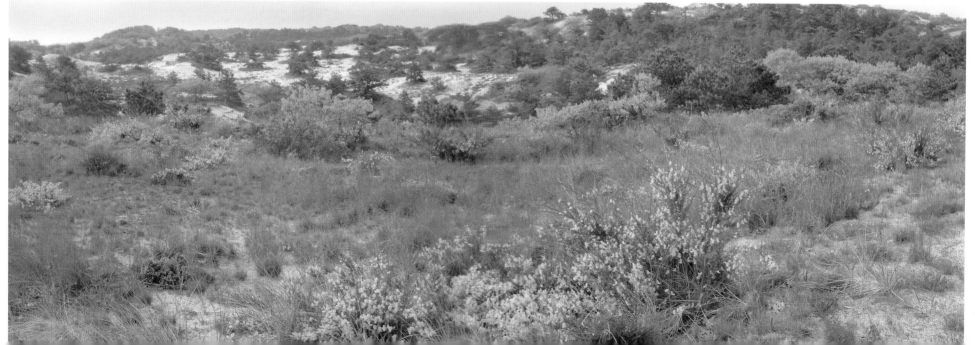

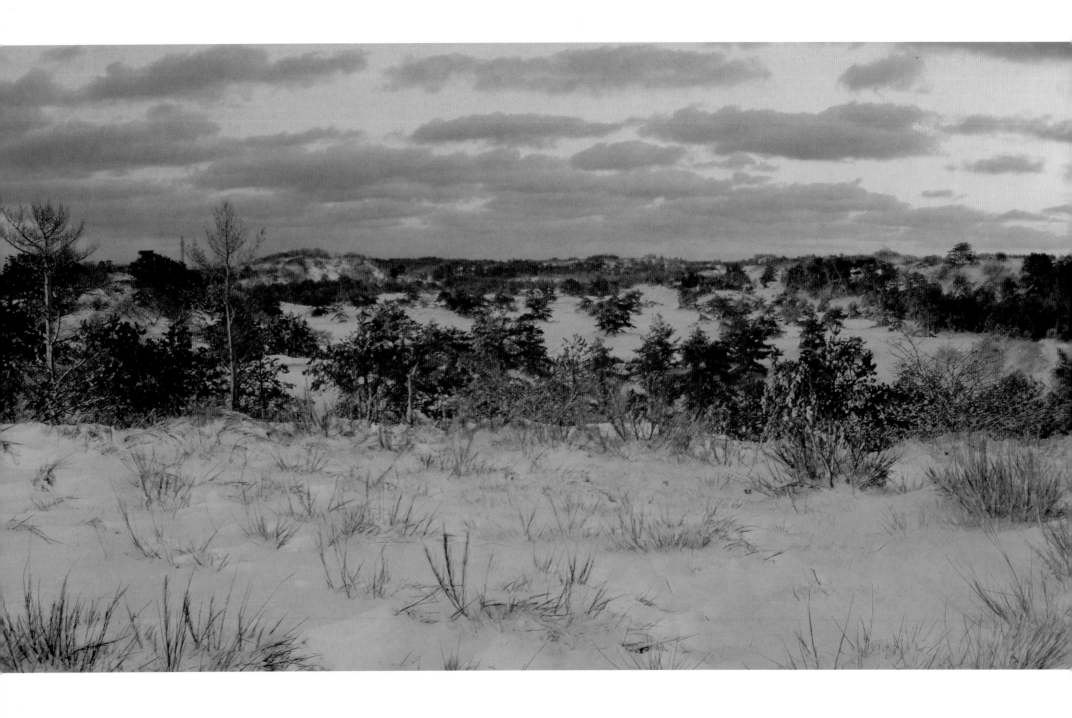

The dunes near Race Point light, Provincetown, in winter.

The northern most light house on Cape Cod, Race Point, named for the way the waters raced past this area, is situated in the dunes and guides mariners into Provincetown Harbor.

The dunes in the Cape Cod National Seashore.

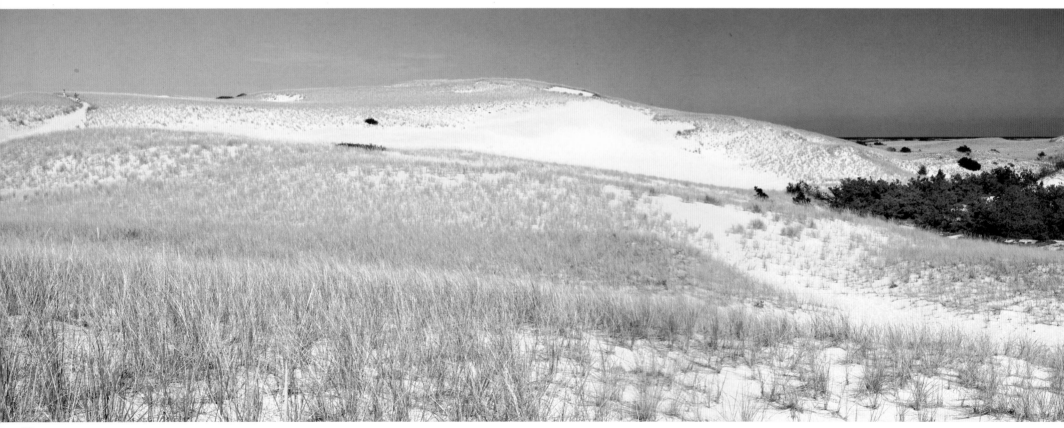

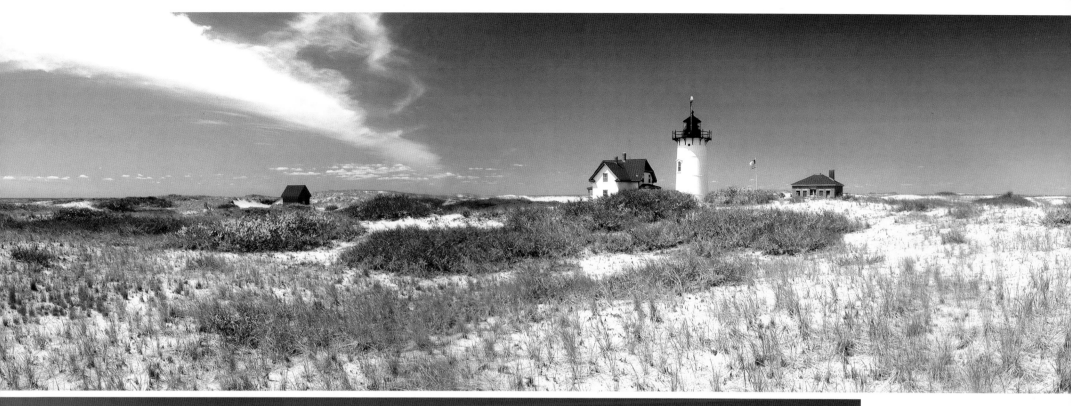

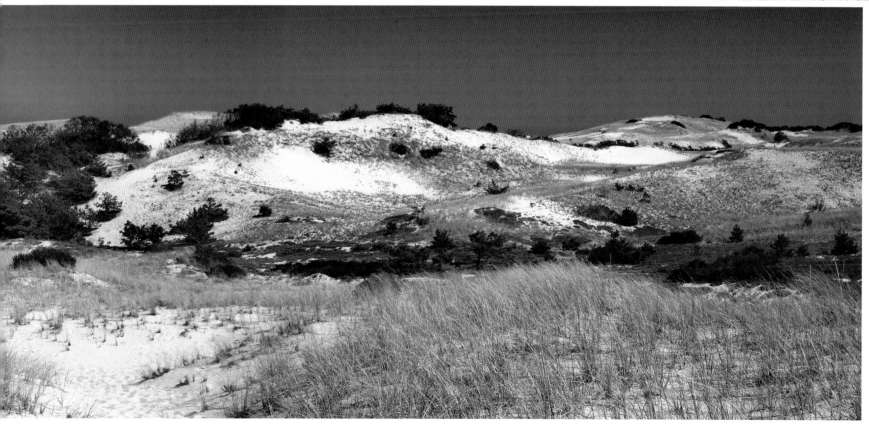

With the last rays of the sun still shining on the dunes,
the moonrise can be seen in the distance.

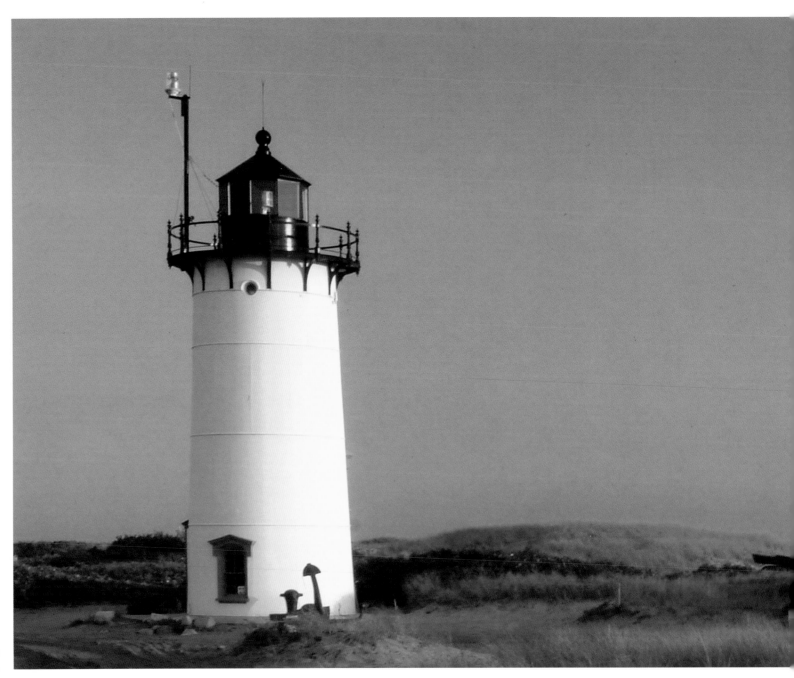

Race Point Light and the keeper's house at sunset.

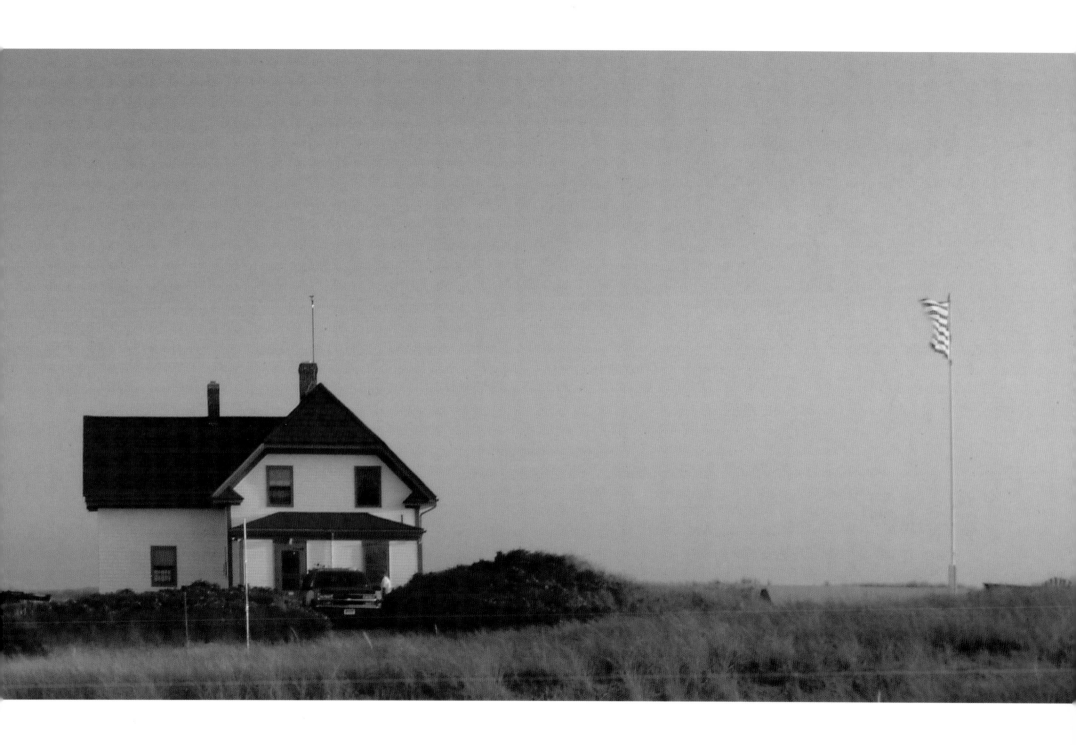

Head of the Meadow Beach in Truro.

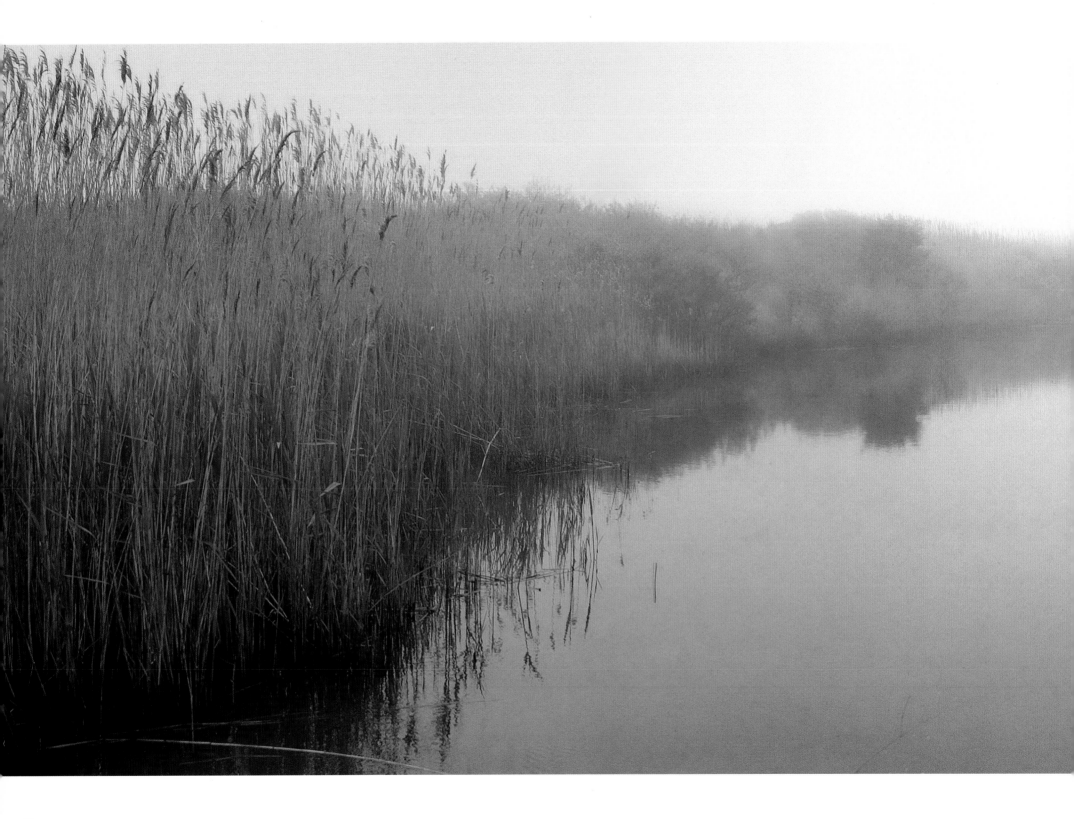

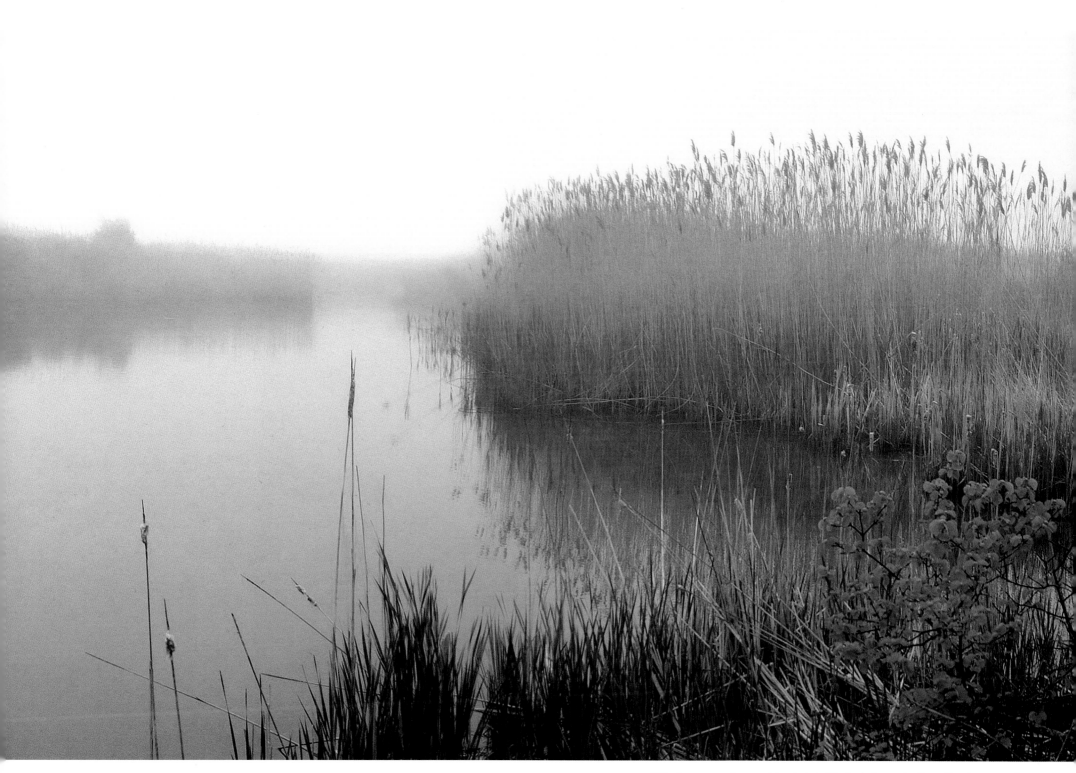

This foggy morning creek leads into Pilgrim Lake on the Truro/Provincetown line.

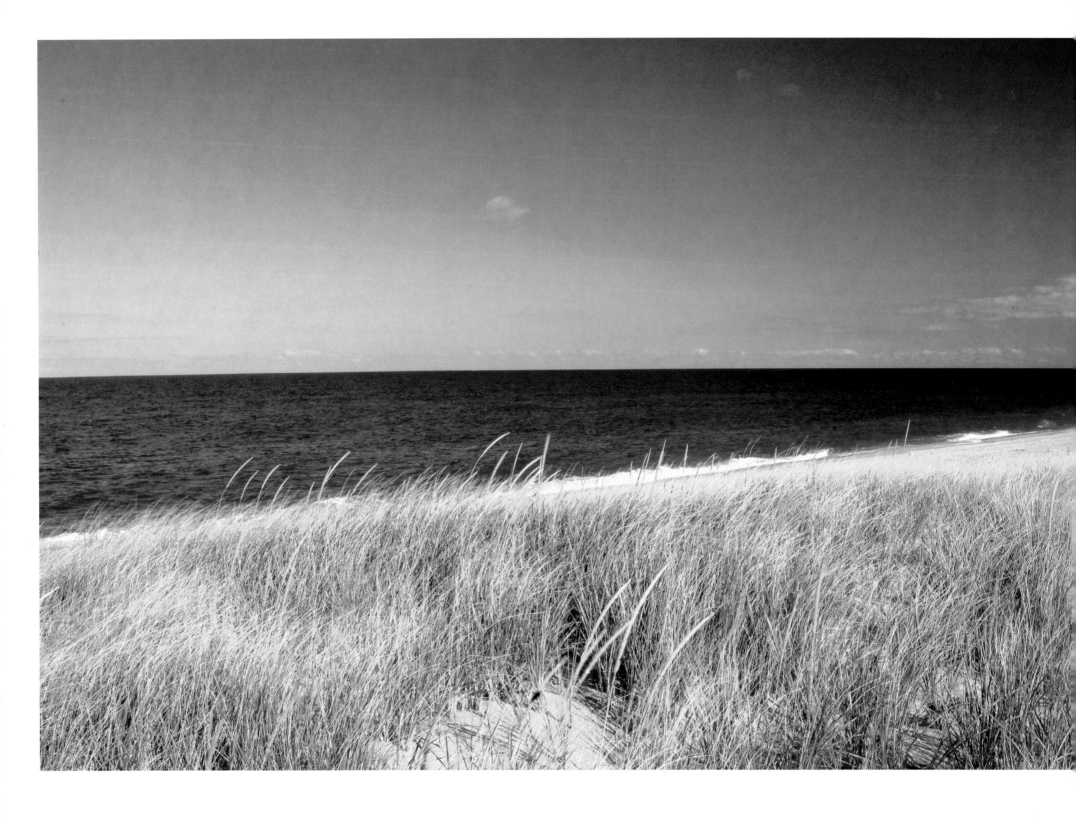

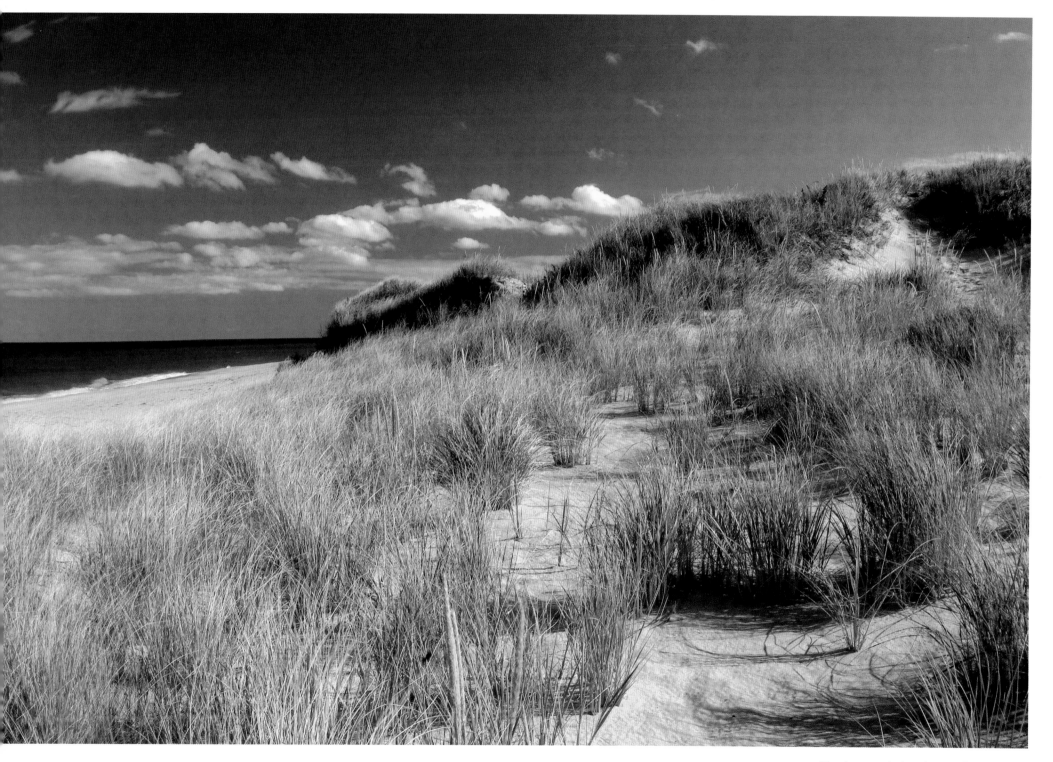

The dunes and a beach near Highland Light.

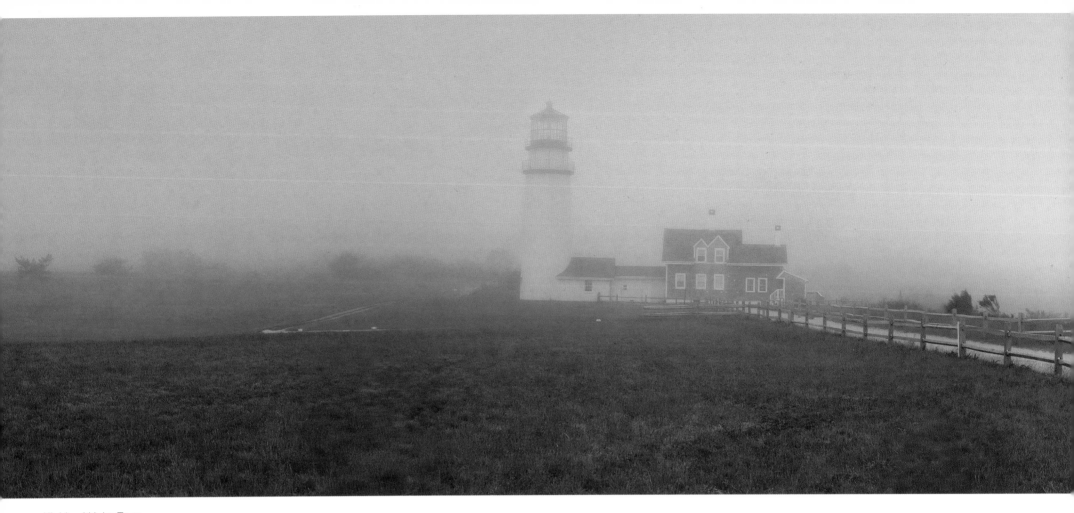

Highland Light, Truro.

Highland Lighthouse is open to the public, and 69 steps
lead to the lantern room where this panorama was taken.

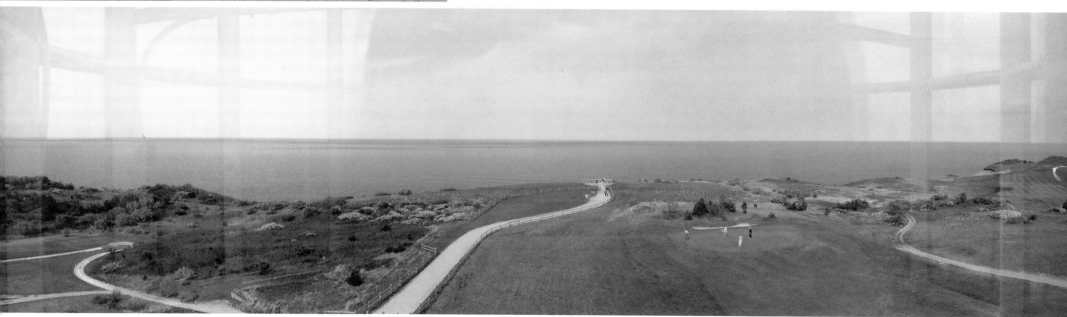

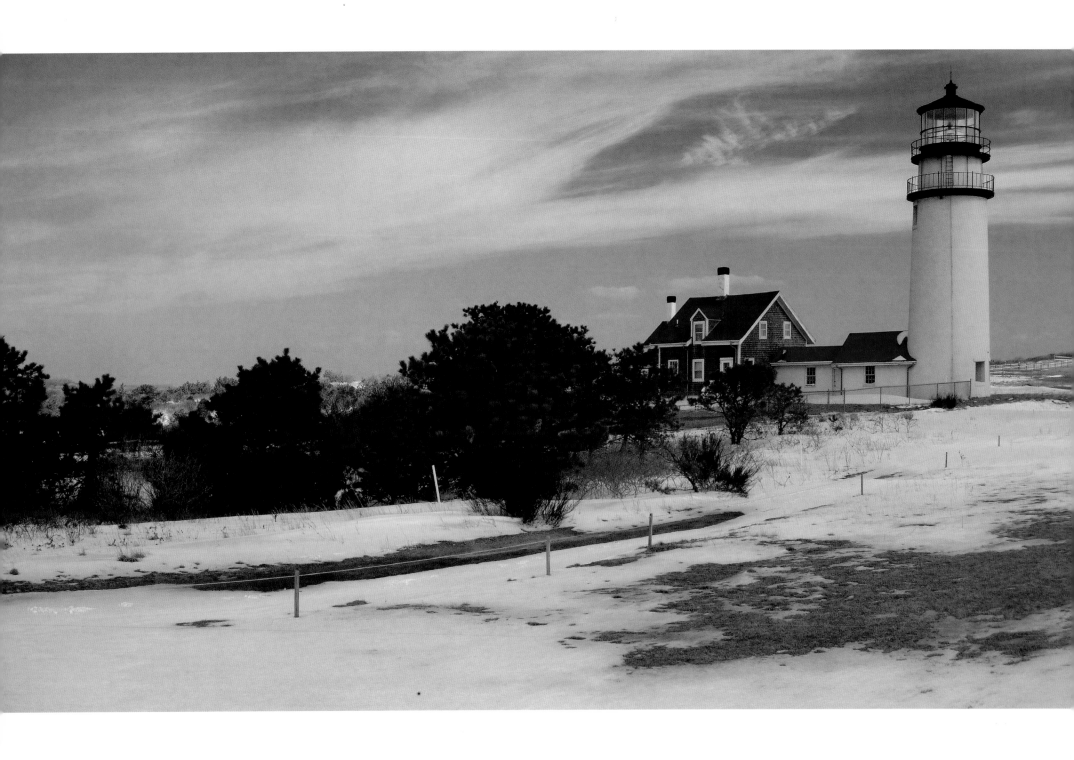

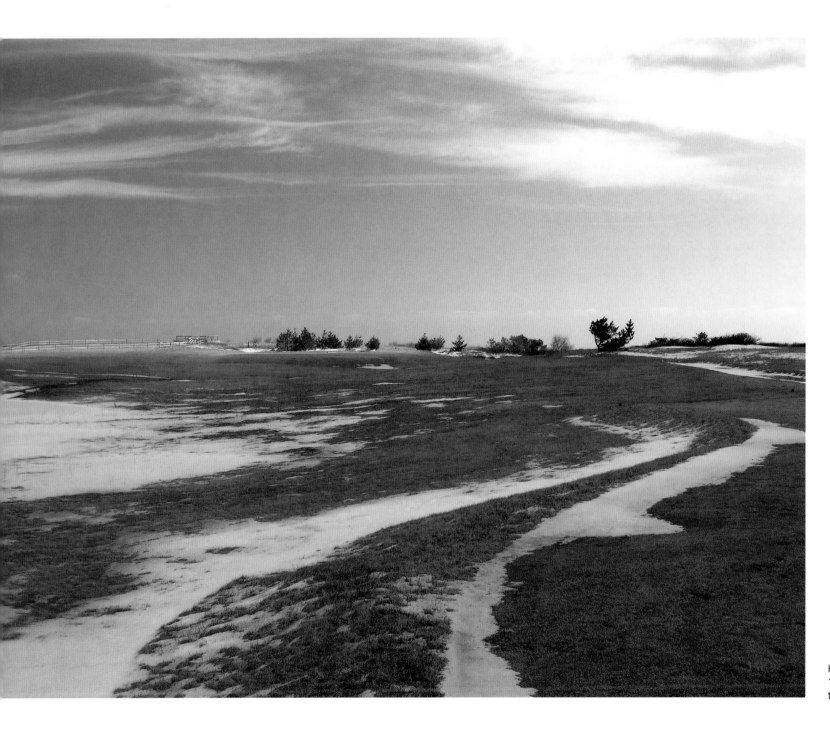

Highland Light in early spring. Moved in 1996, Highland Light still remains close to the ocean and is an active aid to navigation.

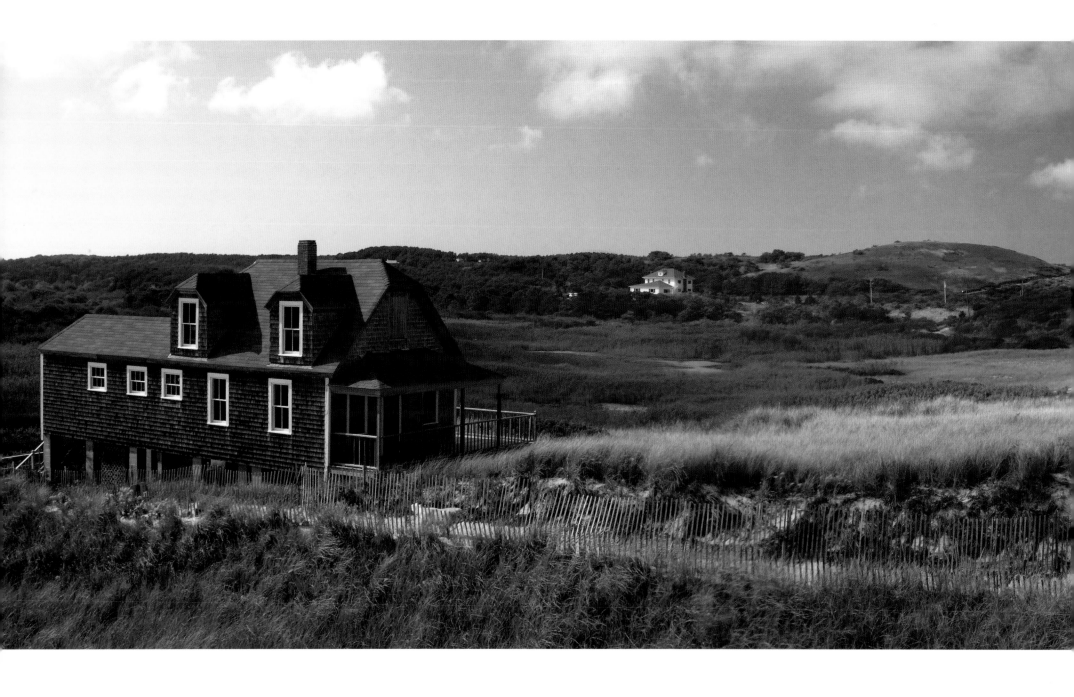

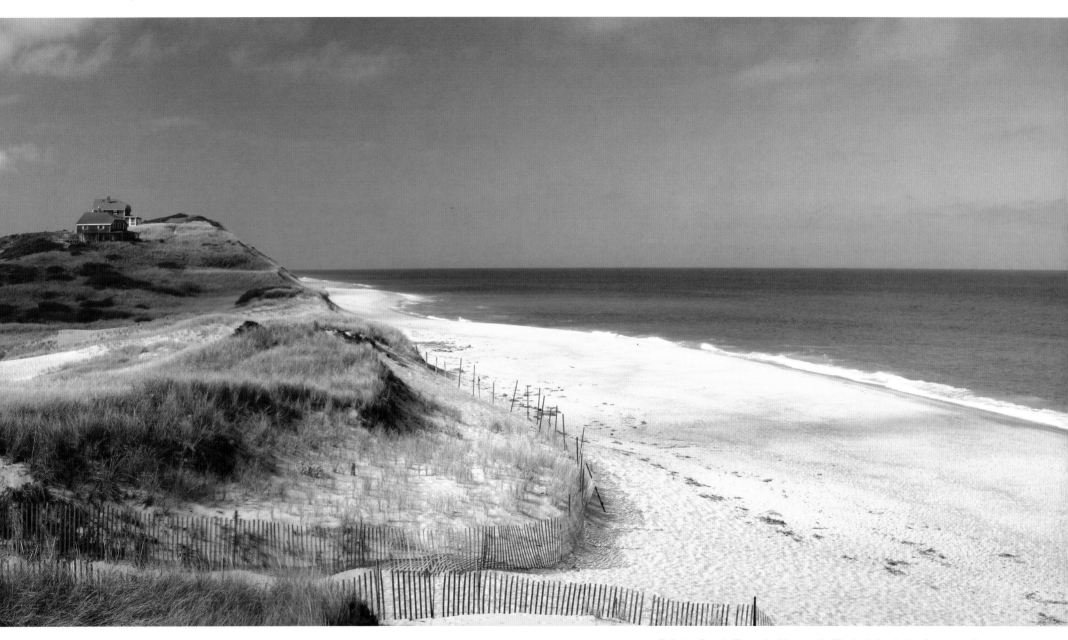

Ballston Beach, Truro, looking north. The building in the foreground may have been associated with the life saving station located here. The white building in the background, which is now an environmental education center, was originally a Coast Guard installation.

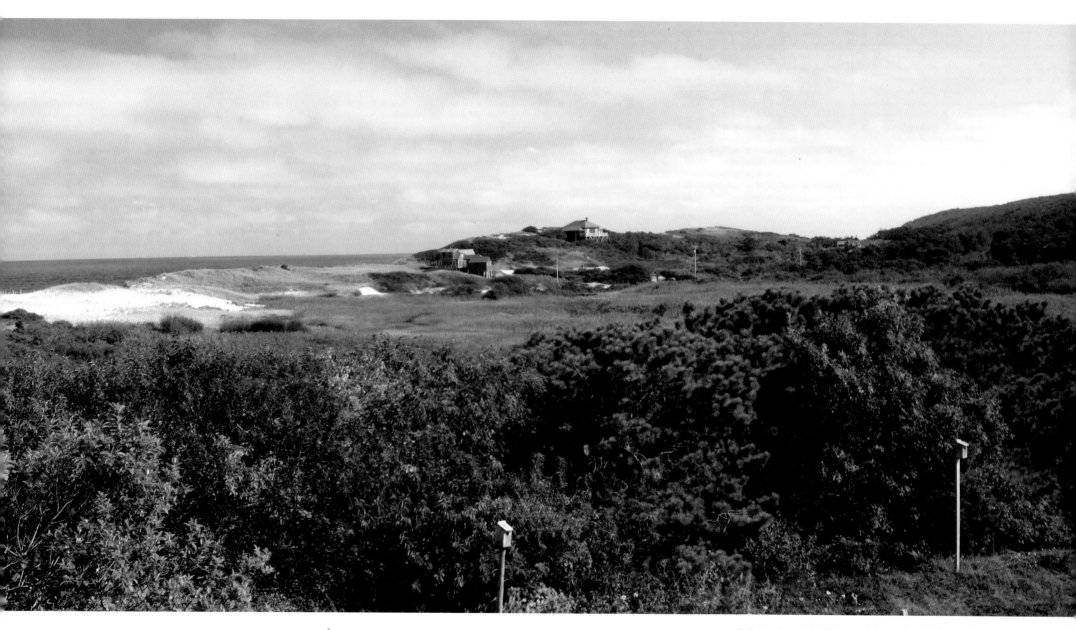

Ballston Beach looking south from the old Coast Guard Station.

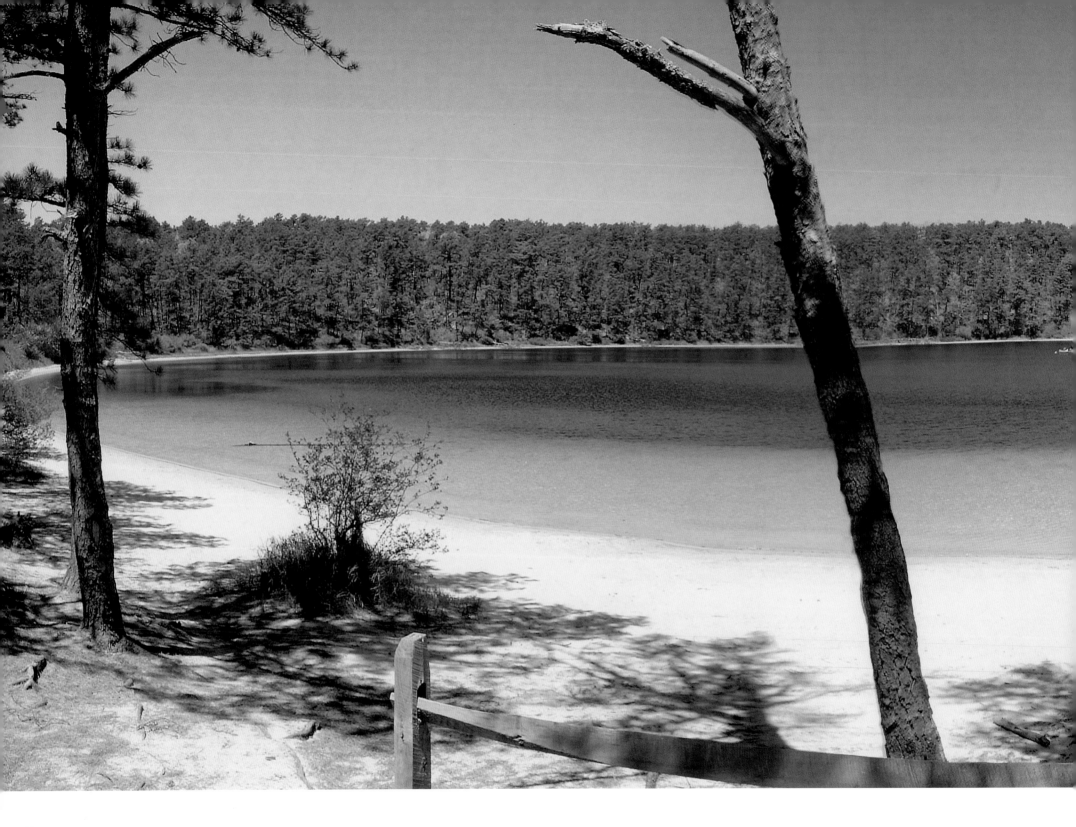

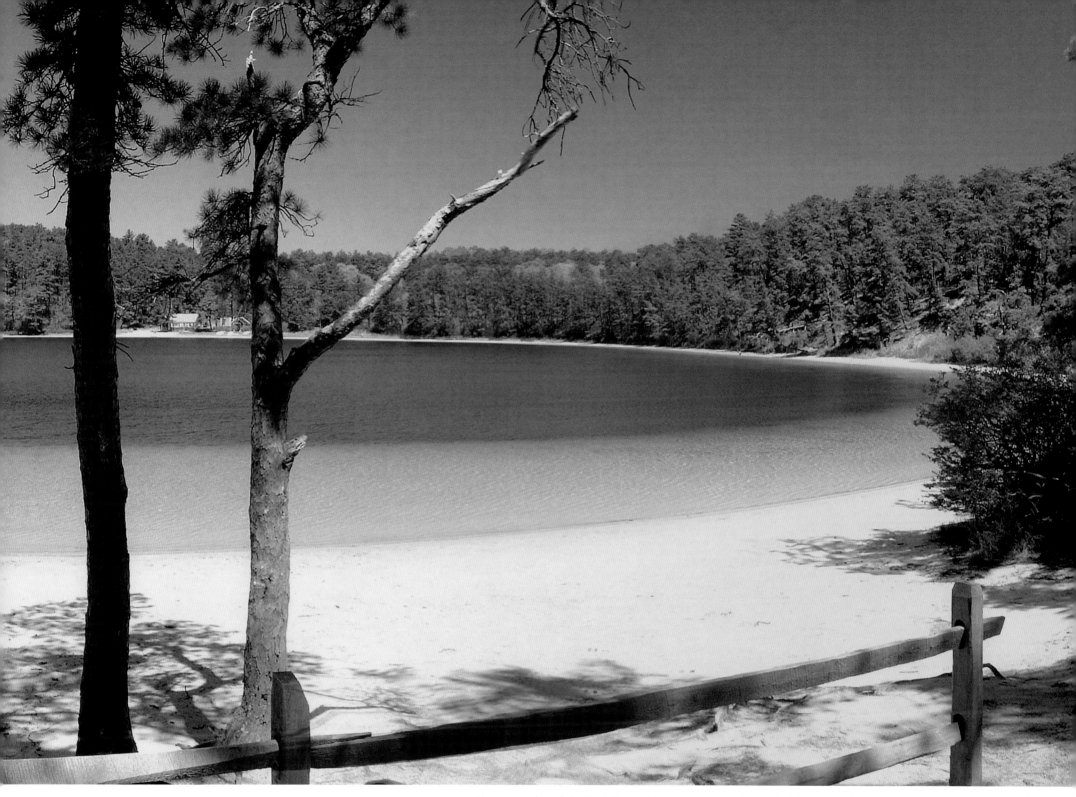

Almost a perfect circle, Duck Pond, hidden in the woods in Wellfleet, is a product of the glaciers that formed Cape Cod. Huge blocks of ice remained when the glaciers retreated and formed the numerous kettle ponds.

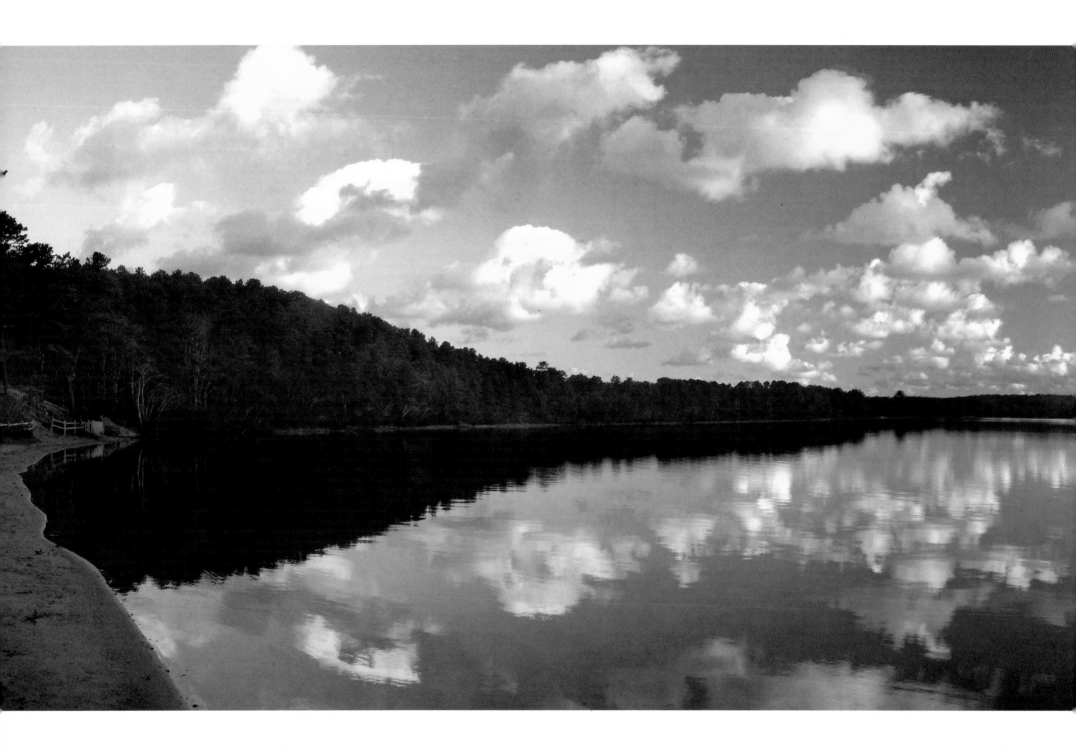

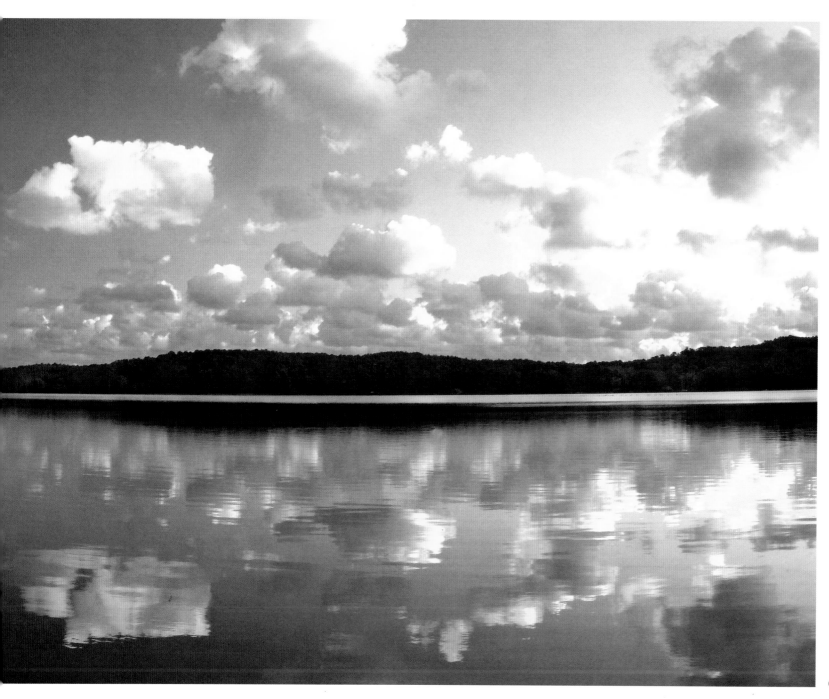

Gull Pond, another kettle pond in Wellfleet.

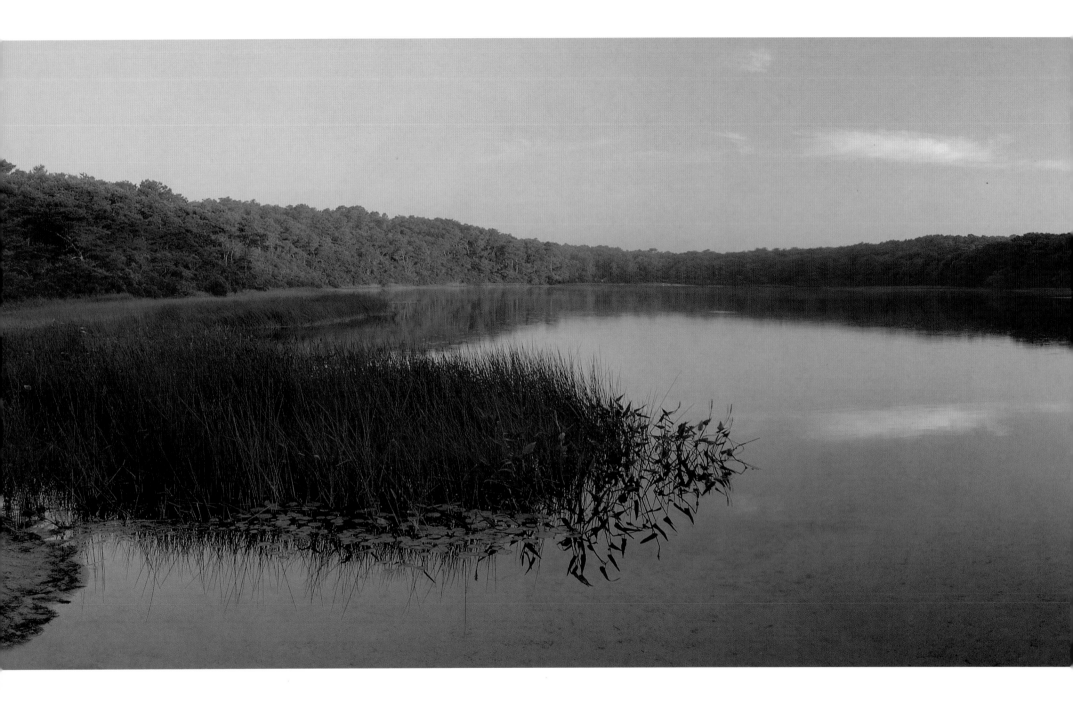

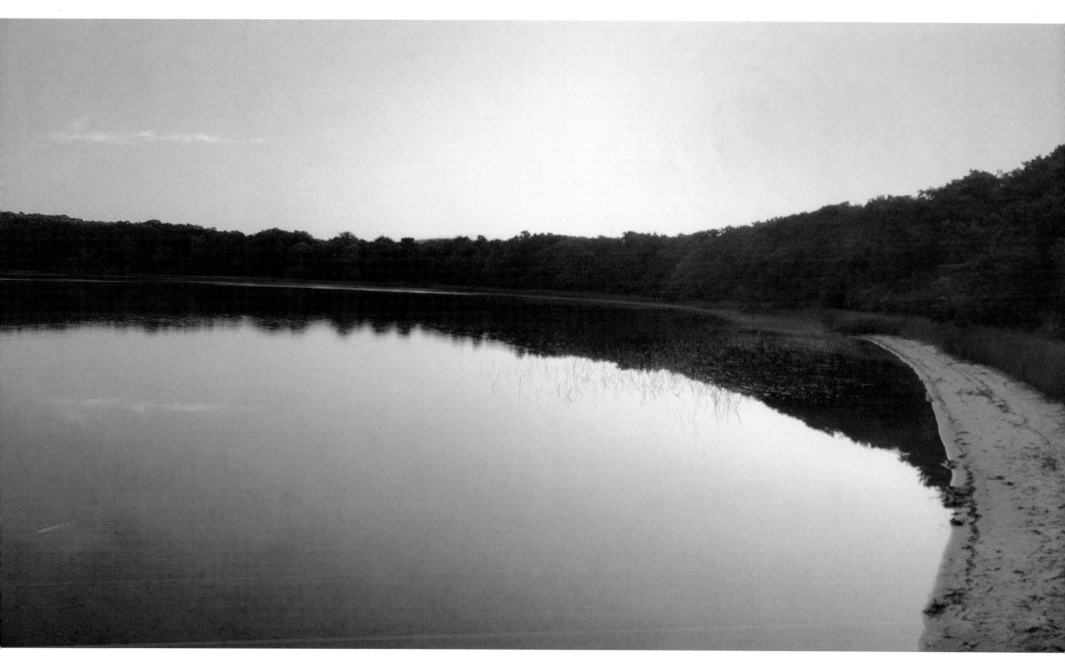

Horseleech Pond, Wellfleet, in the early morning.

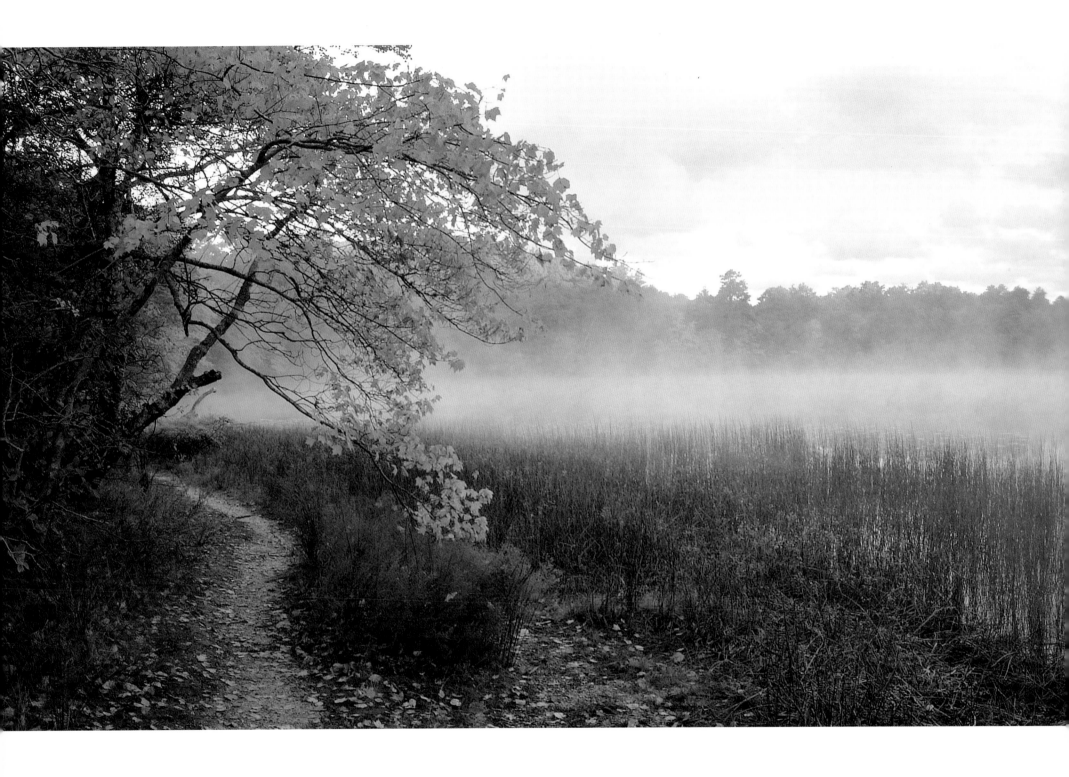

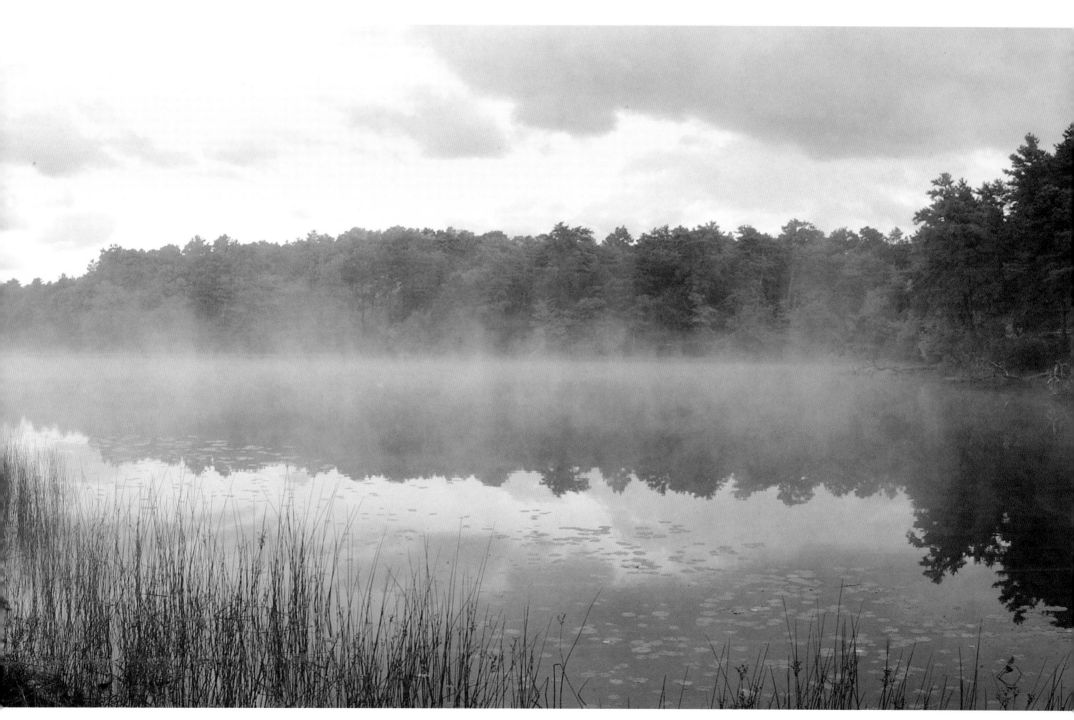

In the fall, a morning fog hangs over Snow Pond, Truro

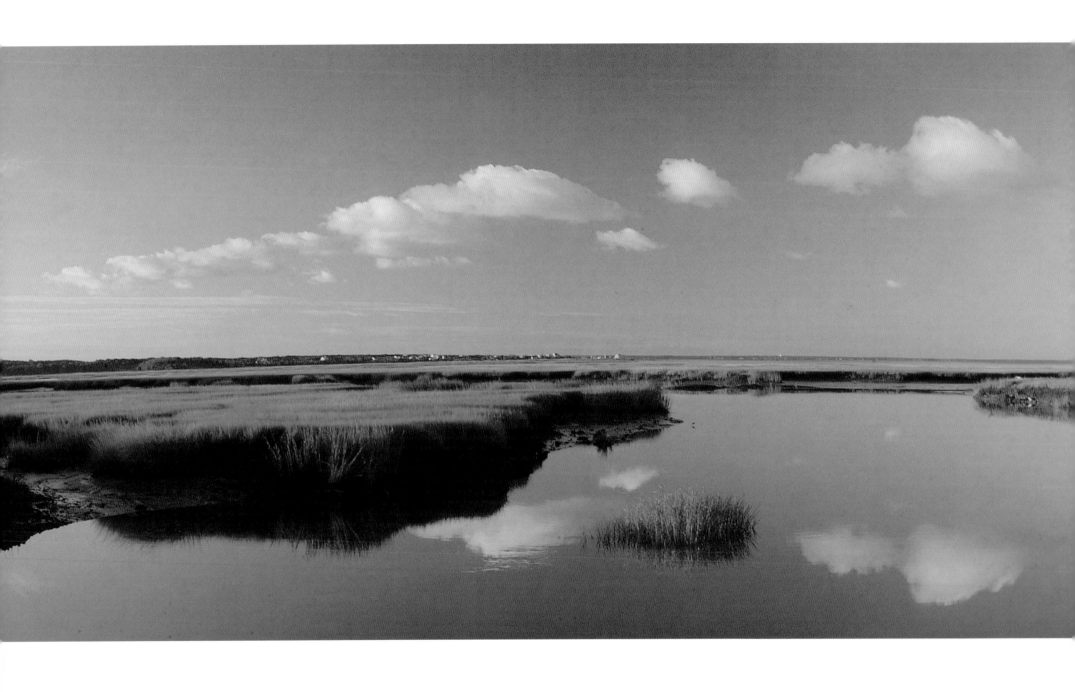

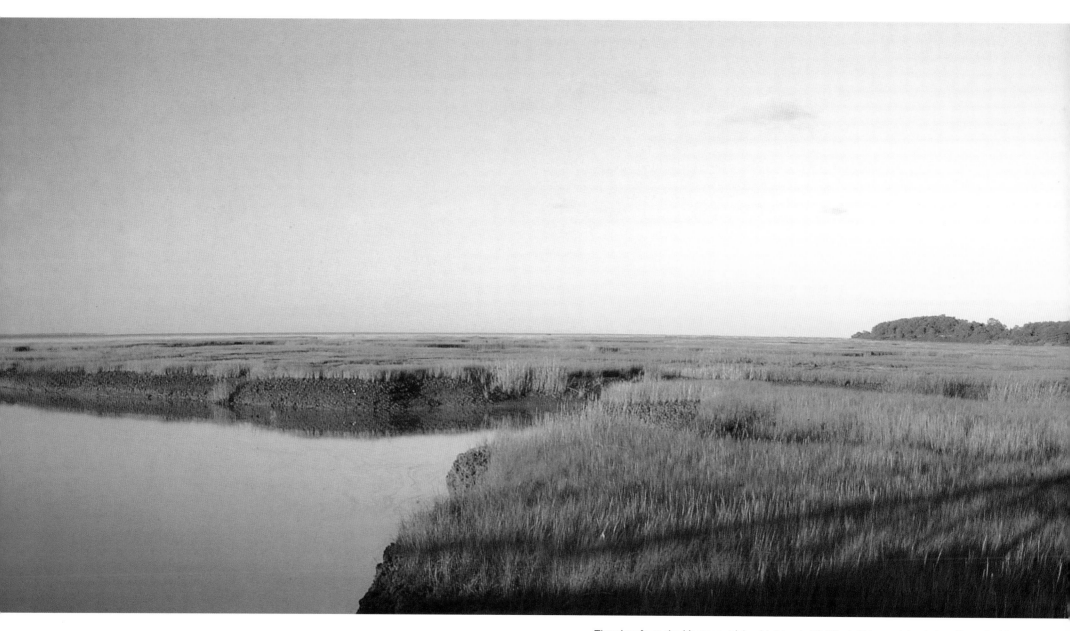

The view from the Lieutenant Island bridge in Wellfleet. This creek leads into Cape Cod Bay.

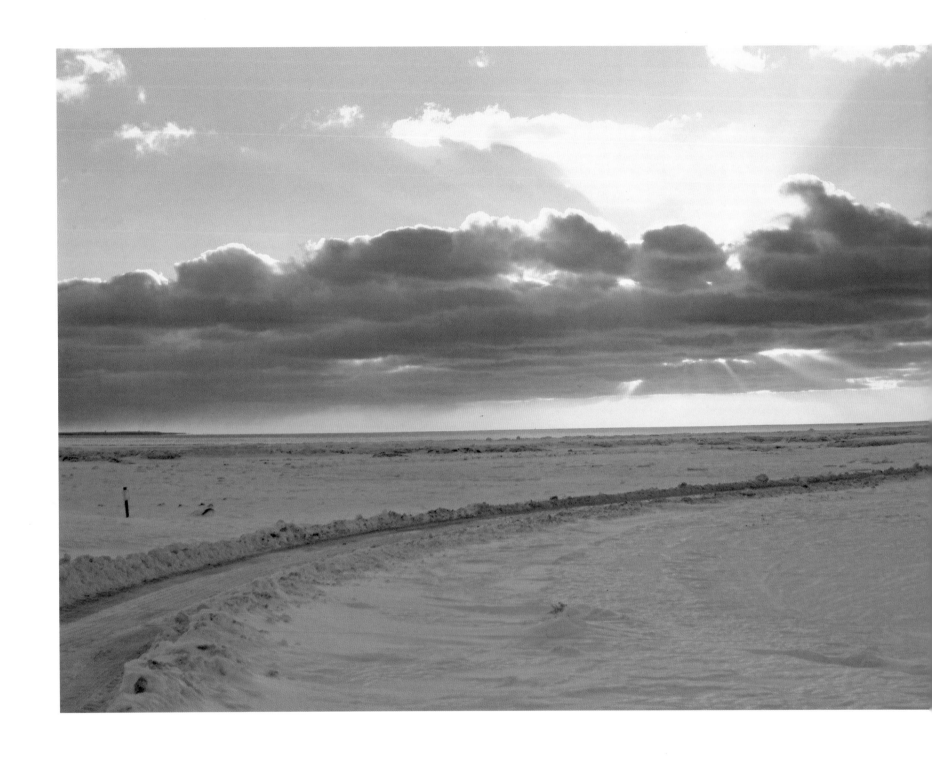

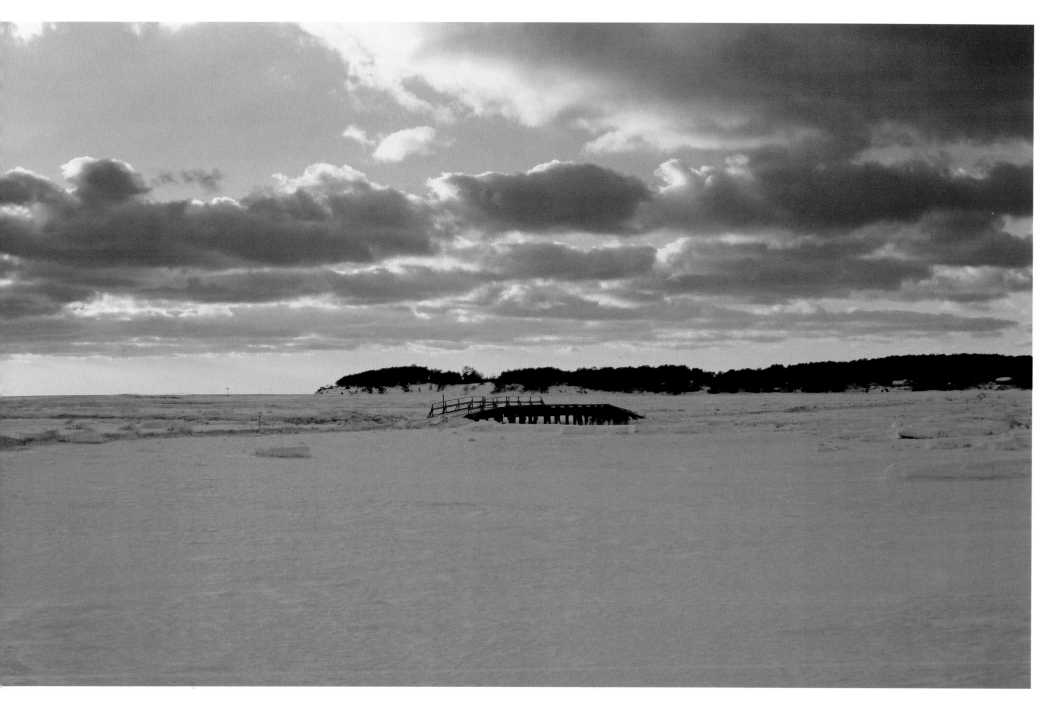

The road to the Wellfleet bridge, seen in winter. Lieutenant Island is in the background.

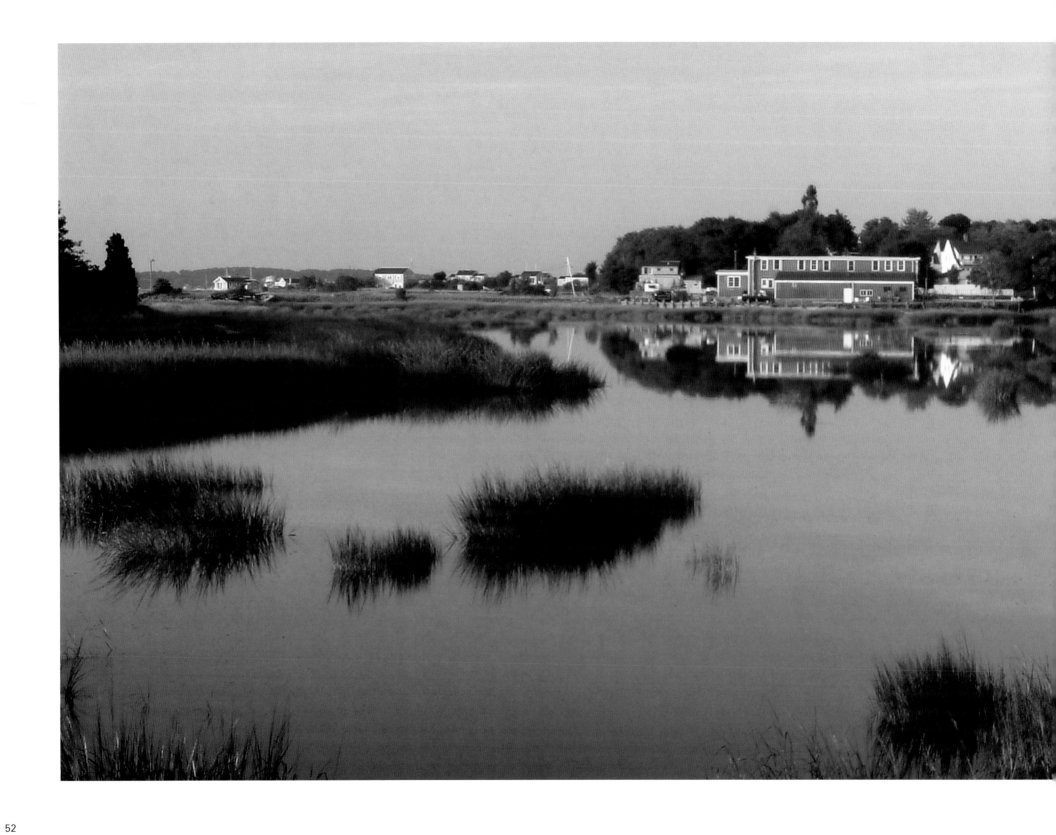

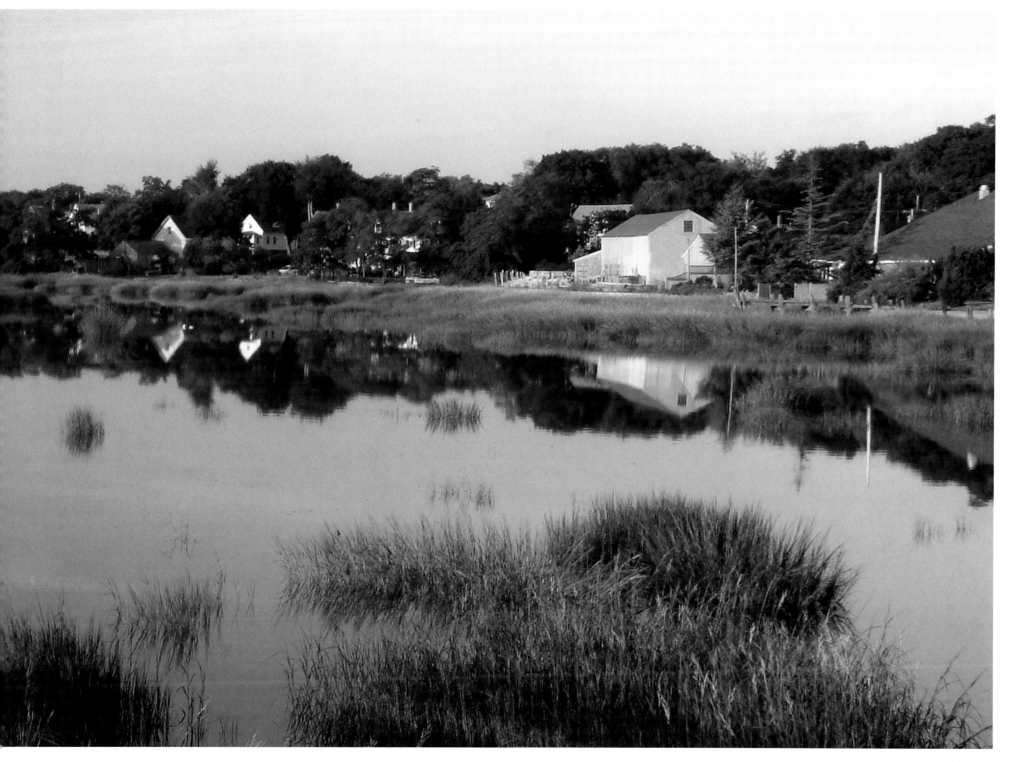

Duck Creek, Wellfleet.

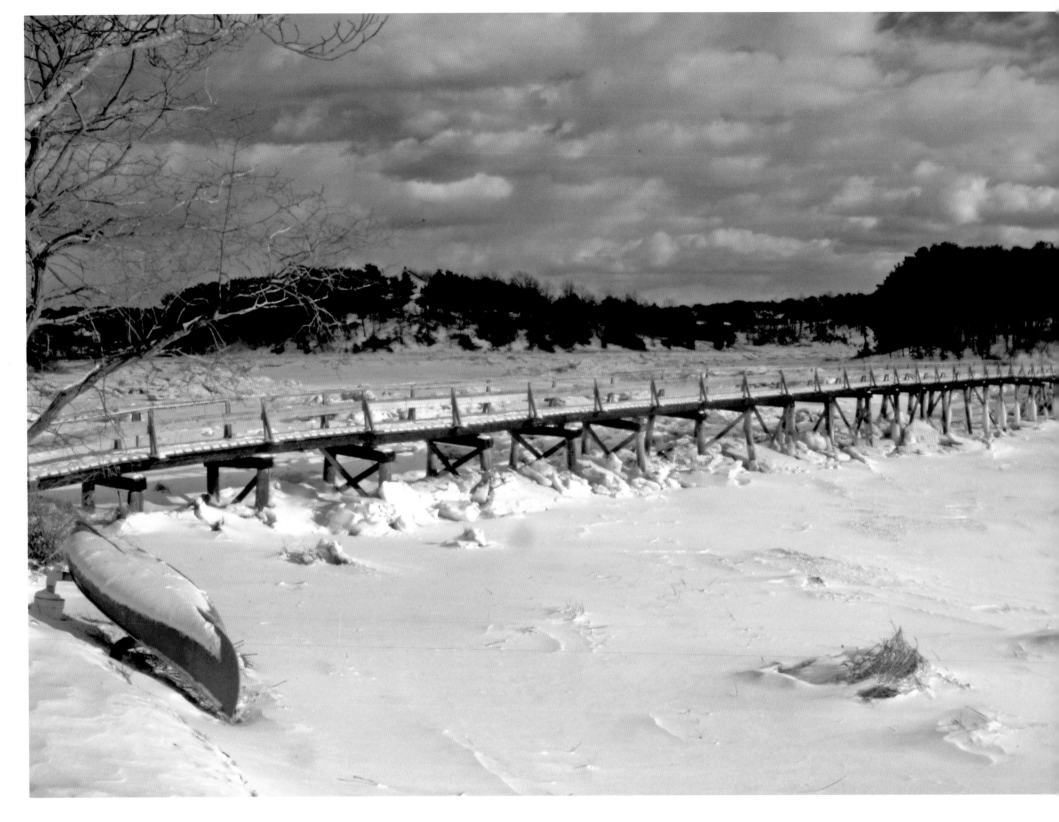

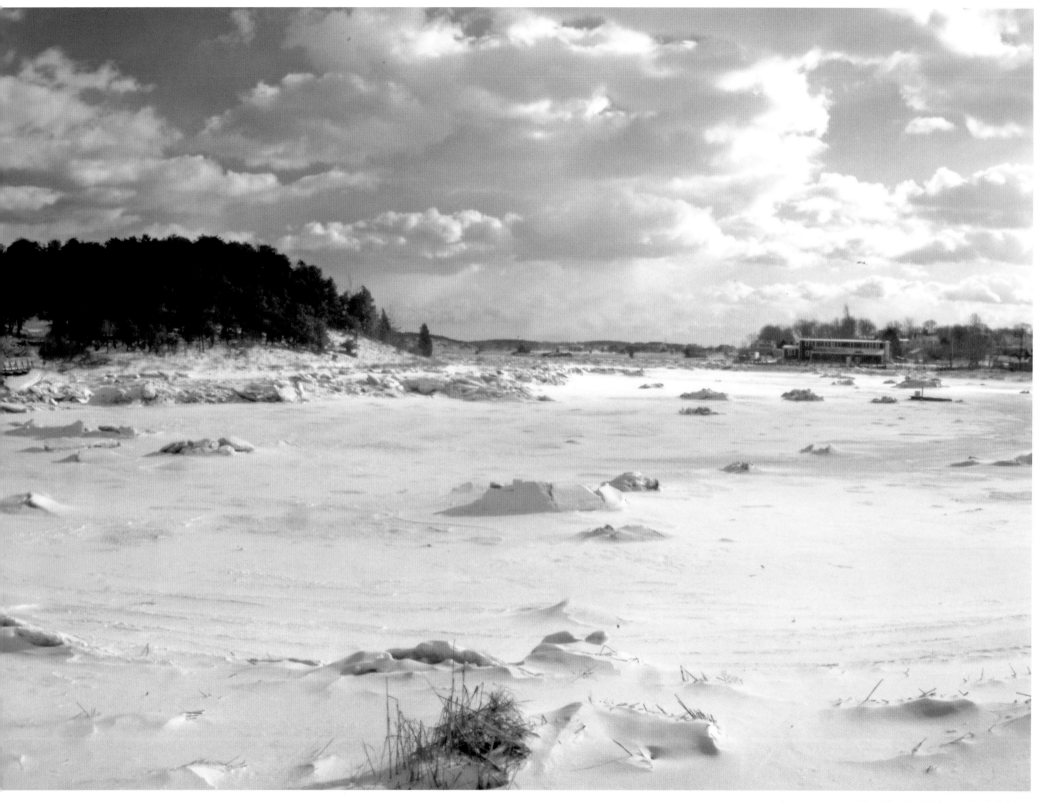

A snow-covered Duck Creek with Uncle Tim's bridge.

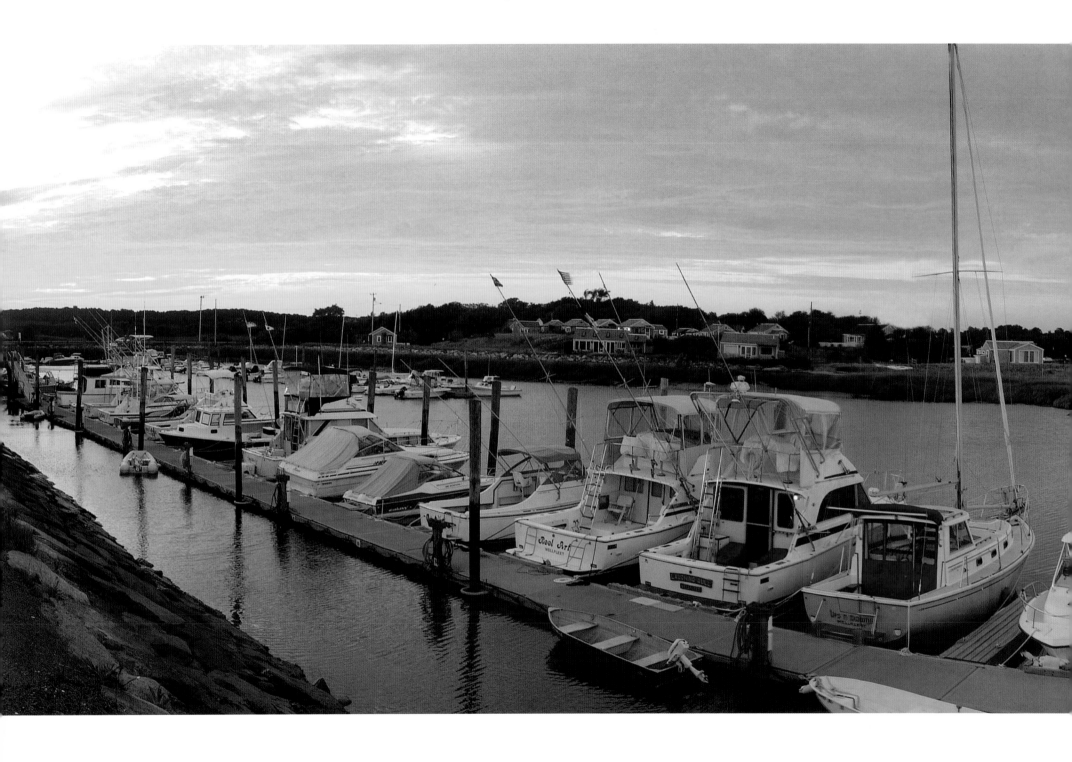

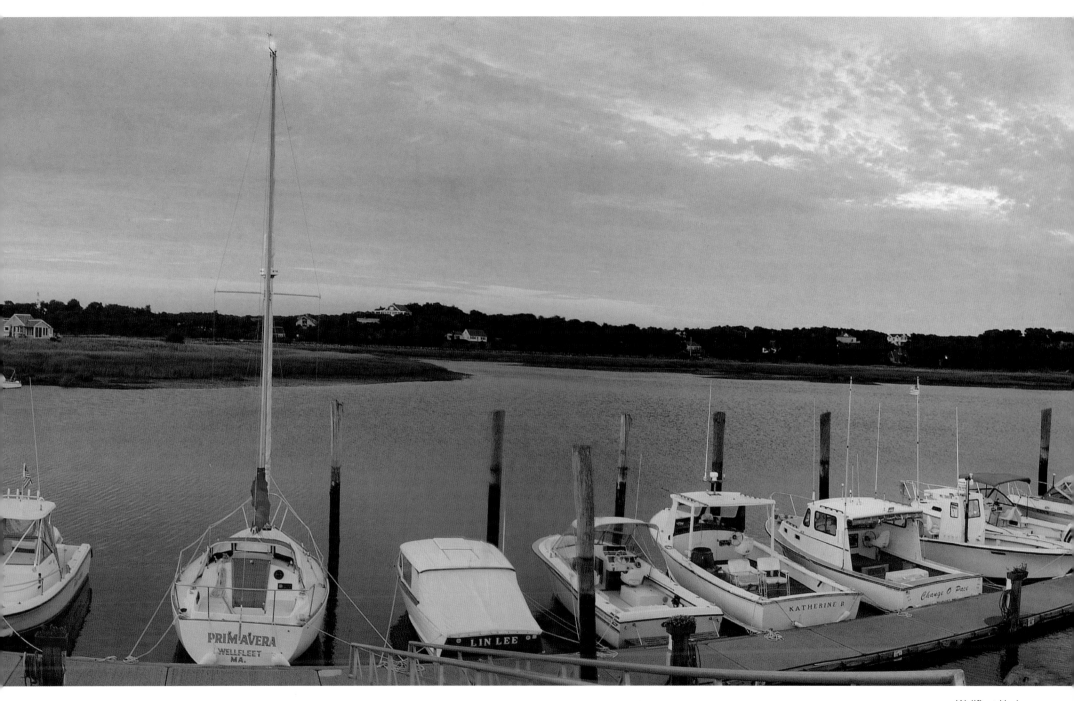

Wellfleet Harbor.

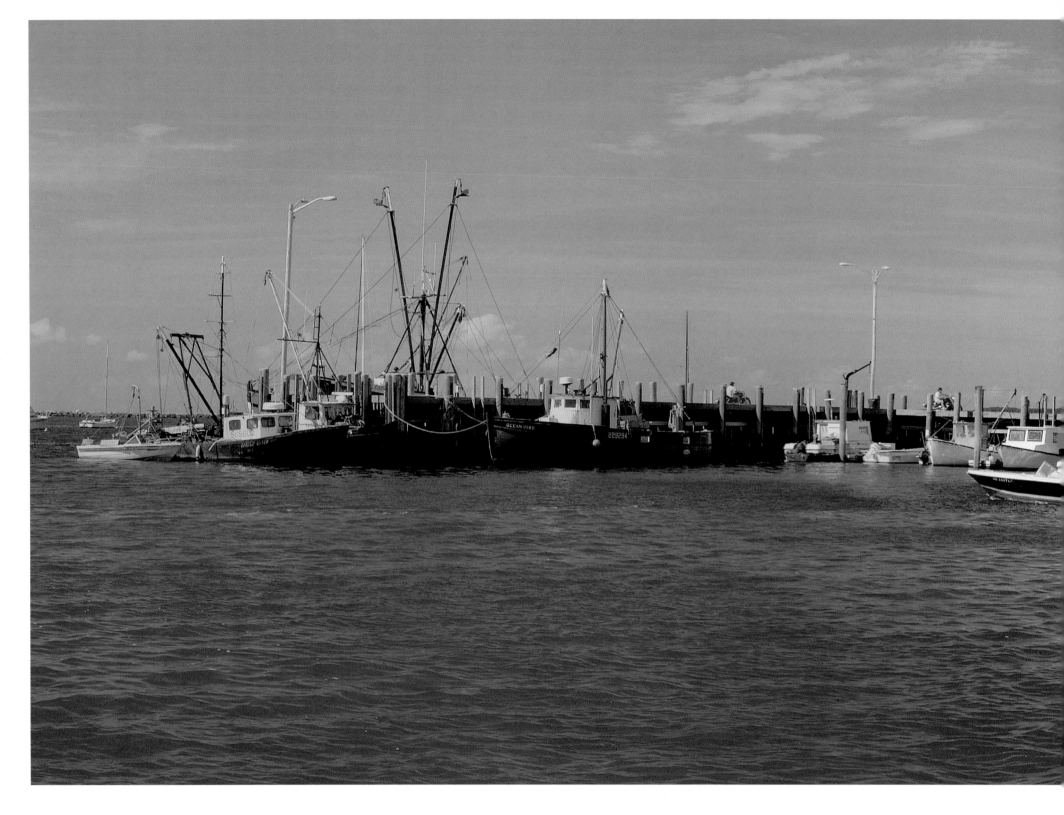

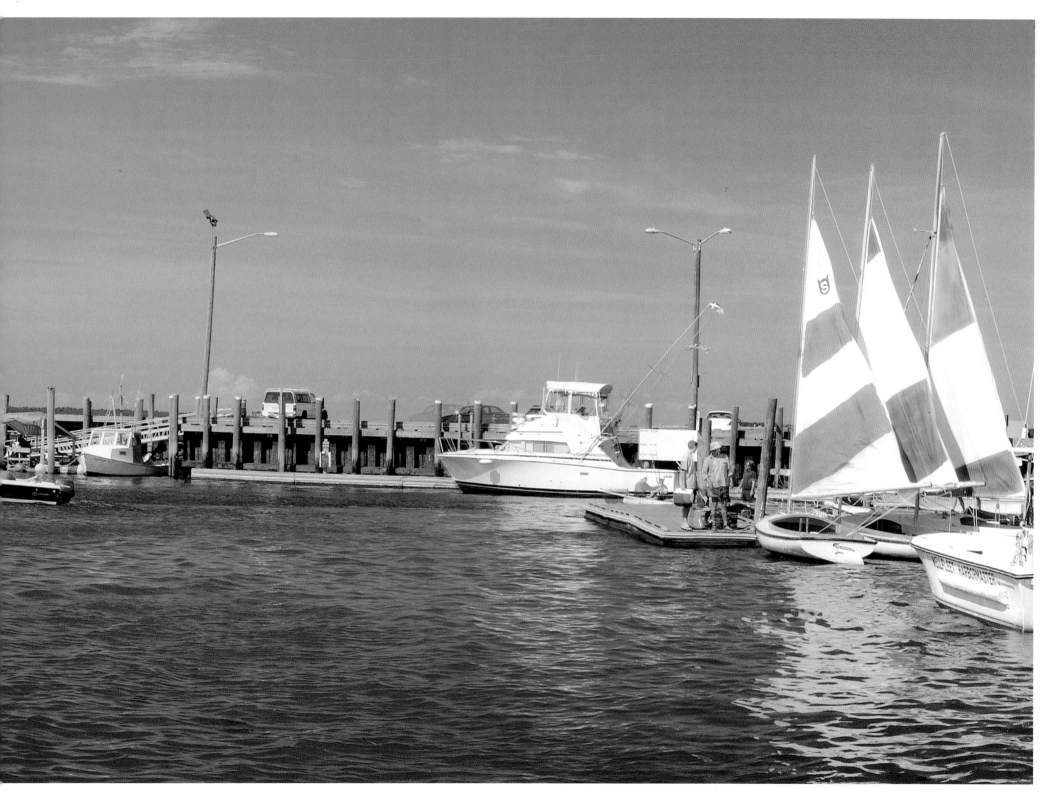

Wellfleet Harbor is port to both commercial craft and recreational vessels.

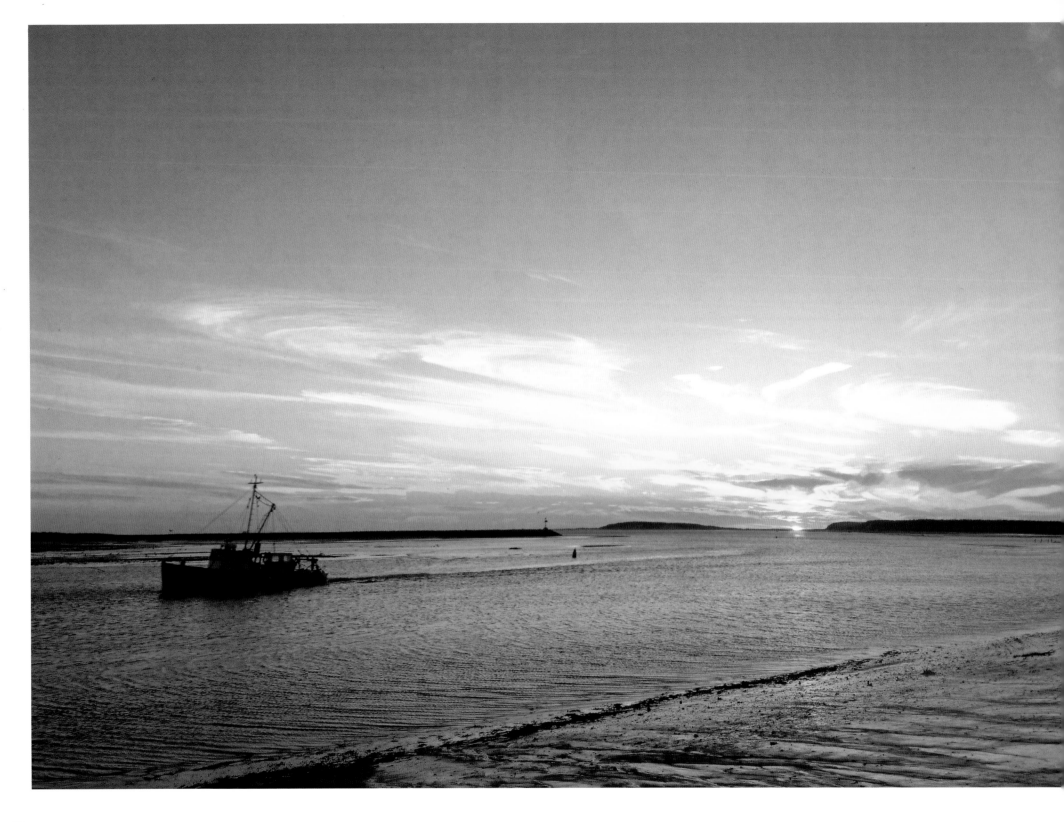

At low tide, a dragger returns to harbor while clam diggers work the flats.

Sunrise at Marconi Beach.

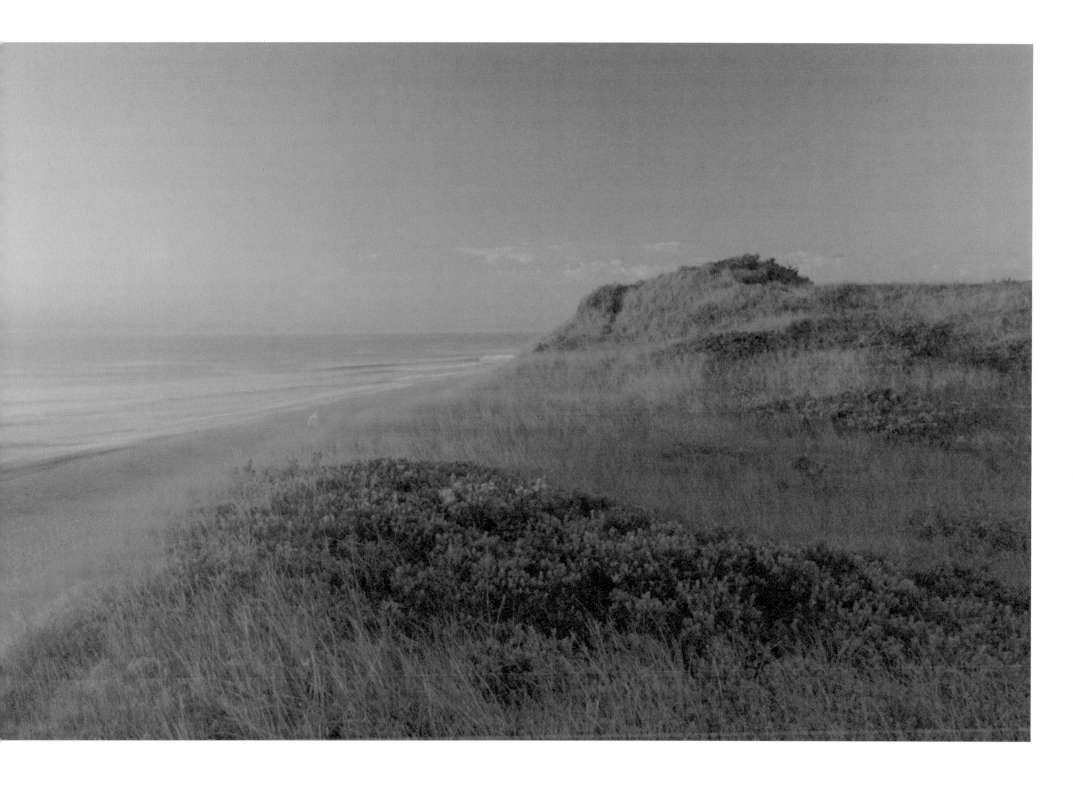

Following pages: A peaceful sunrise on the outer beach.

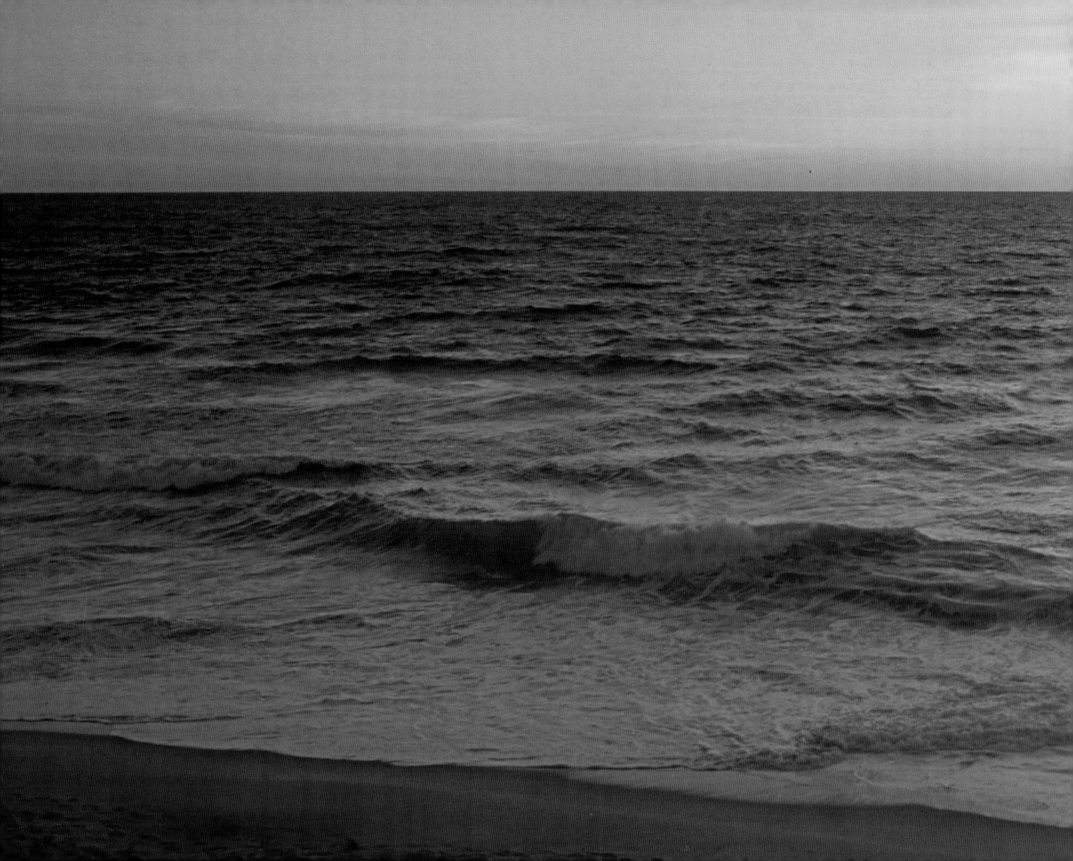

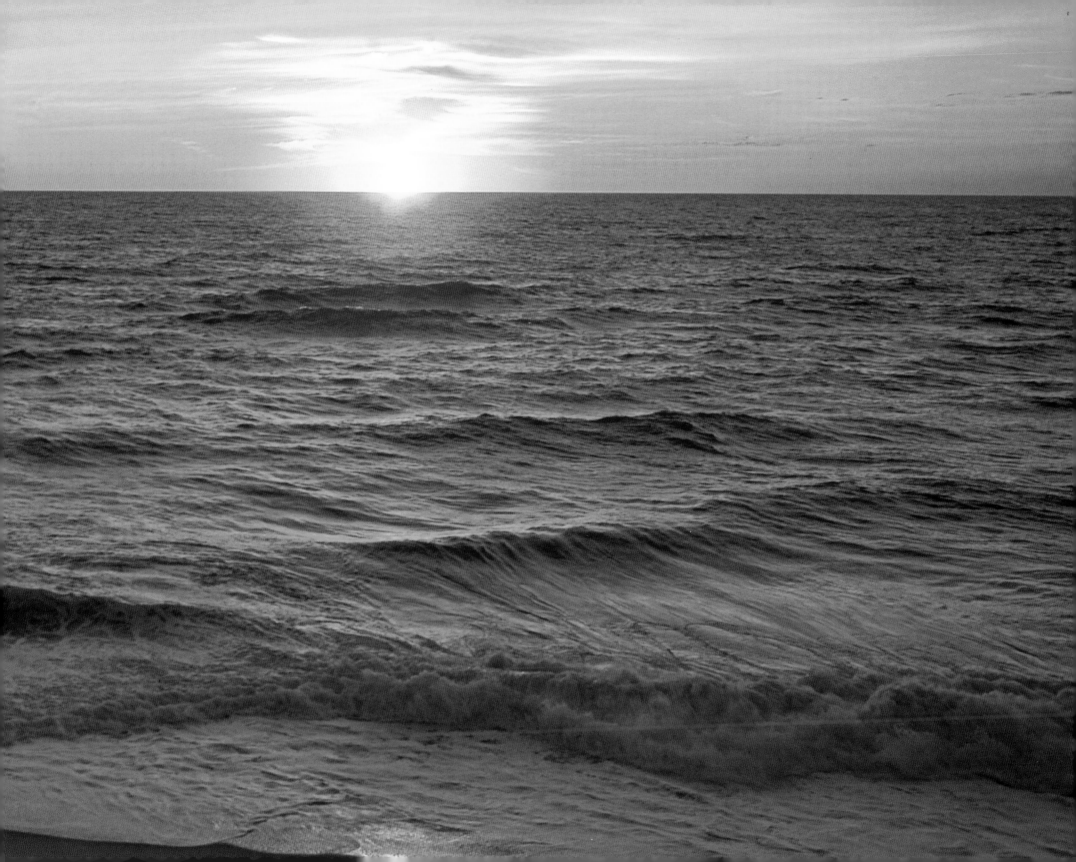

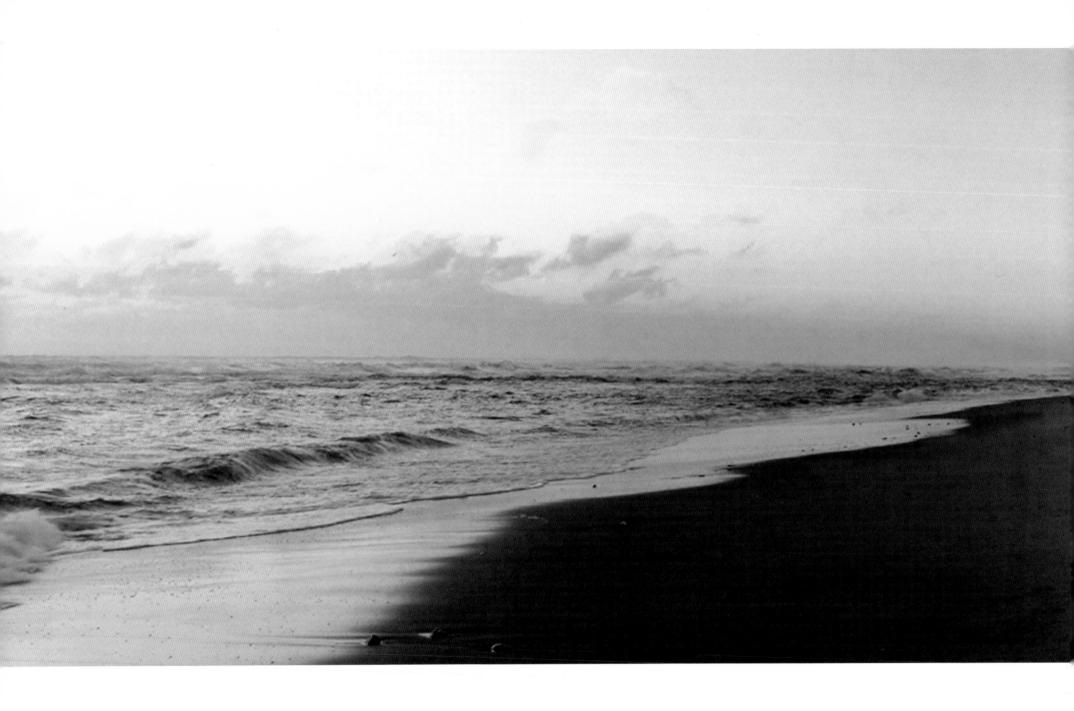

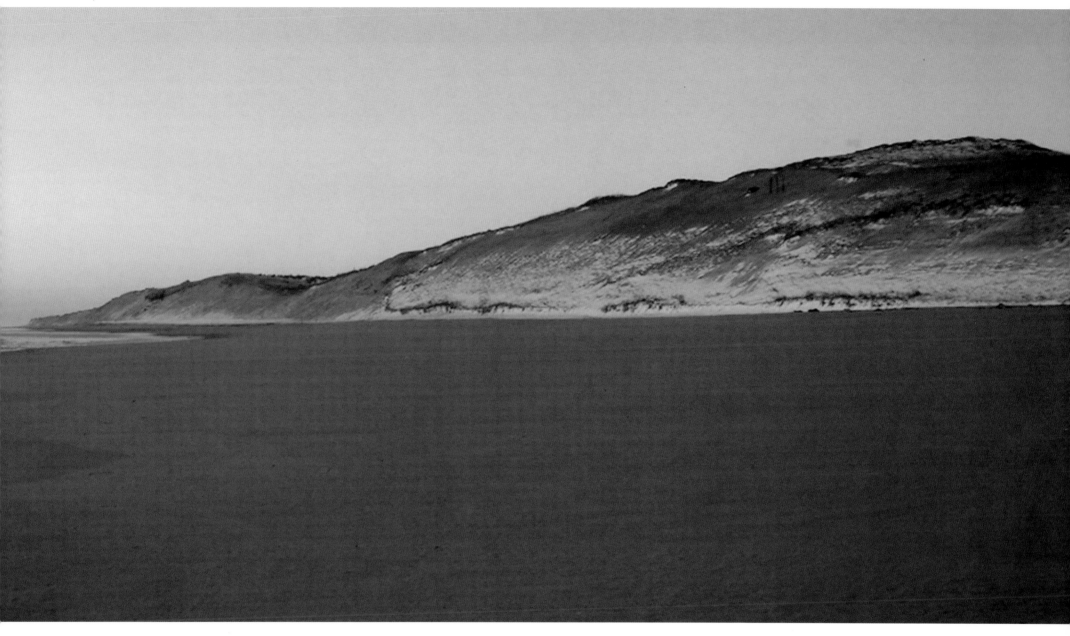

Winter storms at Lecount Hollow have swept the beach clean.

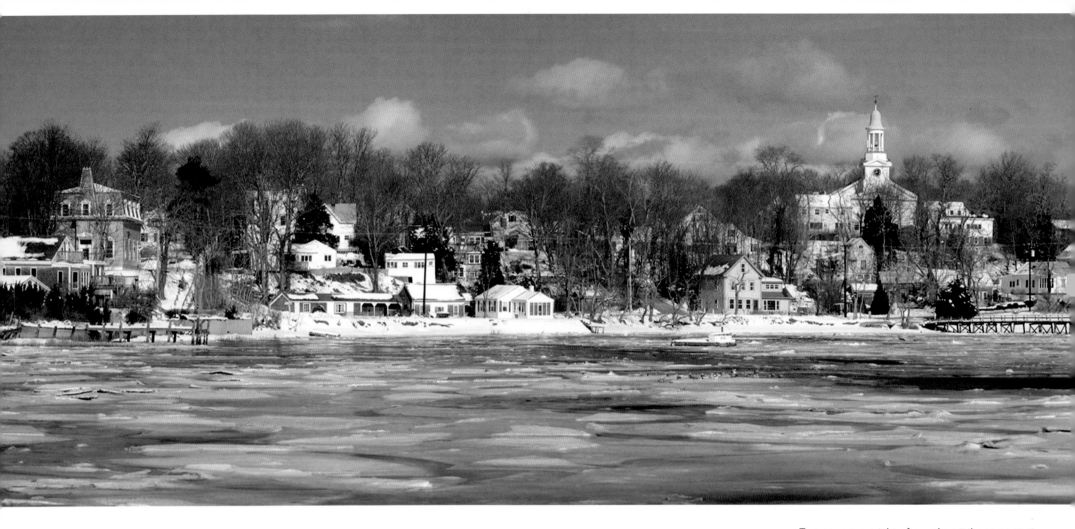

Two panoramas taken from almost the same spot,
looking at Wellfleet in two seasons.

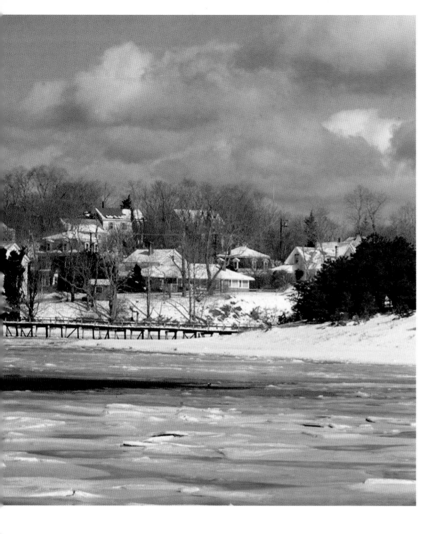

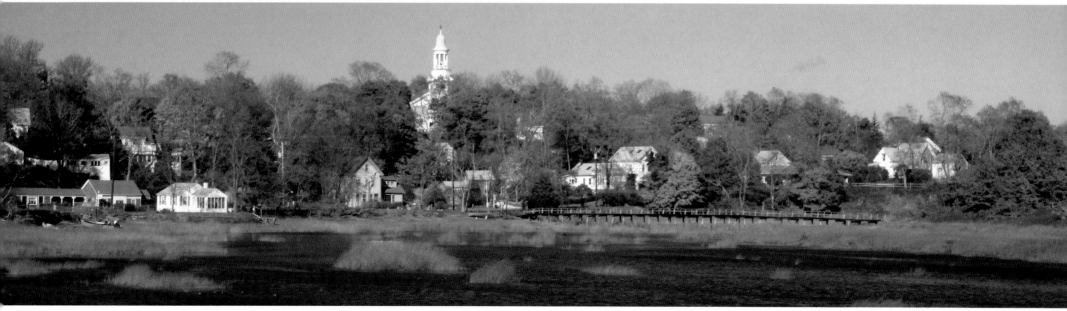

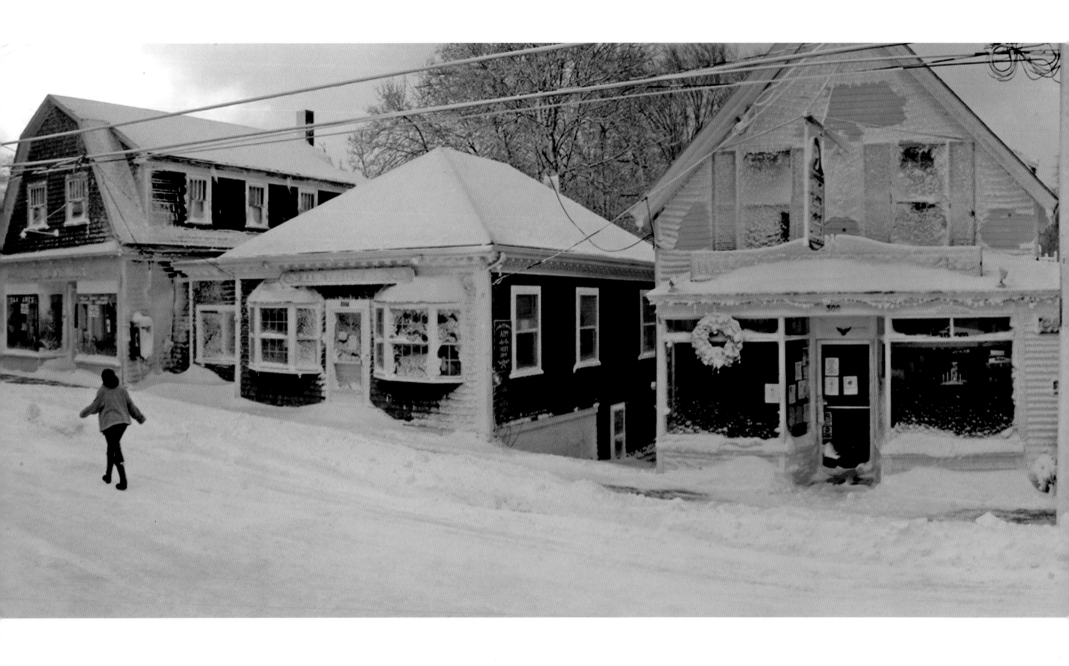

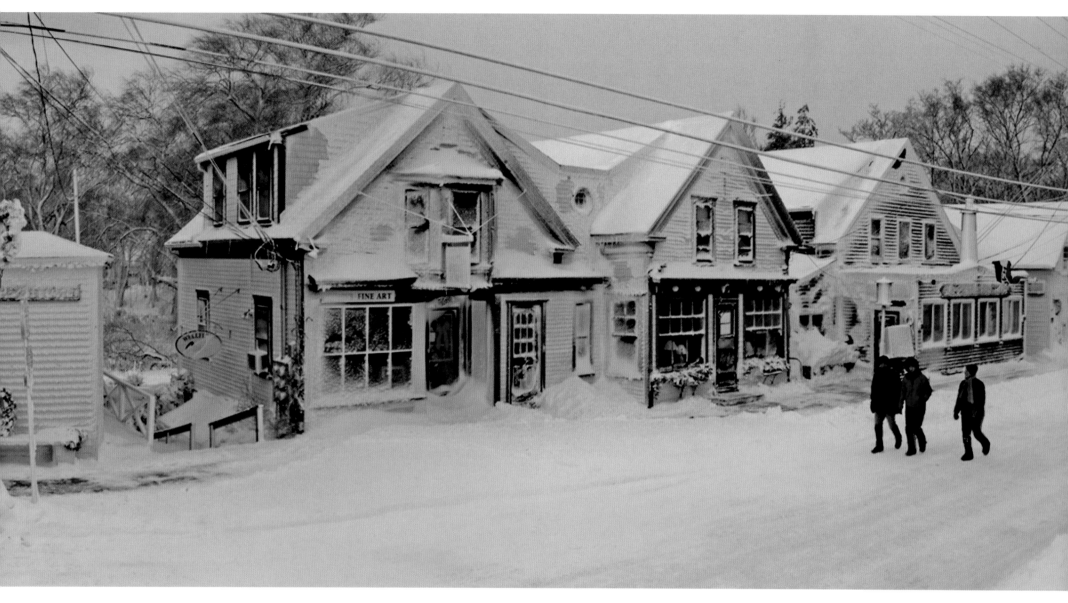

Downtown Wellfleet after a storm.

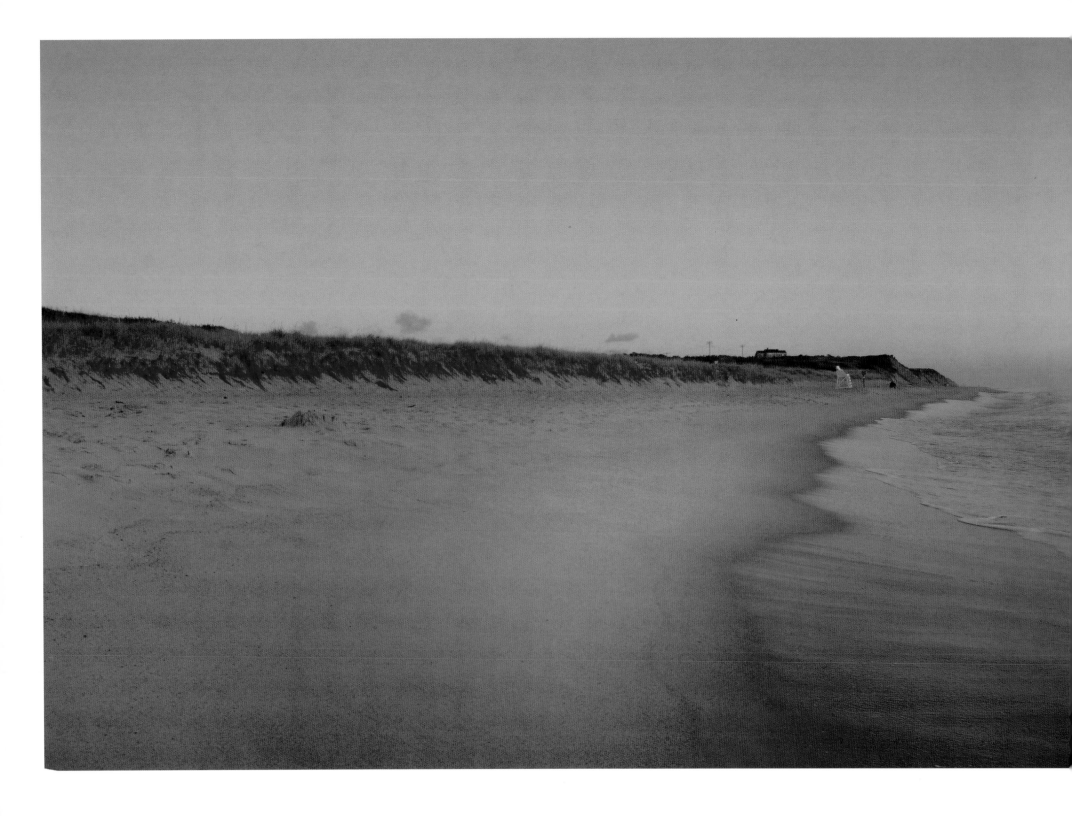

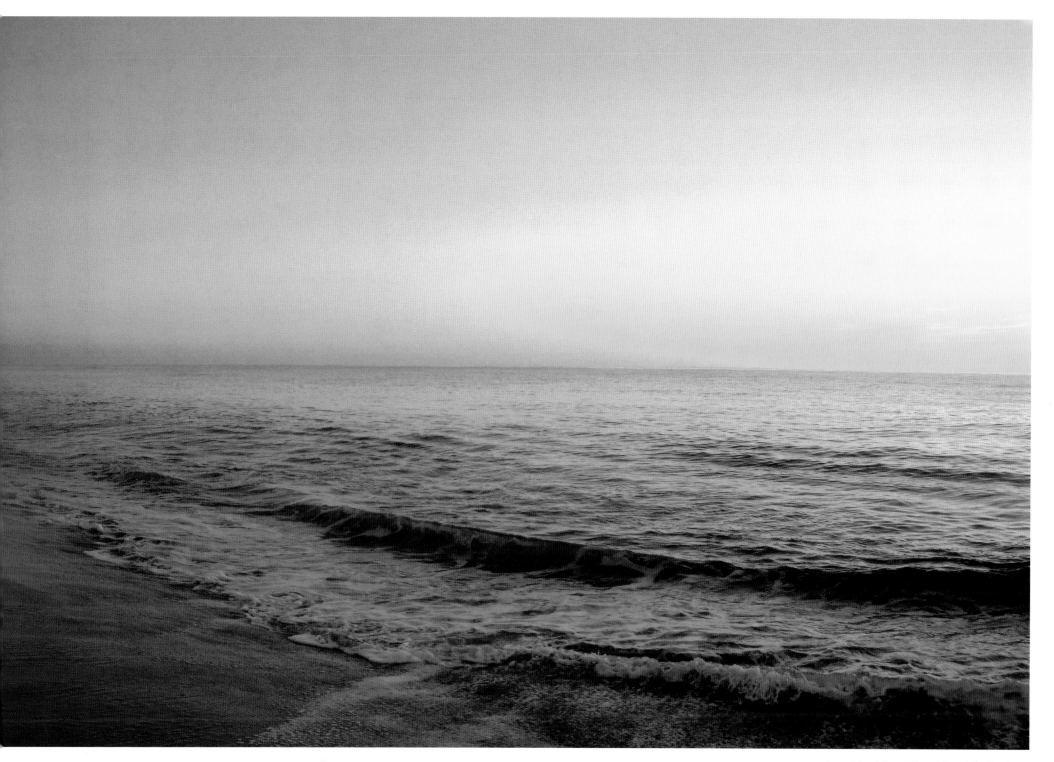

Low tide at Coast Guard Beach in Eastham.

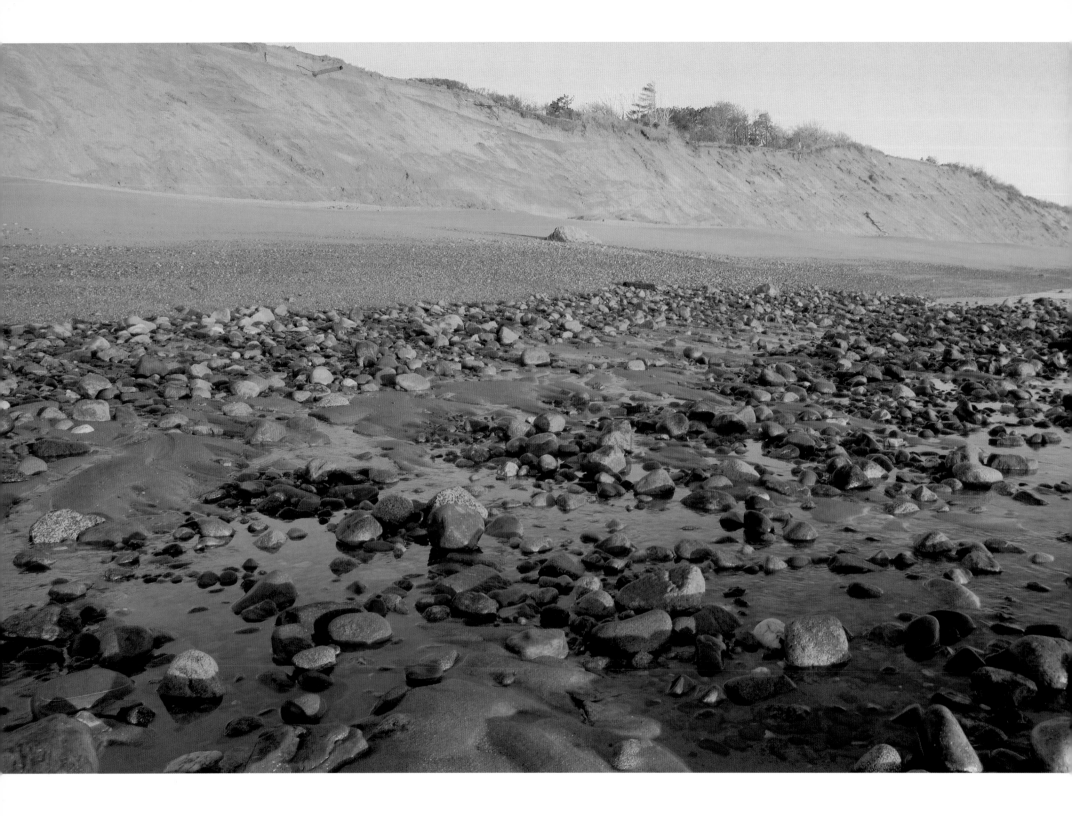

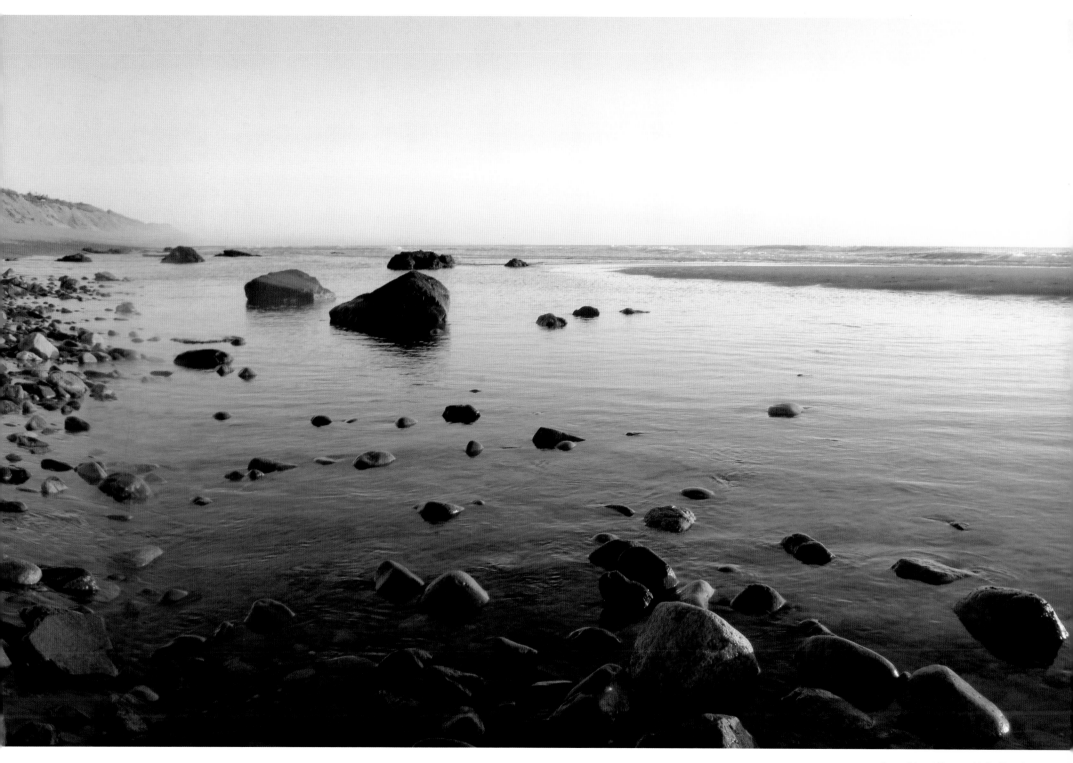

Low tide at Nauset Light Beach

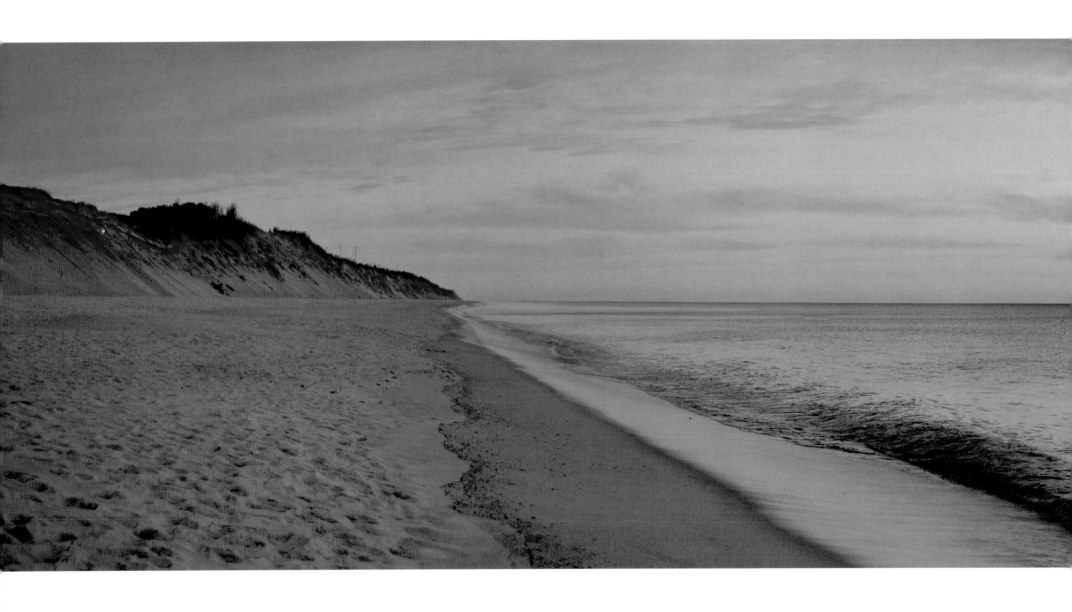

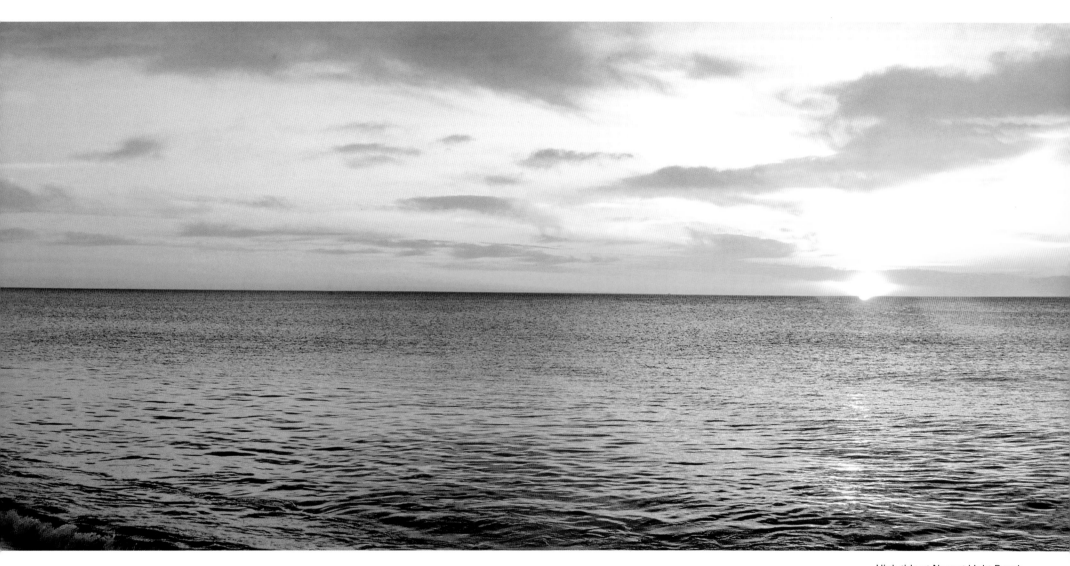

High tide at Nauset Light Beach.

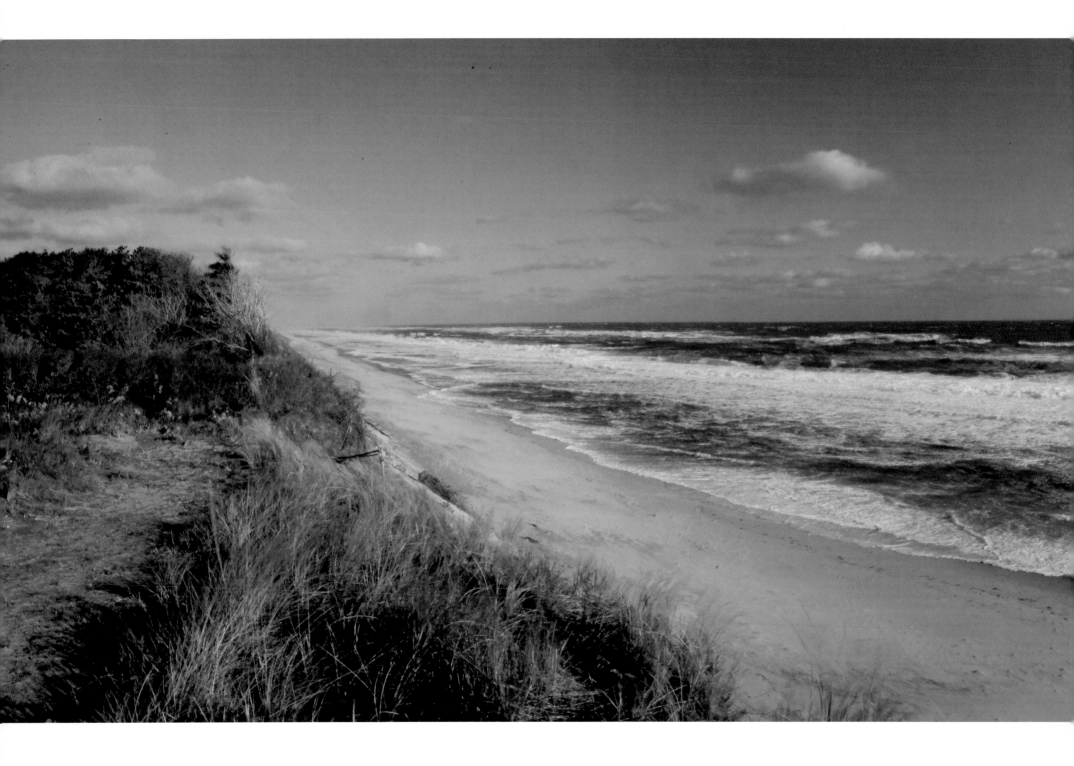

High tide at Nauset Light Beach from the top of the dunes.

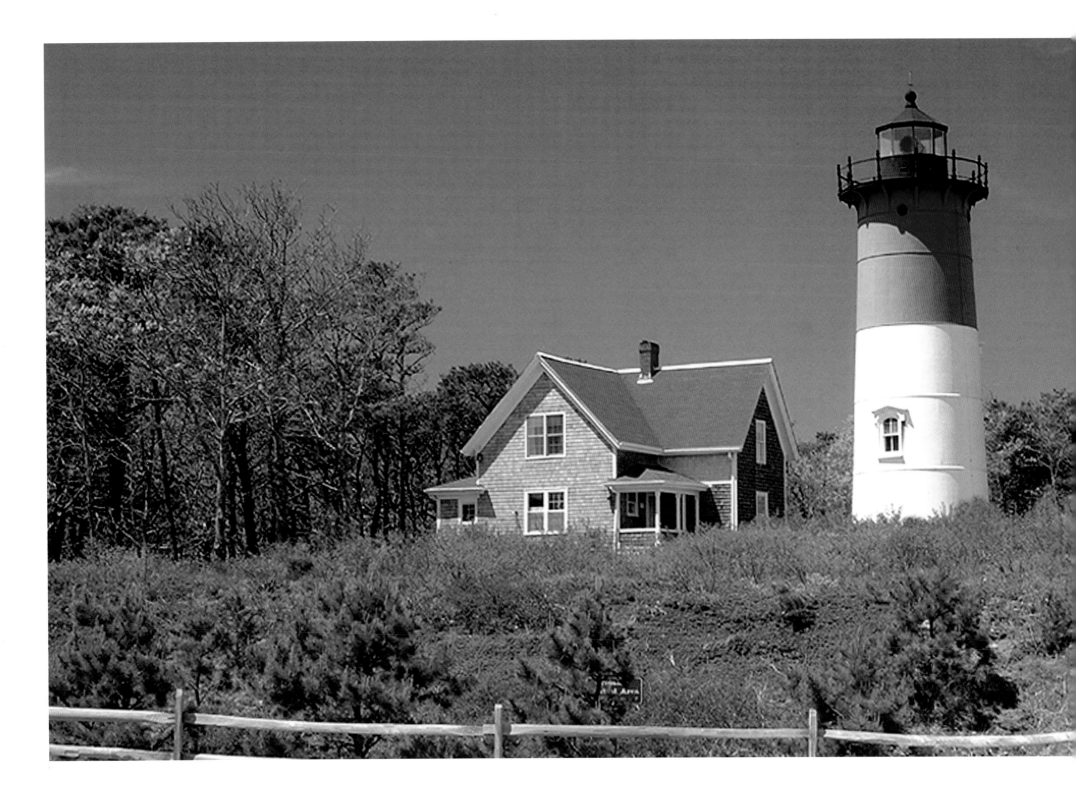

In 1996, to prevent it from falling into the sea, Nauset Light was moved to its present location.

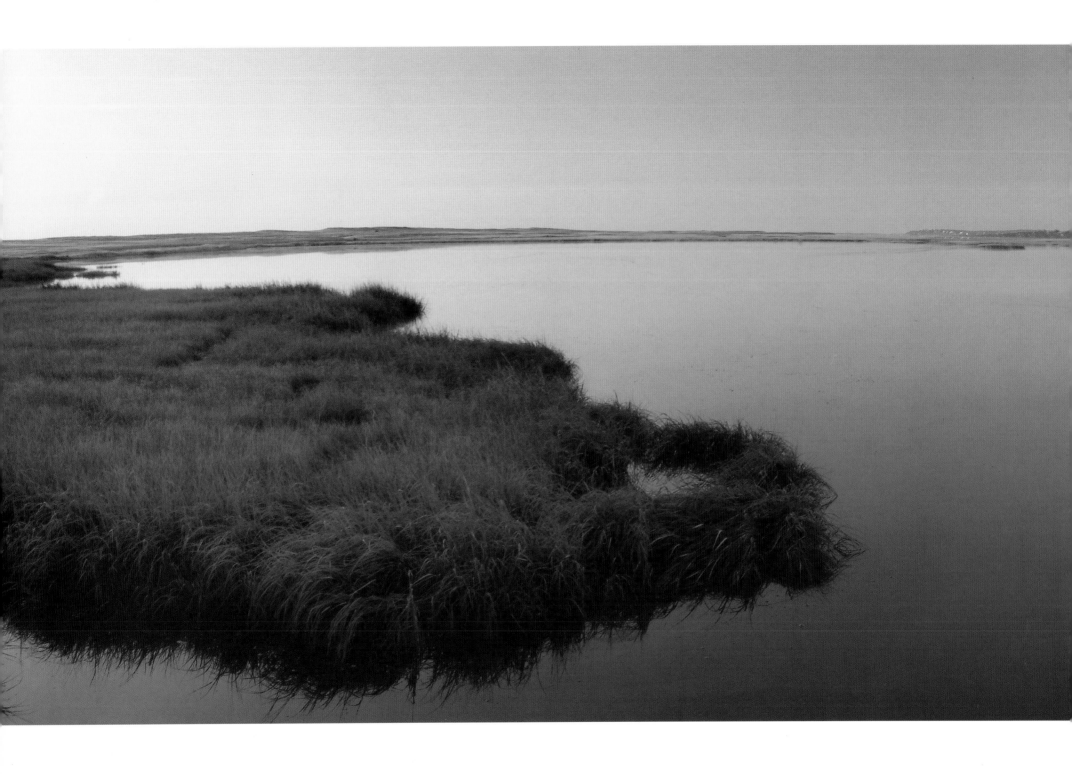

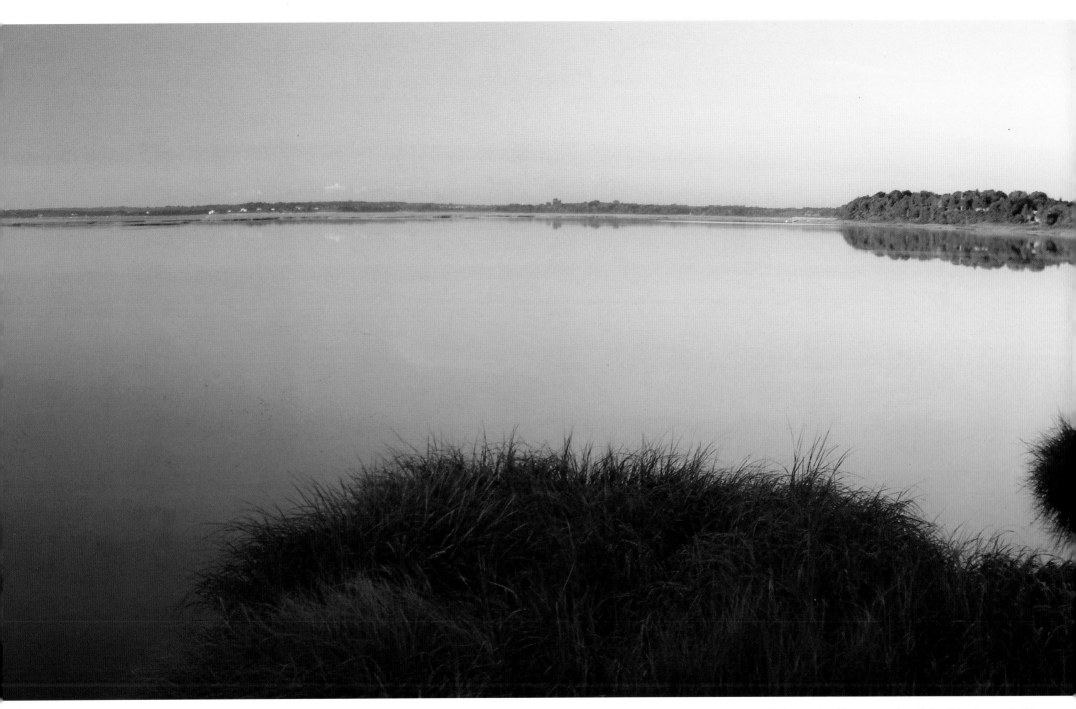

Early morning Nauset marsh and the air is clear and still.

Fort Hill overlooking Nauset marsh on a fall morning.

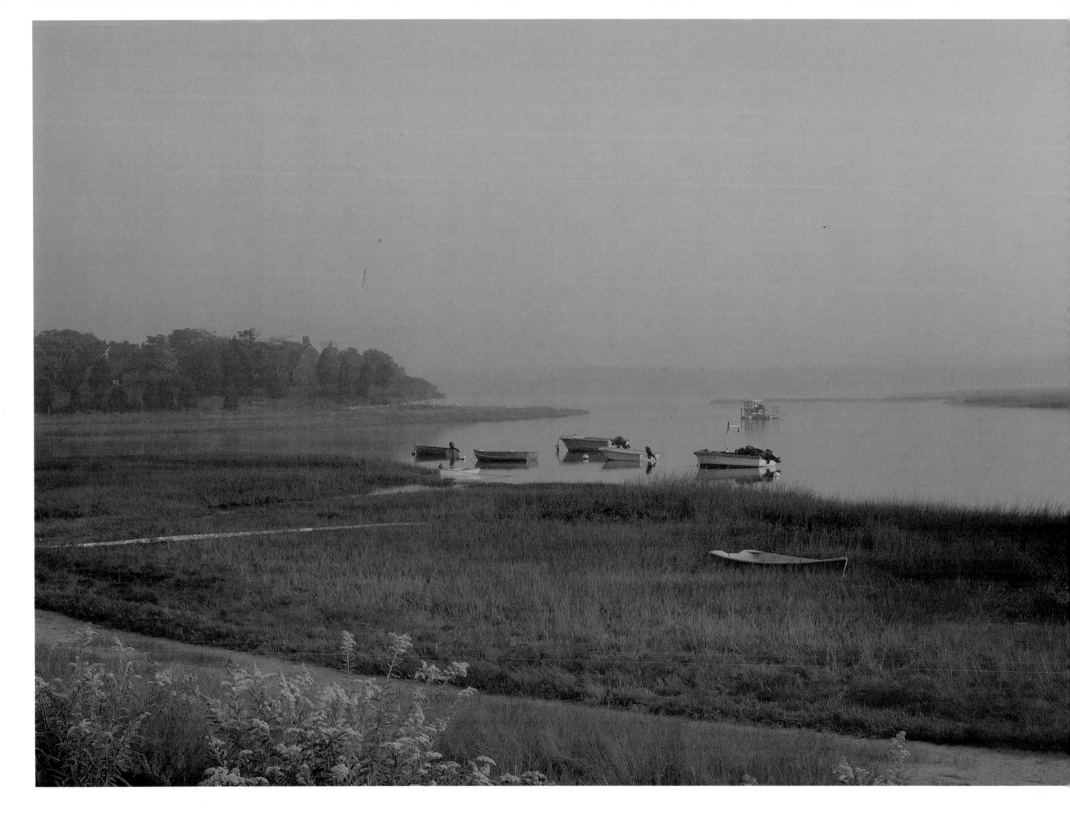

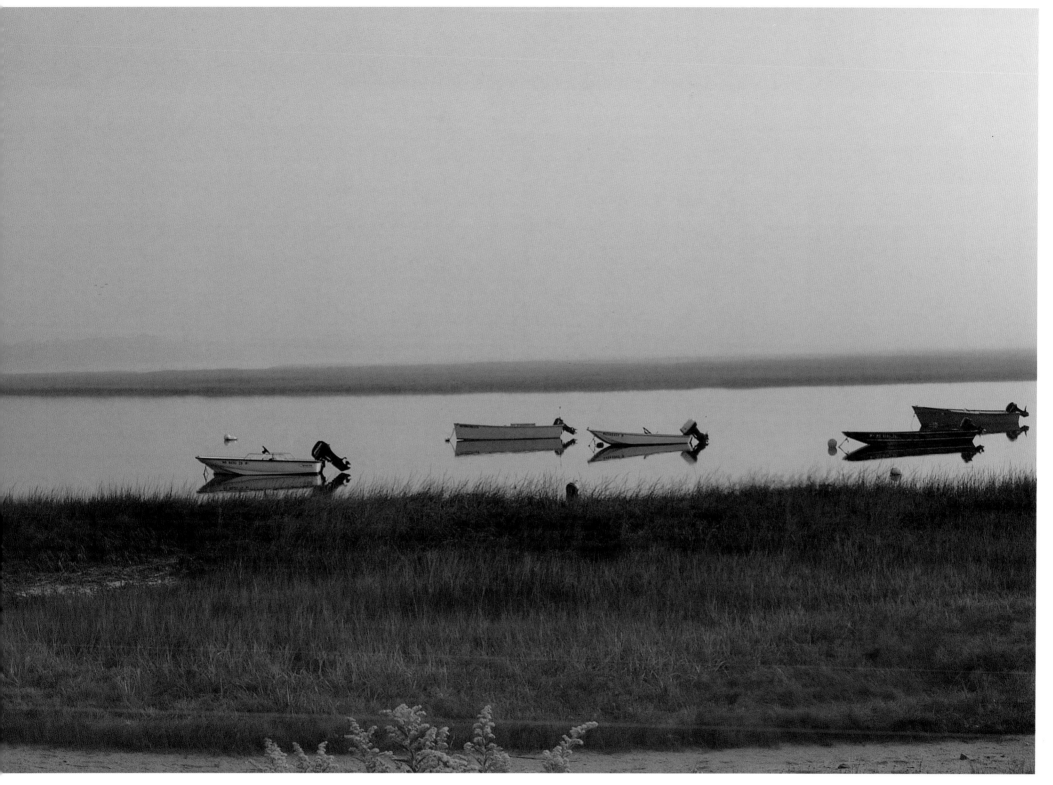

Hemmingway Landing, looking out on Nauset Marsh.

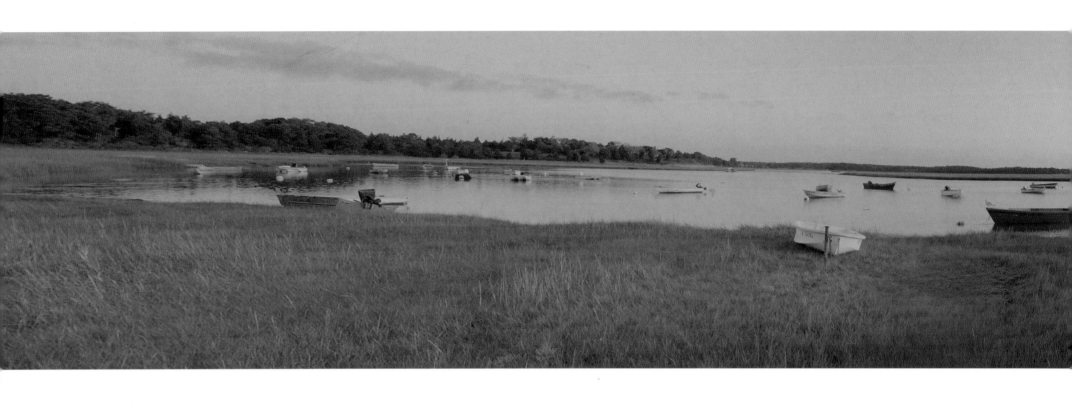

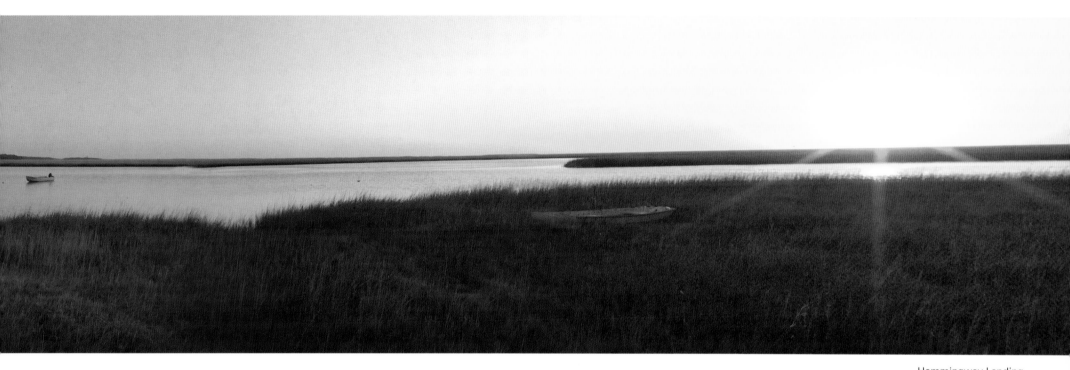

Hemmingway Landing.

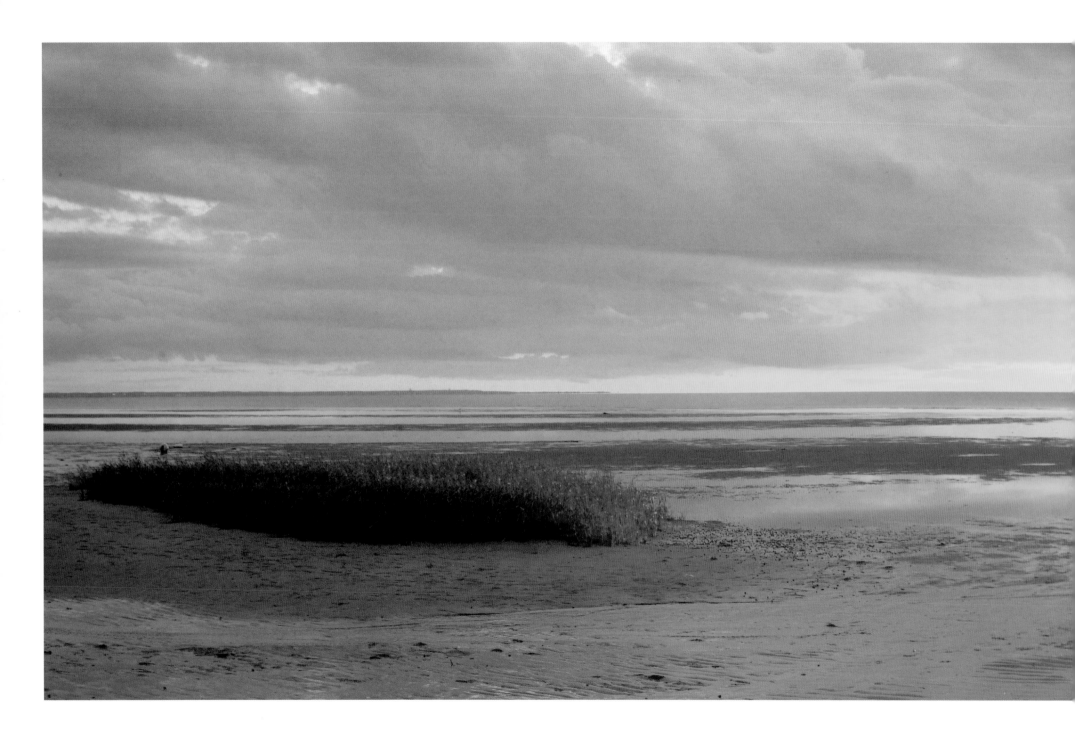

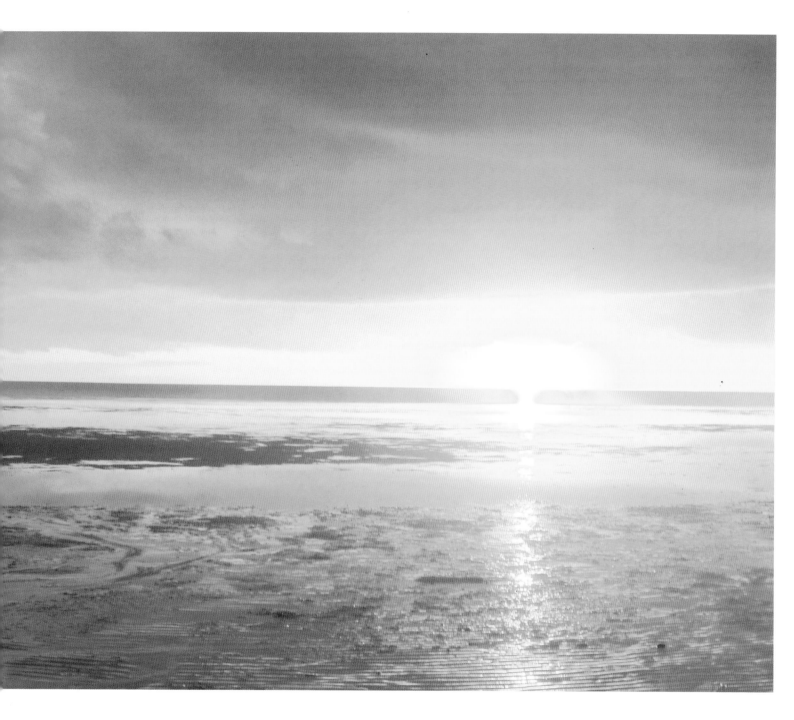

Low tide and a bayside sunset.

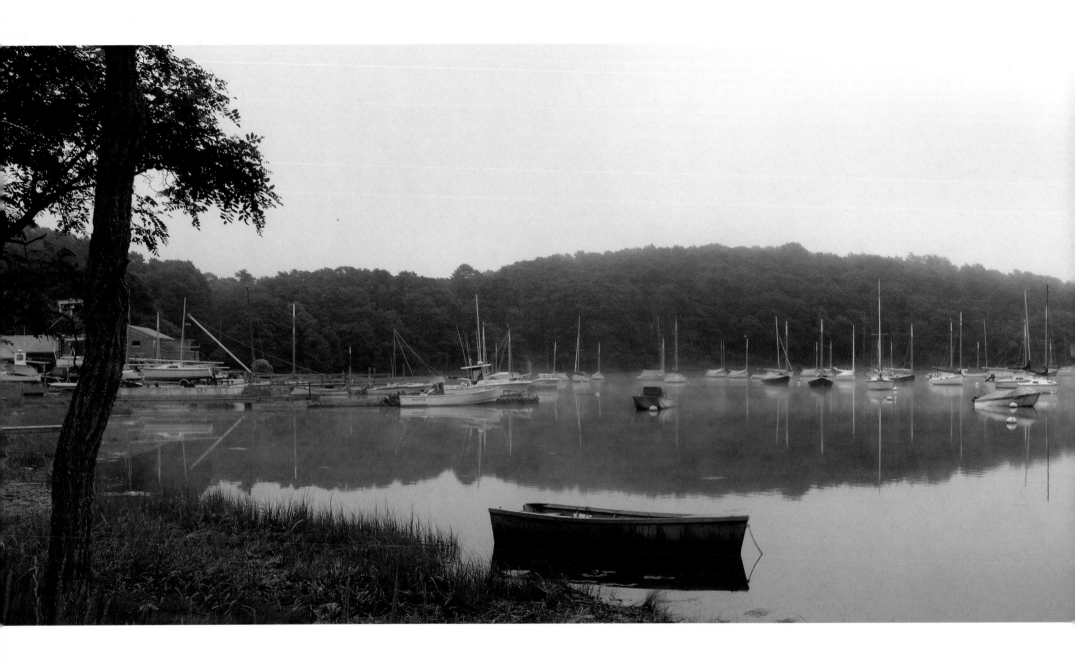

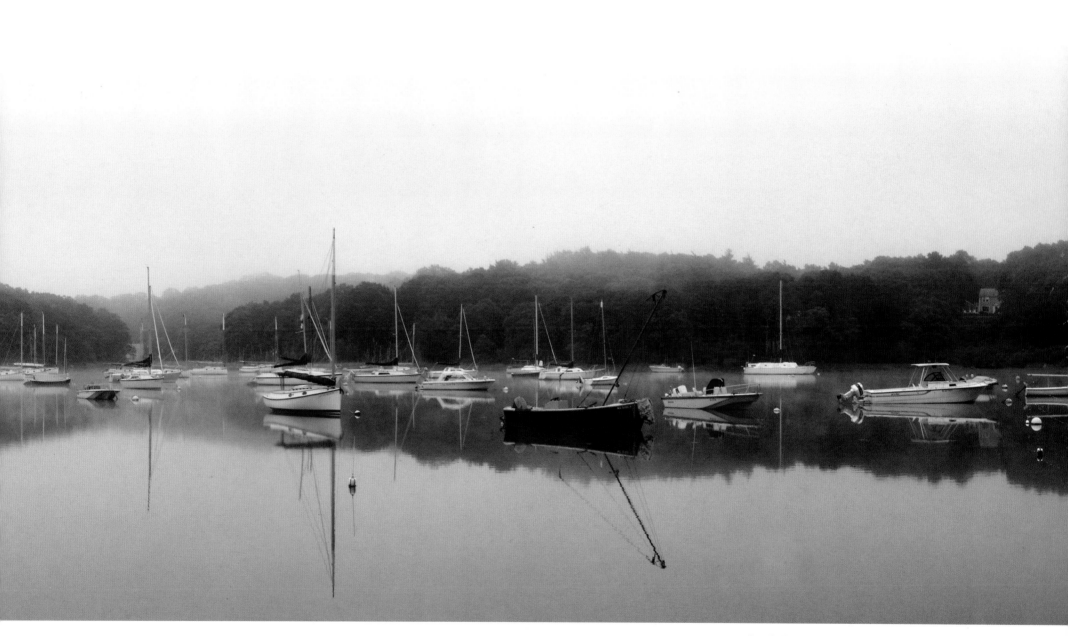

Arey's Pond in South Orleans is a safe haven for sailboats.

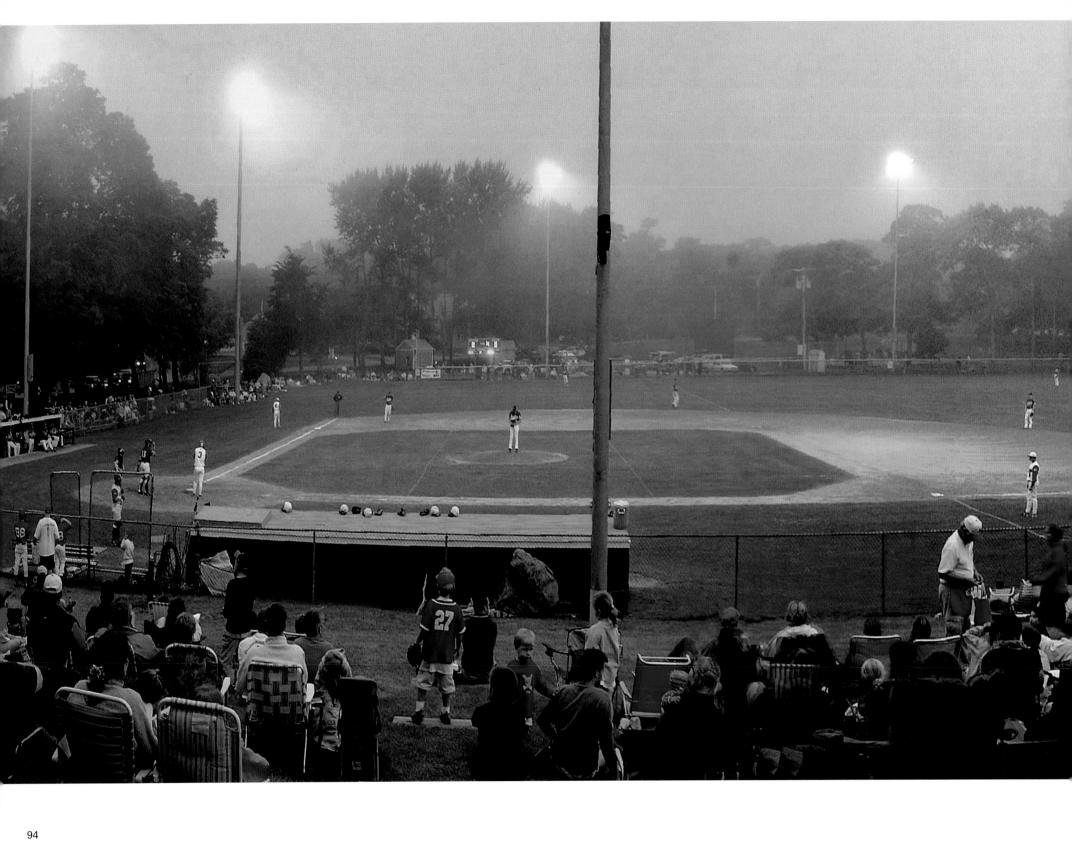

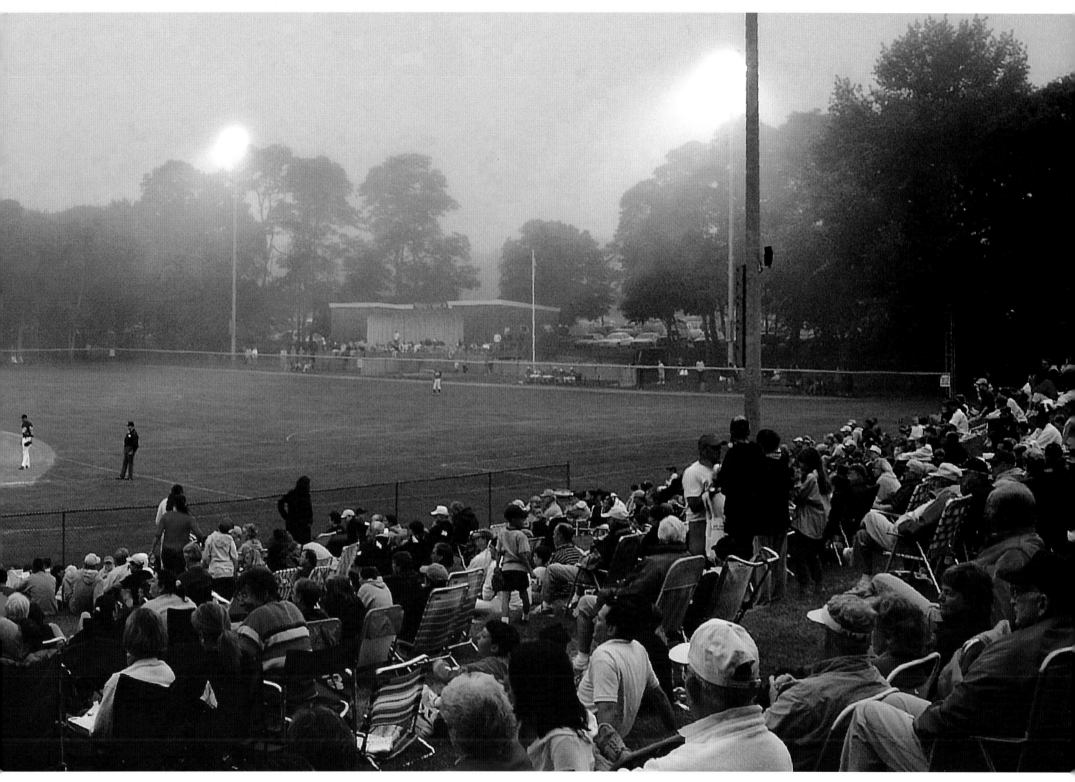

The Orleans Cardinals play in the ten team Cape Cod Baseball League. Eldridge
Park in Orleans is one of the premier amateur baseball fields in America.

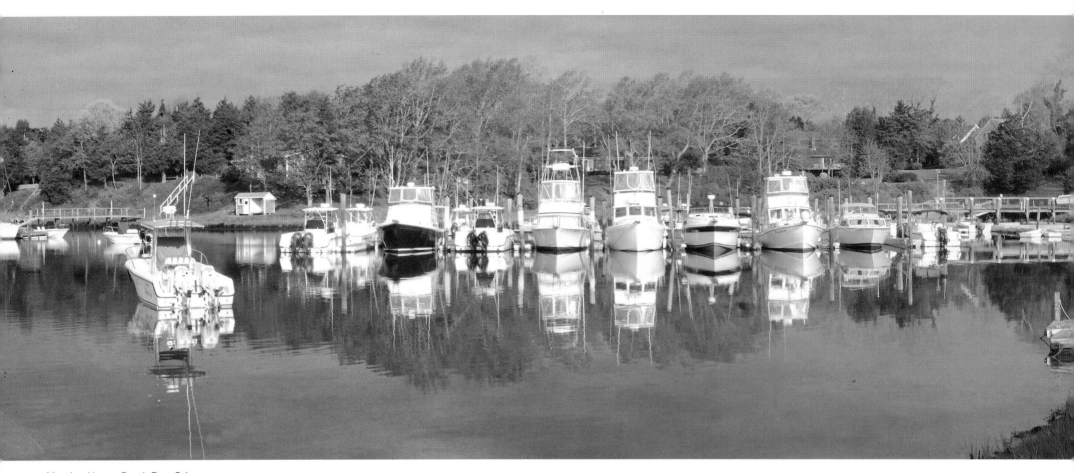

Meeting House Pond, East Orleans.

Meeting House Pond, East Orleans,
from a different perspective.

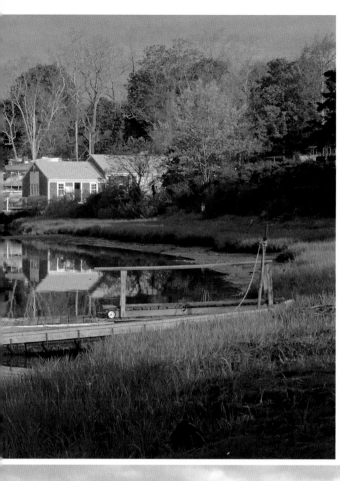

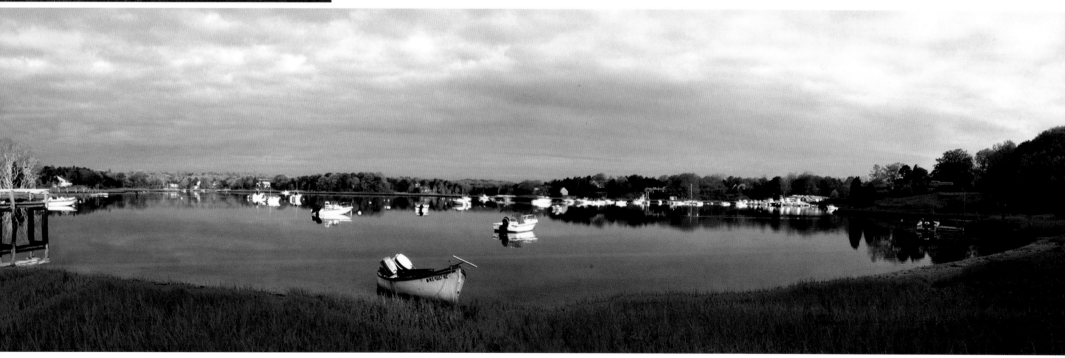

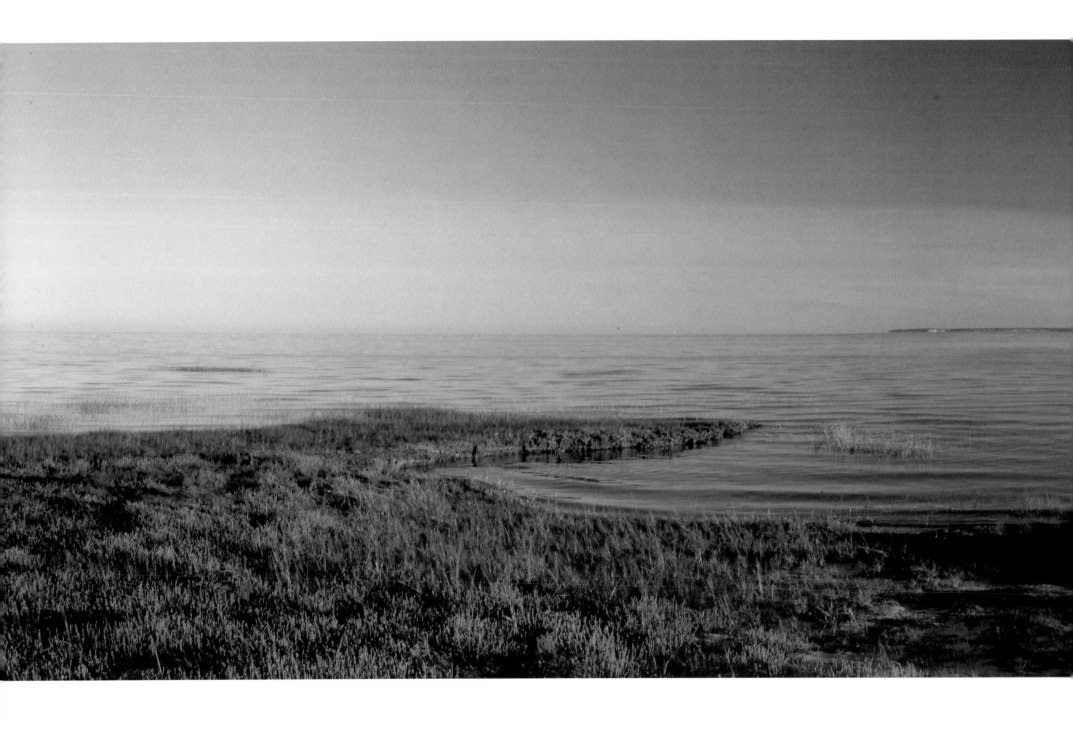

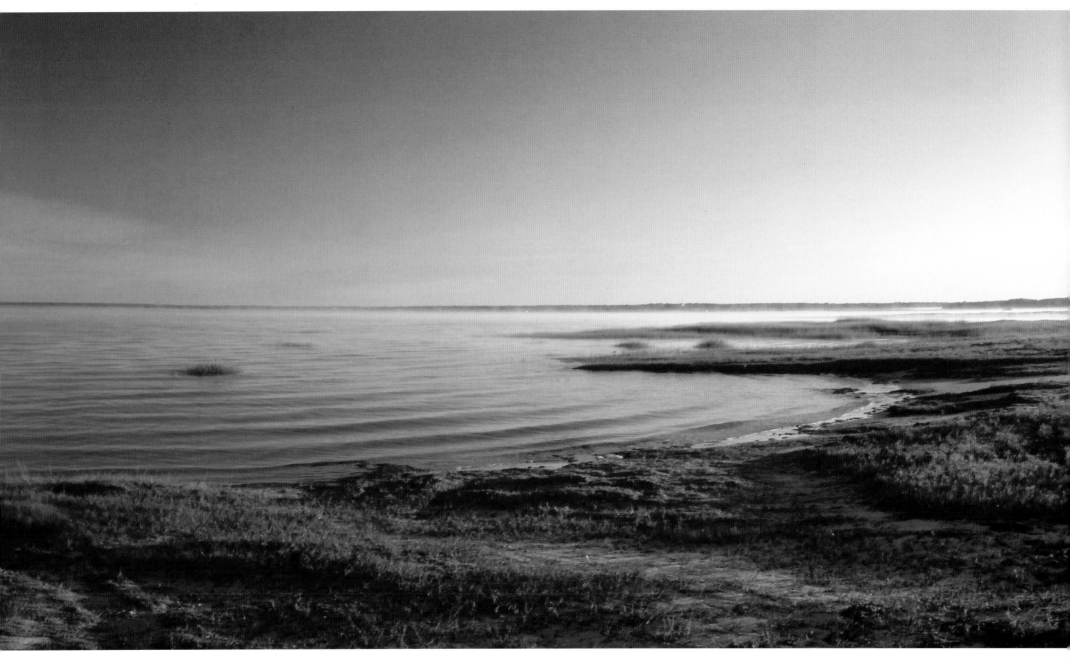

Skaket Beach, Orleans, deserted in the early morning hours.

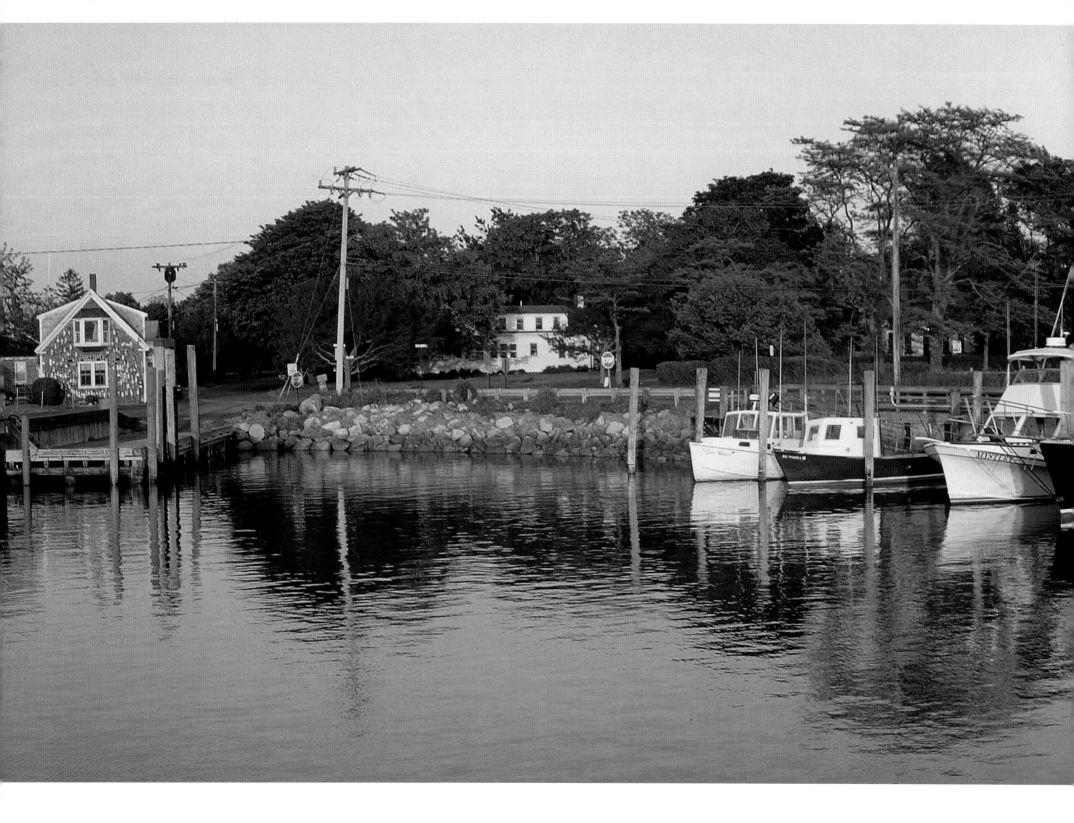

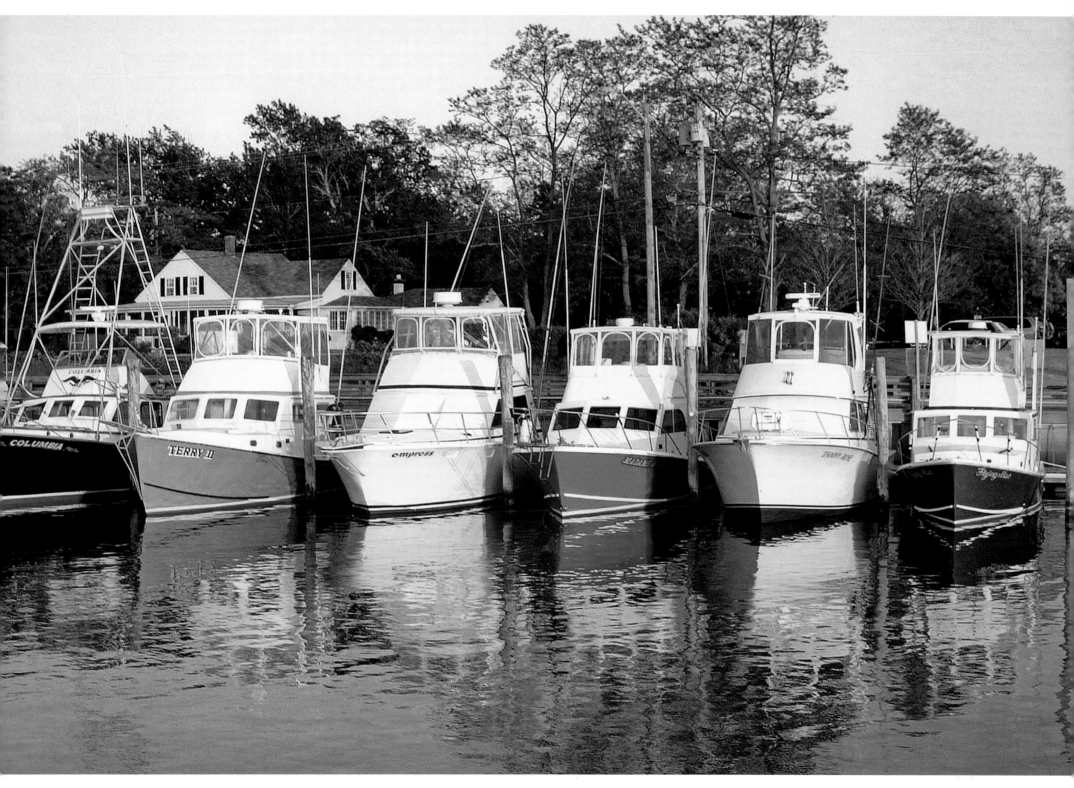

Charter boats in Rock Harbor at the inside elbow of Cape Cod.

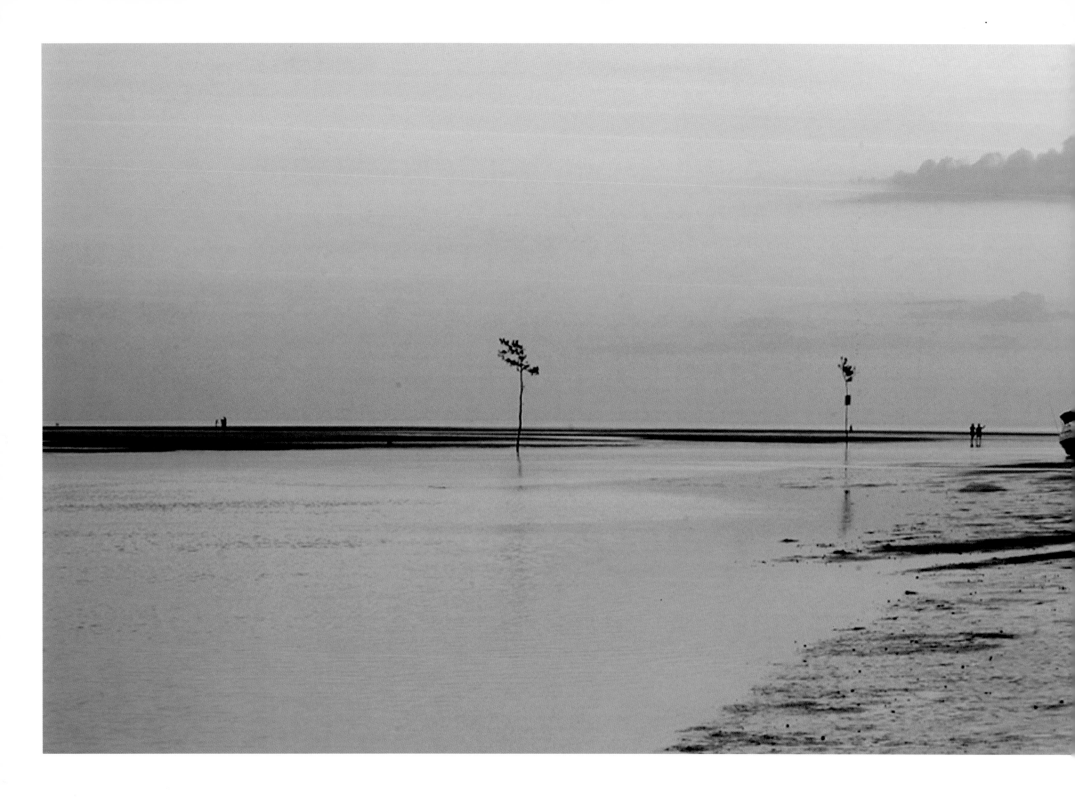

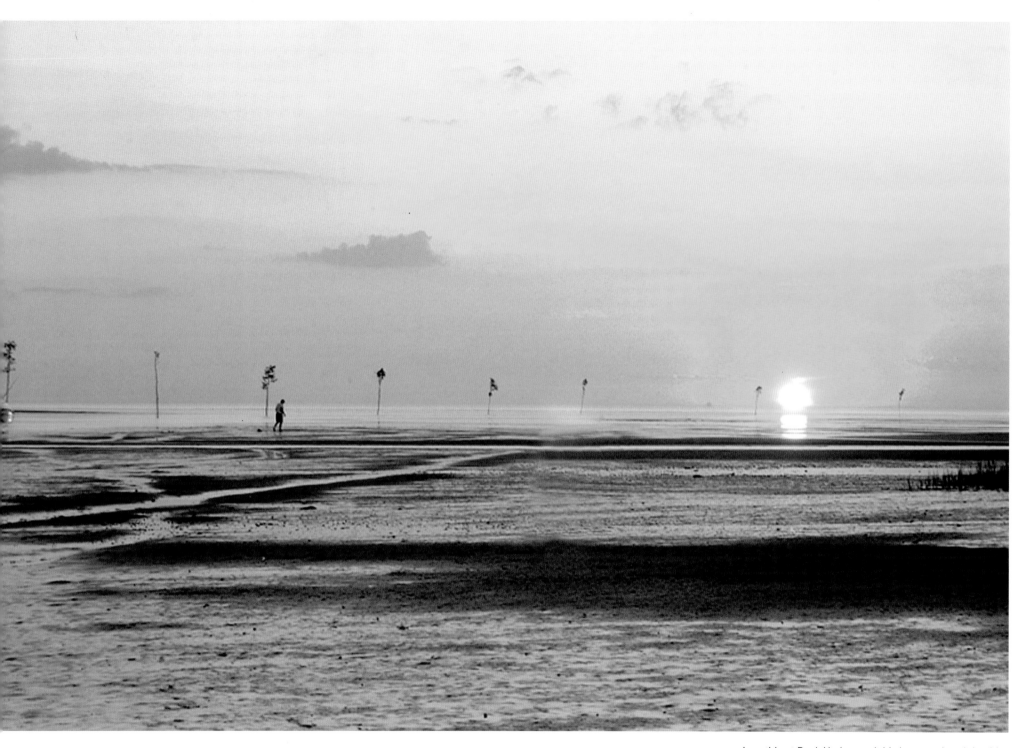

Low tide at Rock Harbor and this boater missed the tide.

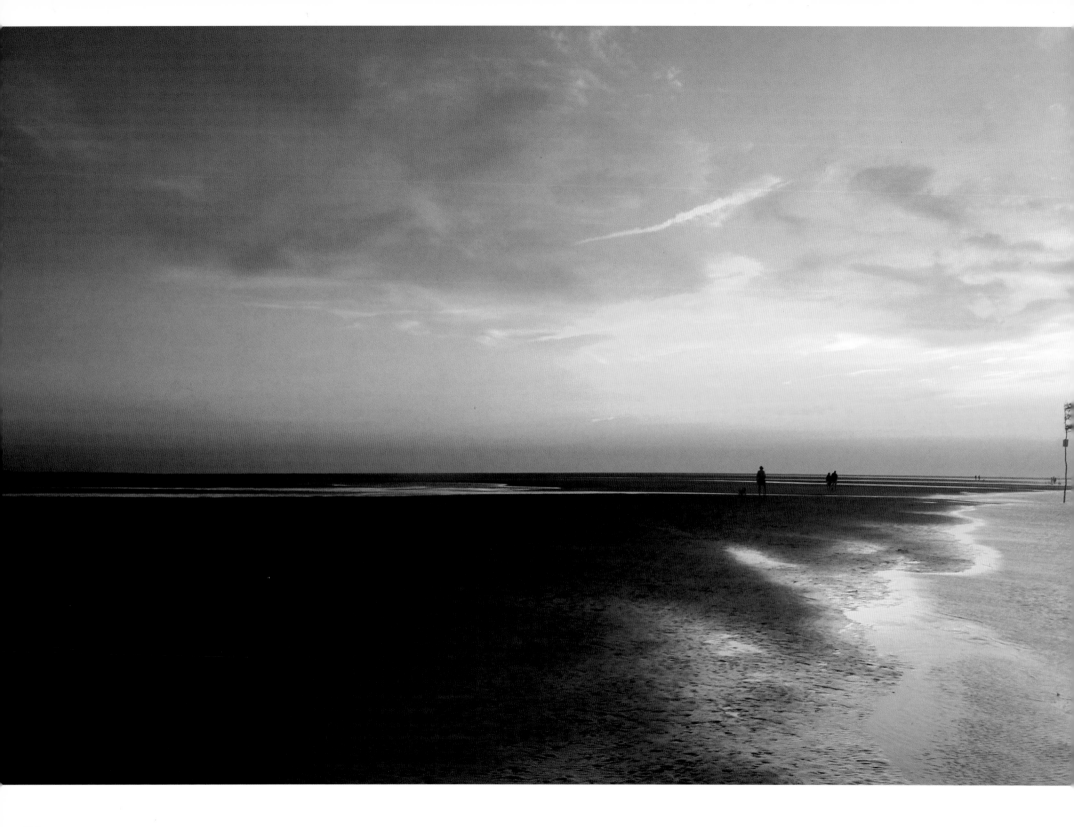

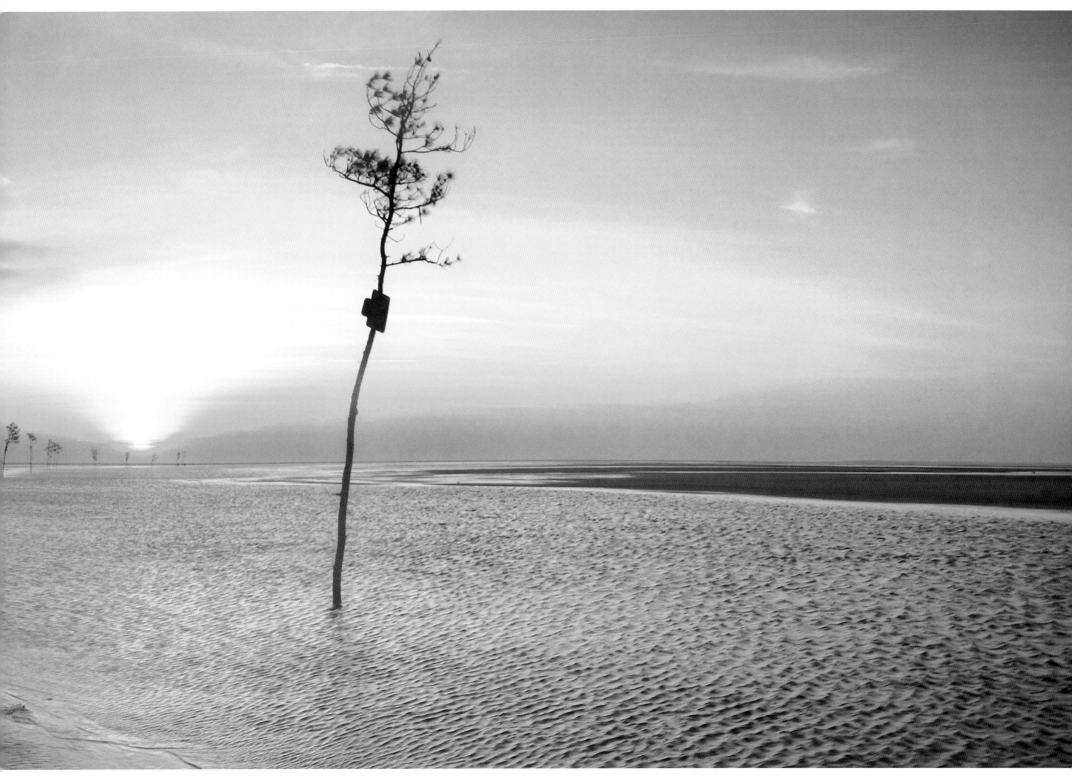

The row of trees marking the channel can be seen leading into deep water. It is not unusual to find traffic signs nailed to the trees.

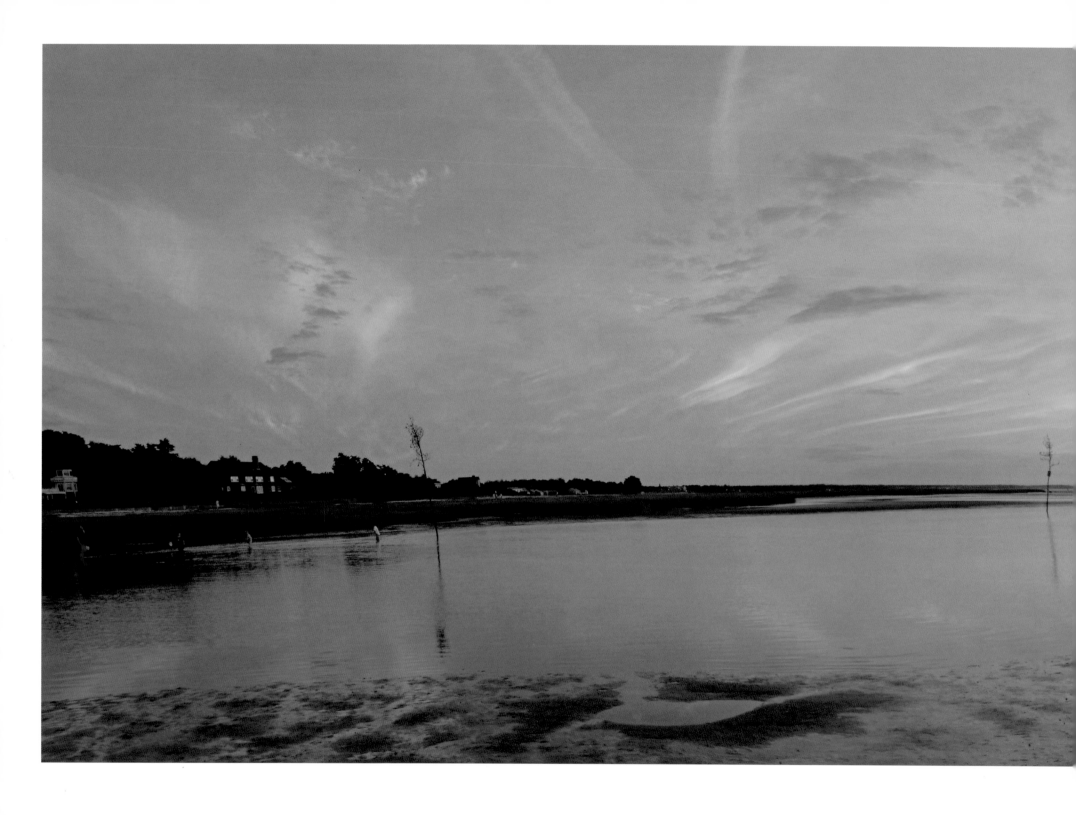

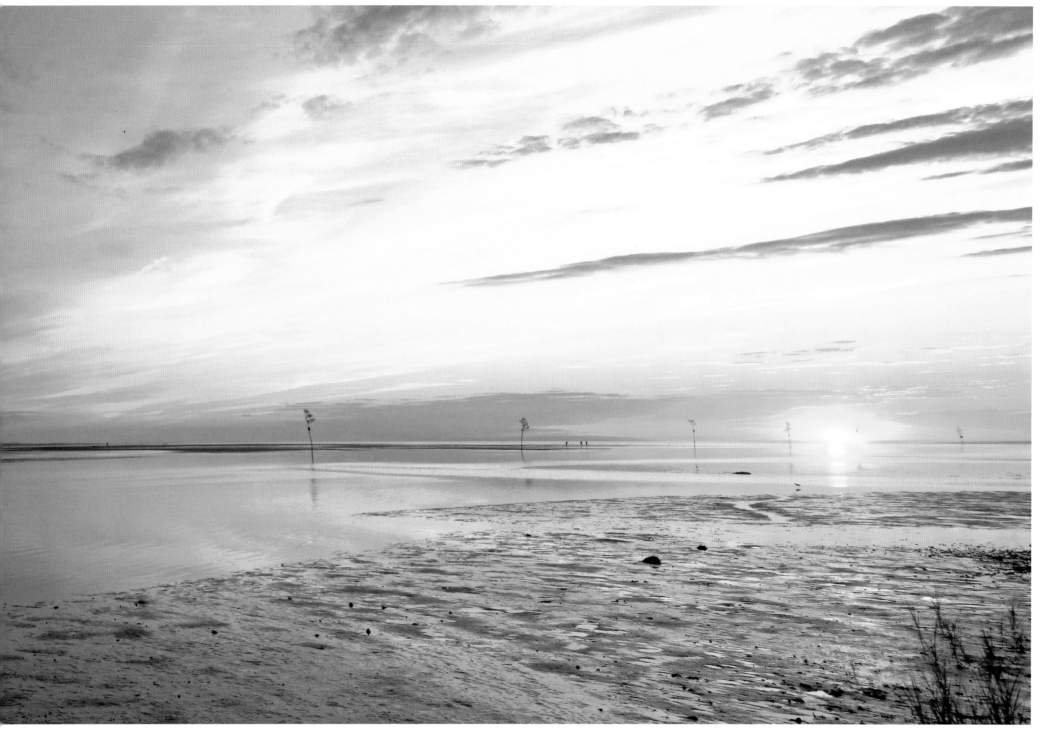

Rock Harbor.

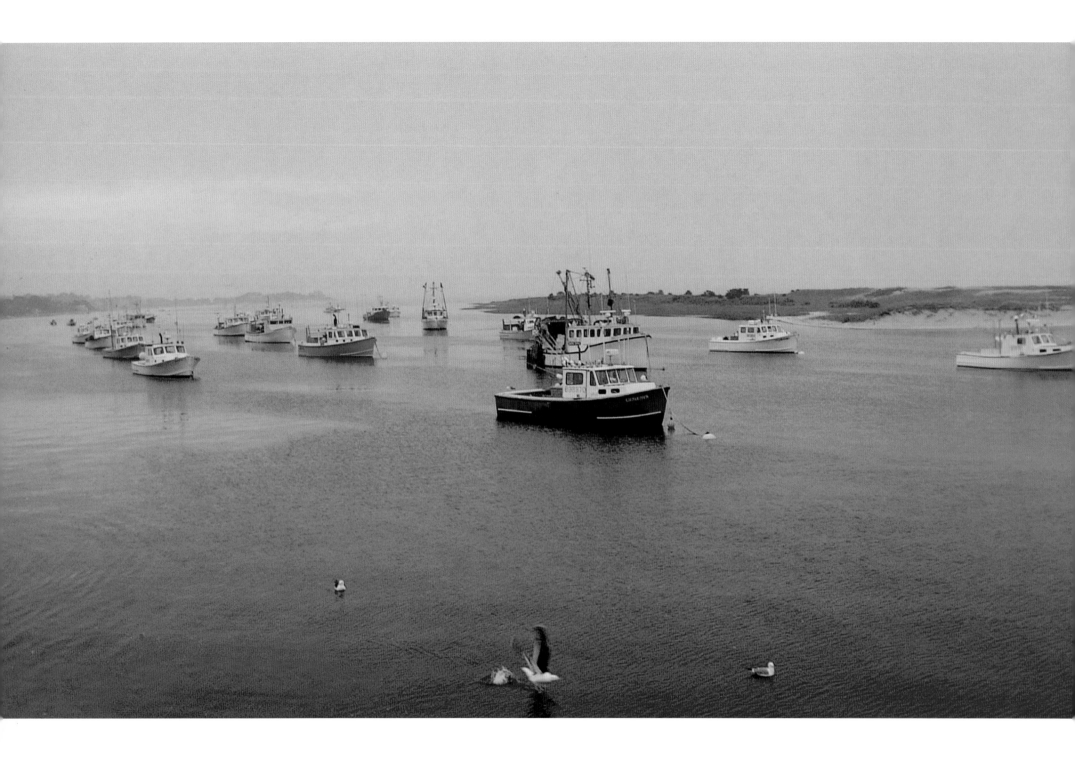

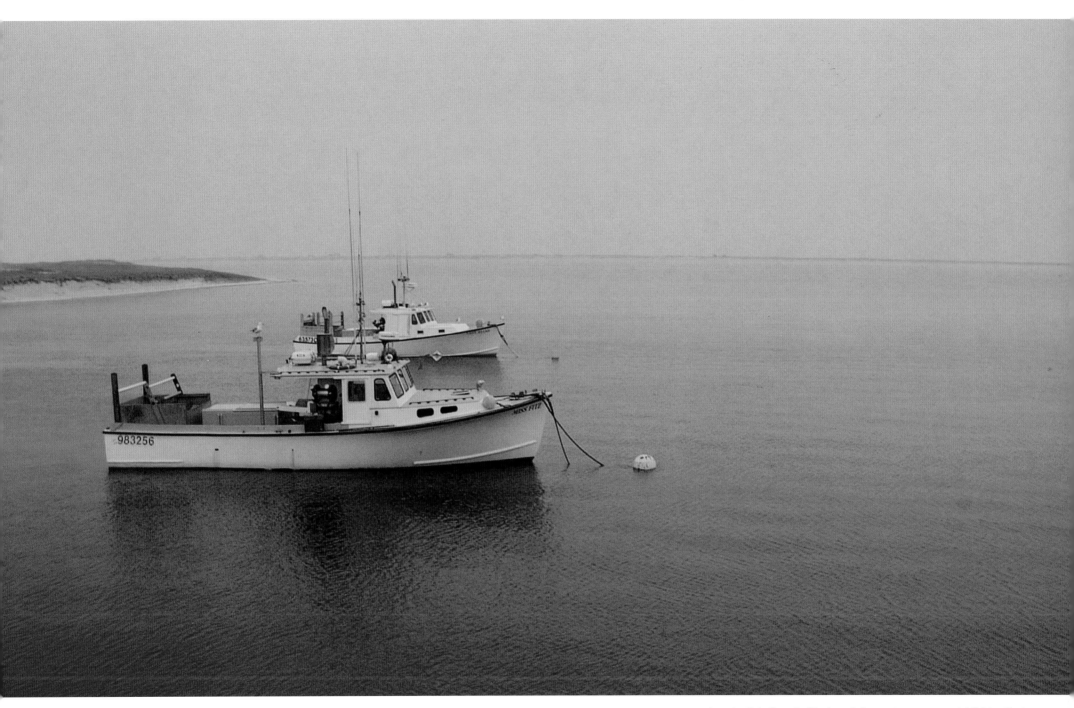

Aunt Lydia's Cove in Chatham is home to a commercial fishing fleet.

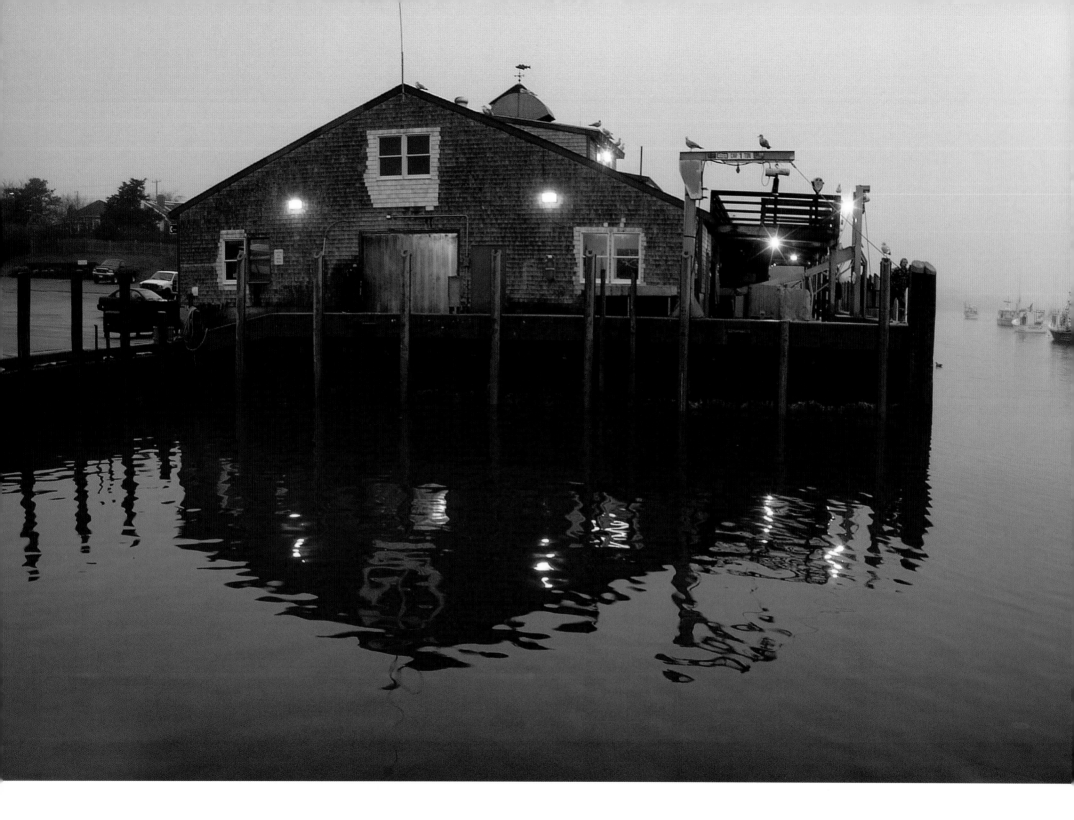

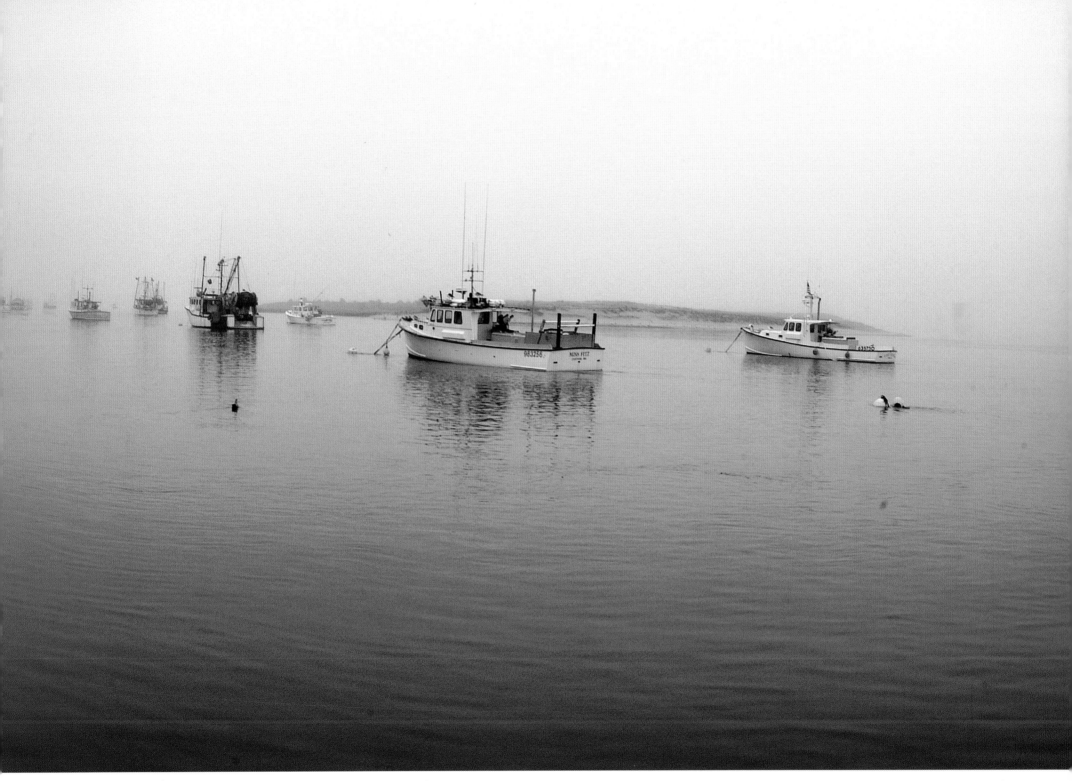

The Chatham fishing pier on an early foggy morning.

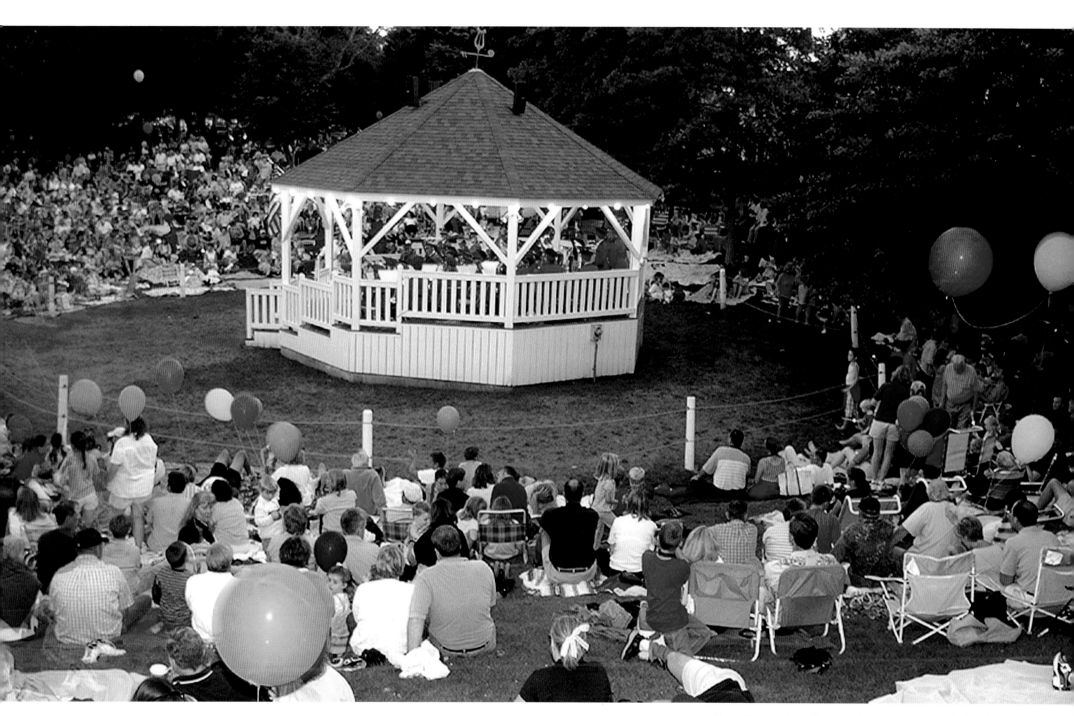

On Friday nights in Chatham during the summer, the band concert attracts families and friends to the musical experience.

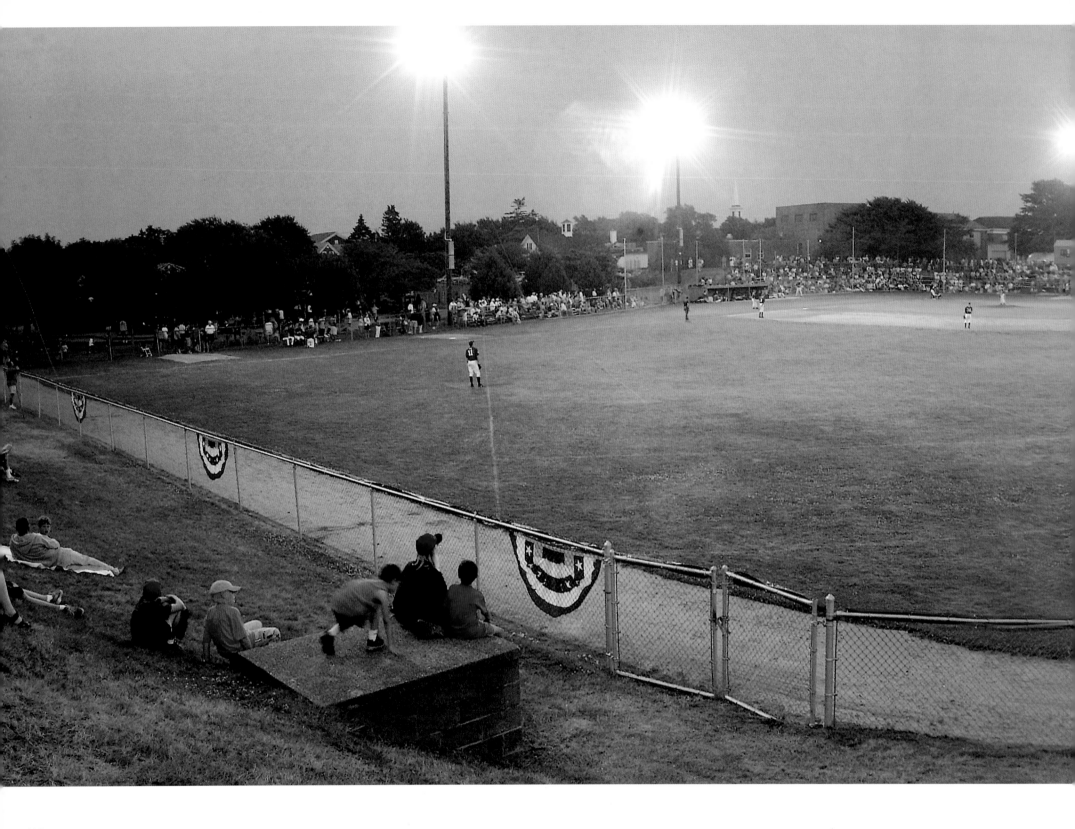

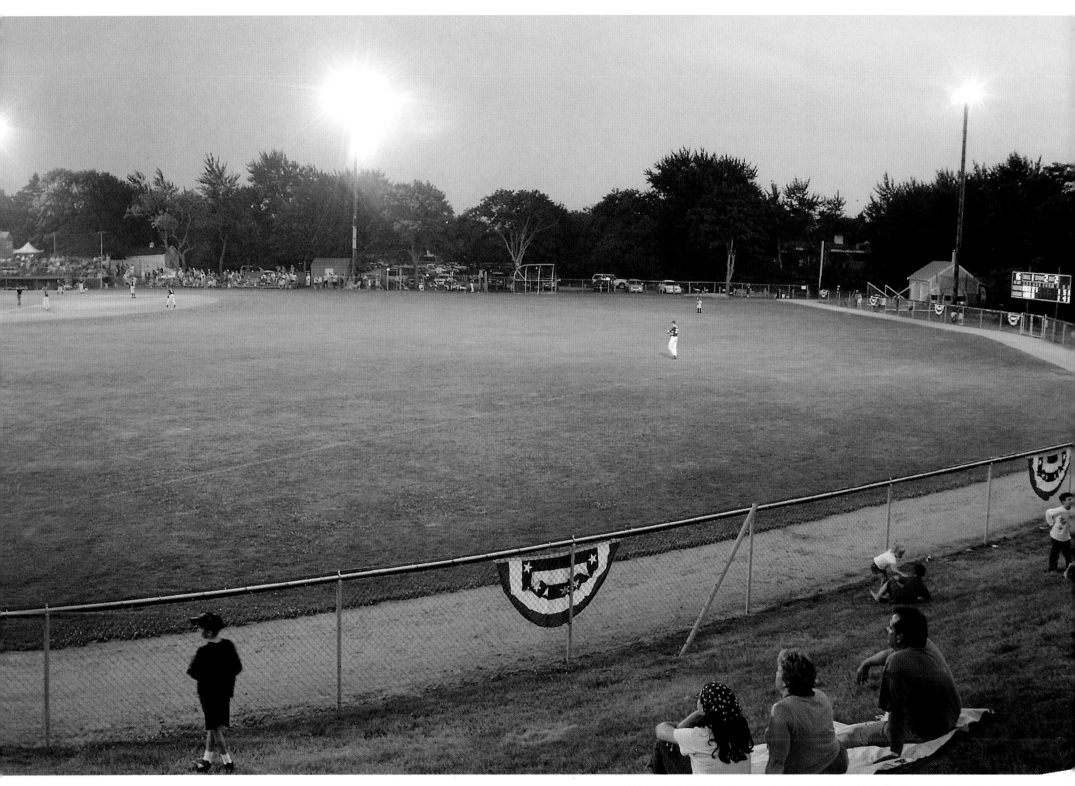

Veteran's Field is the home park of the Chatham A's in the Cape Cod Baseball League.

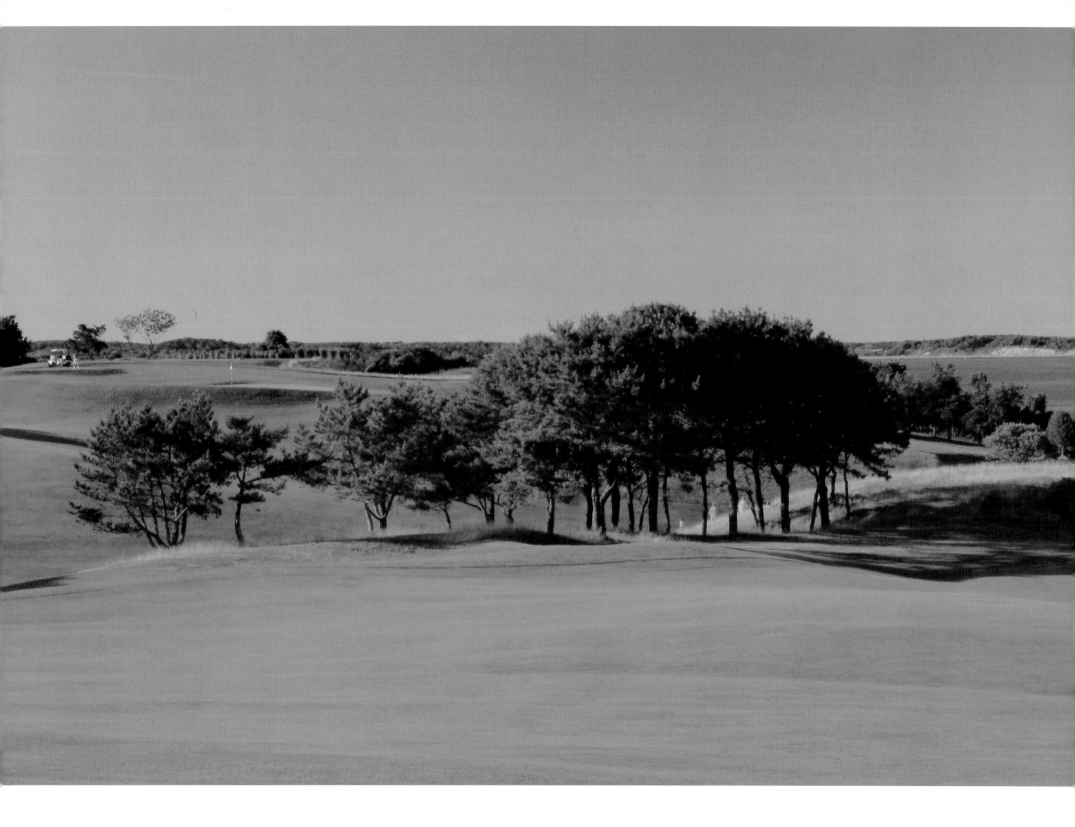

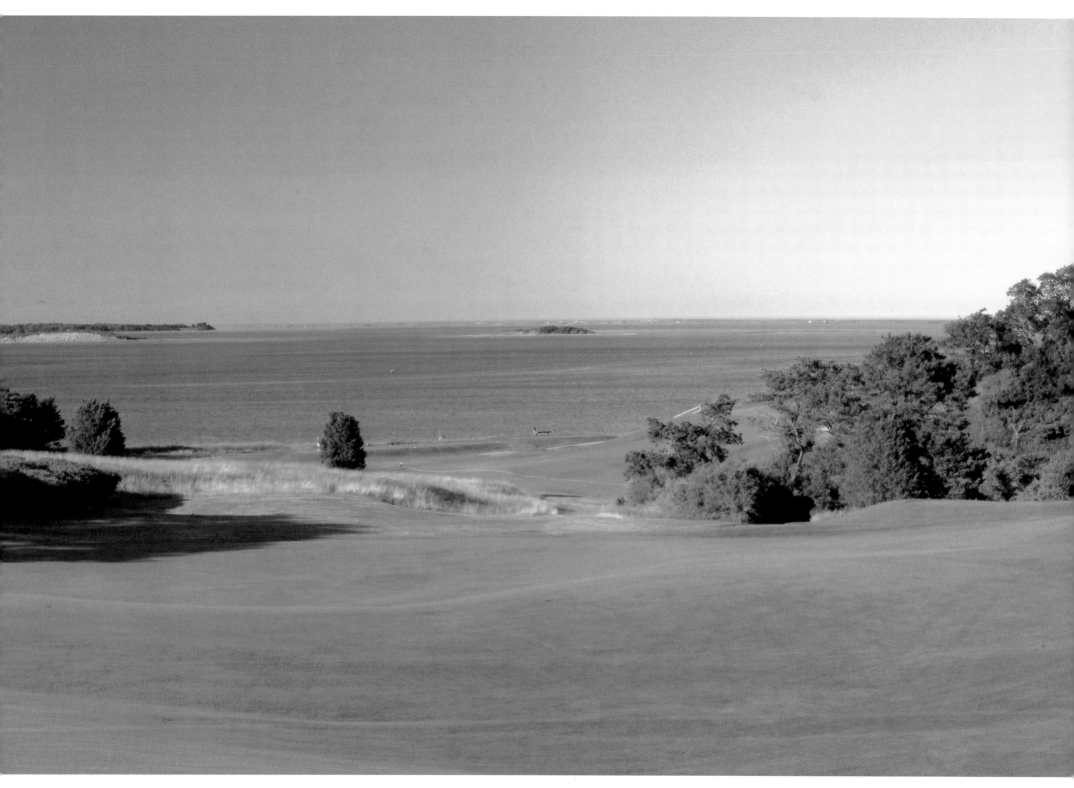

Eastward Ho golf course overlooking Pleasant Bay in Chatham.

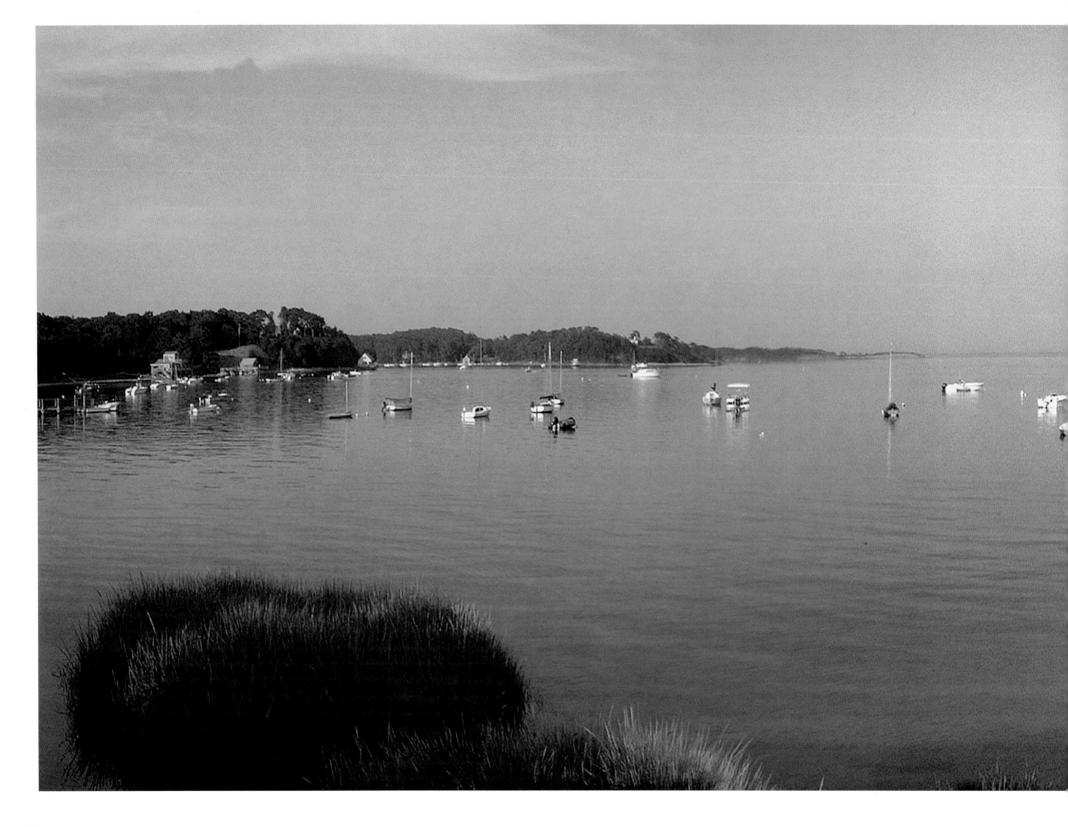

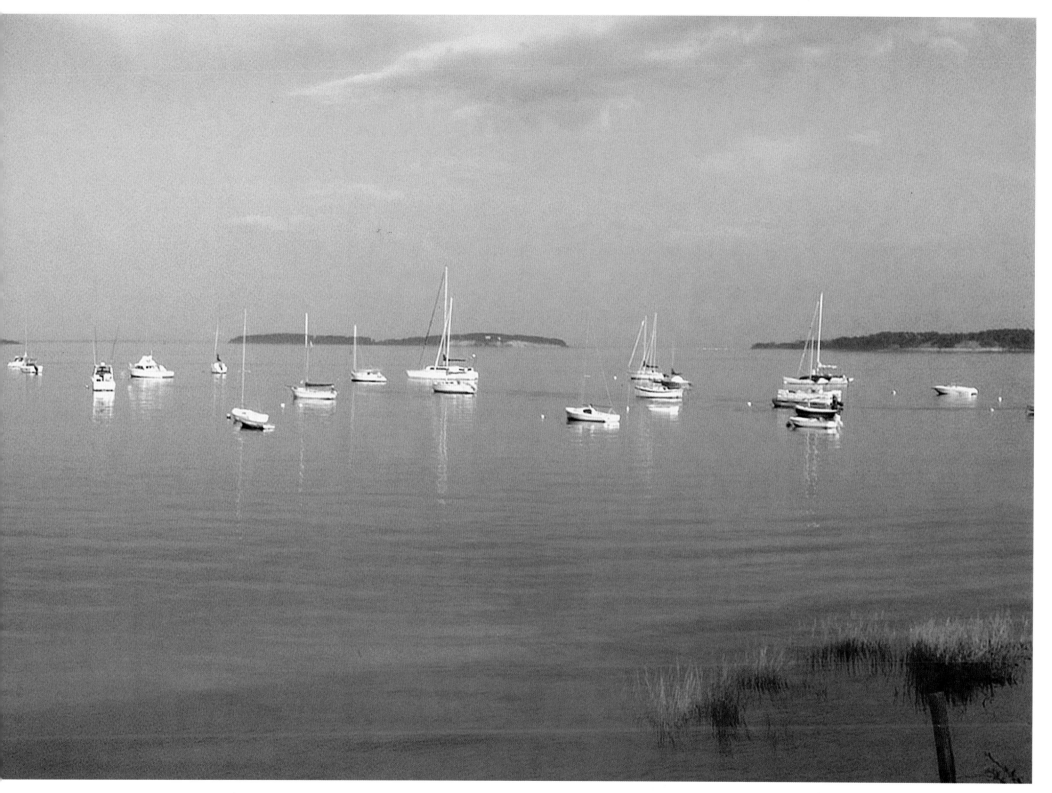

Pleasant Bay, Orleans, on a peaceful late afternoon.

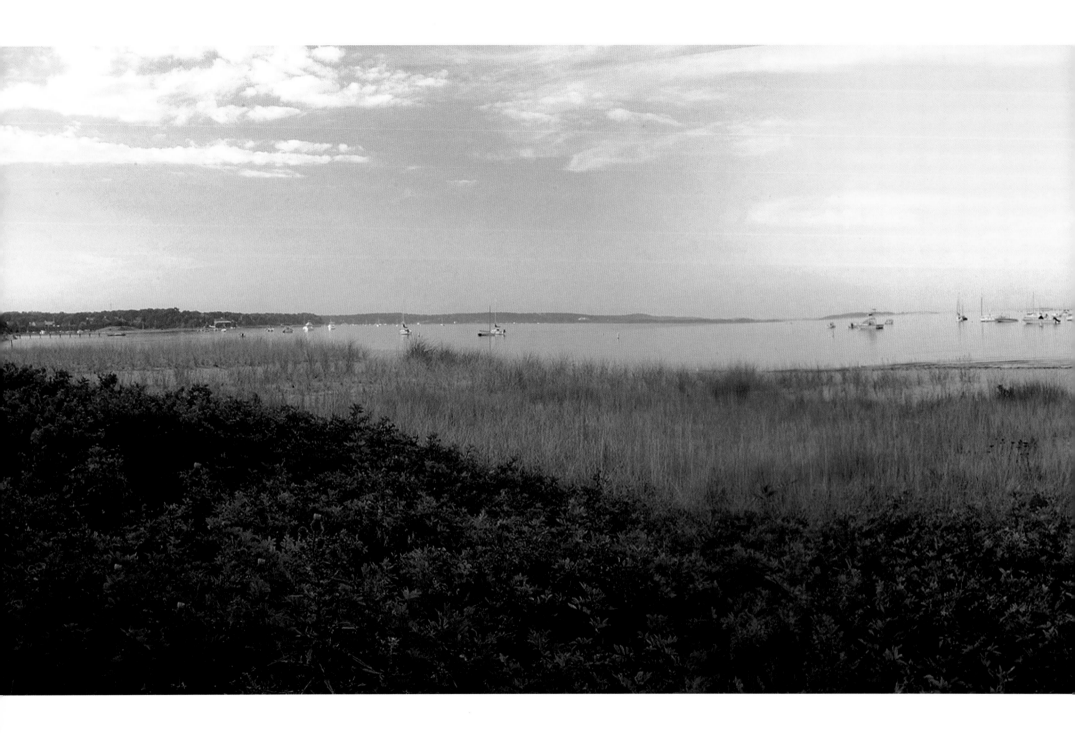

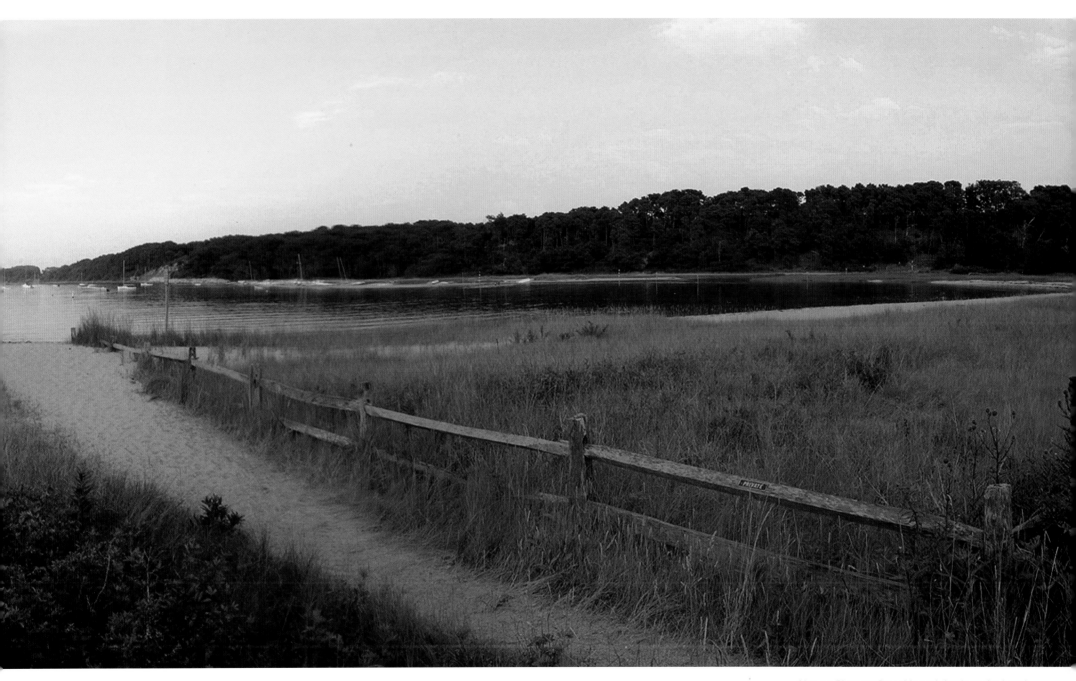

Also on Pleasant Bay, this path leads to the beach.

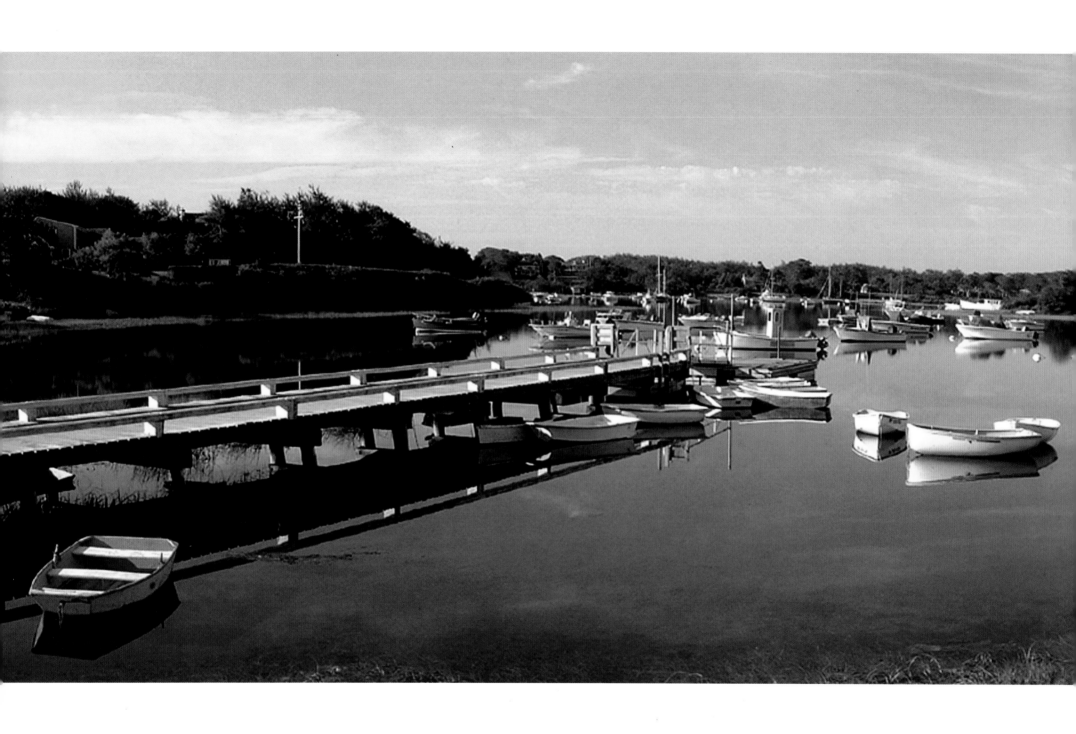

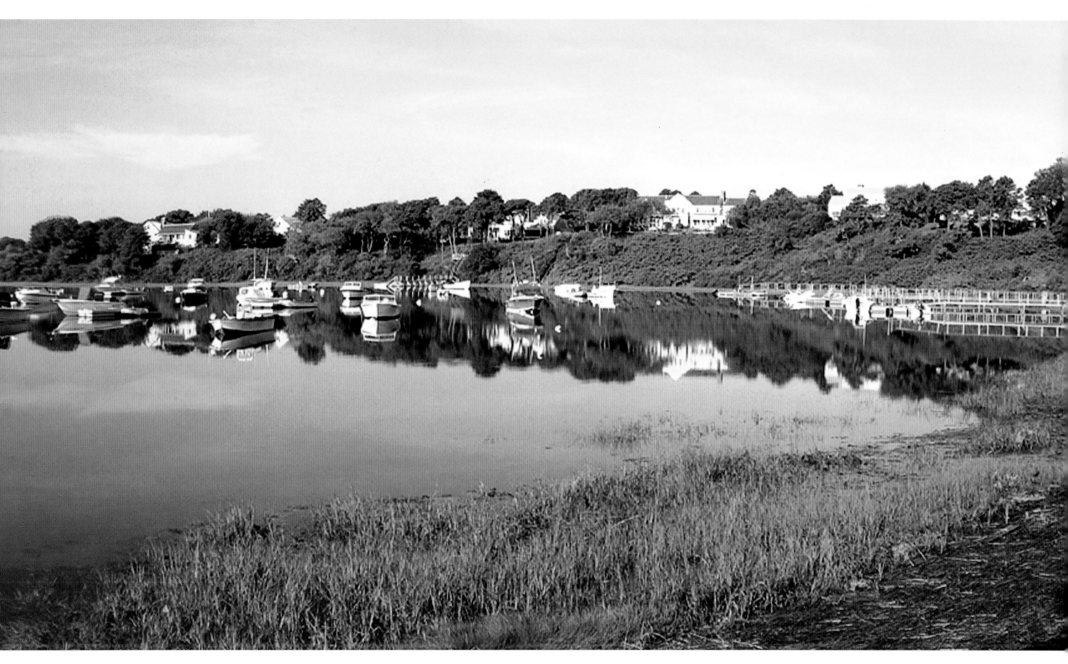

Mill Pond in Chatham.

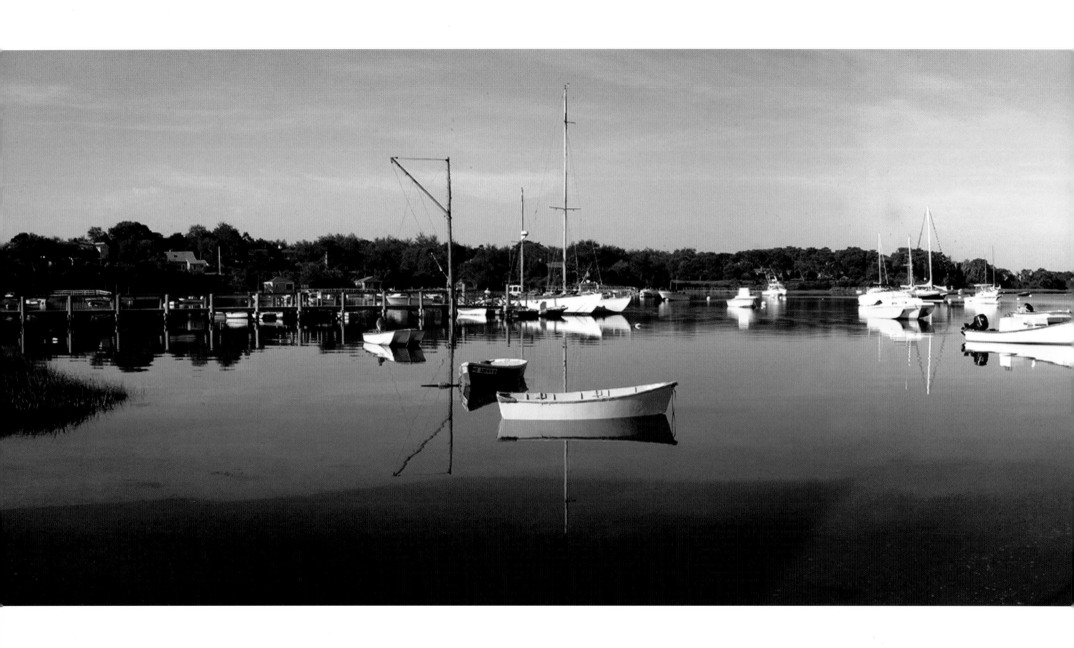

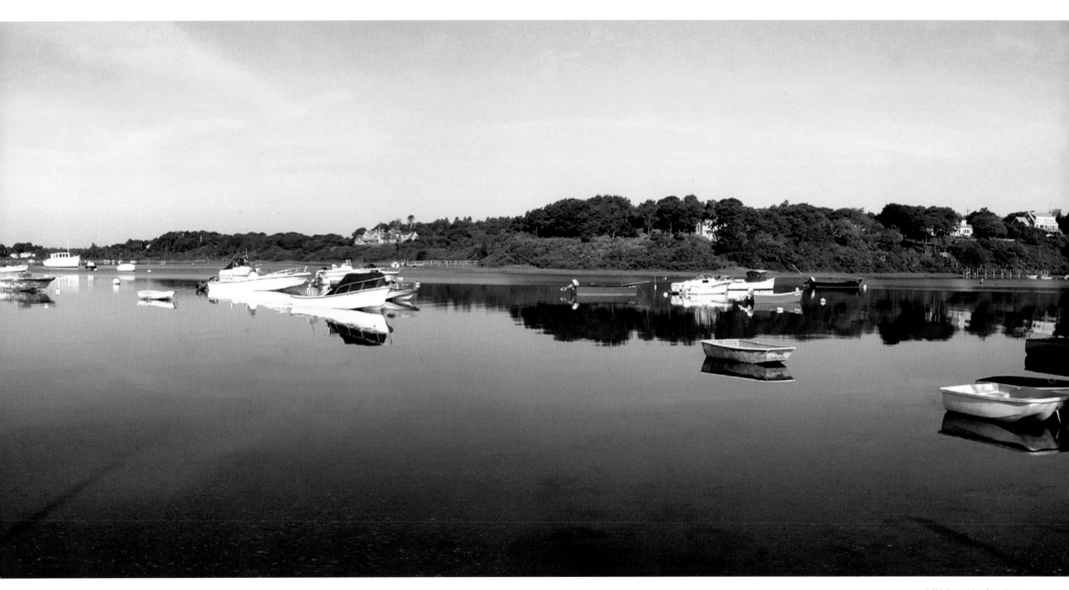

Mill Pond in Chatham.

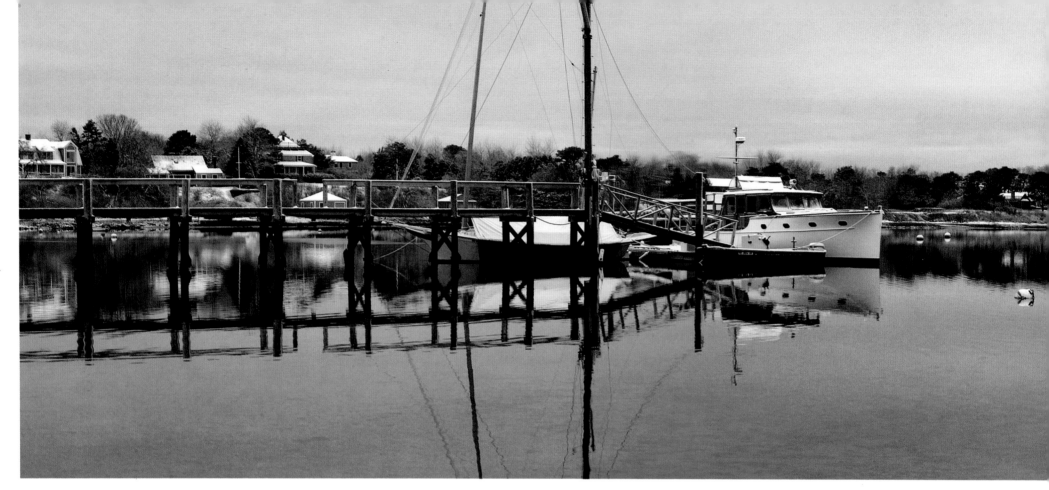

Mill Pond in the winter.

Stage Harbor, Chatham, in winter.

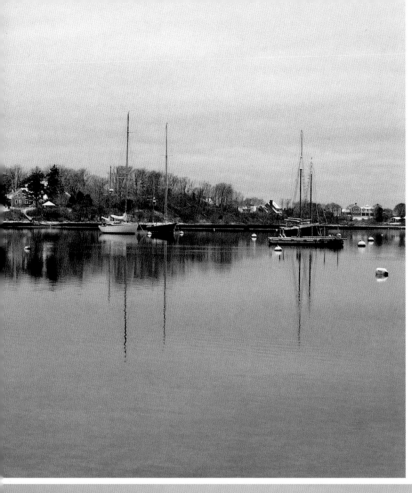

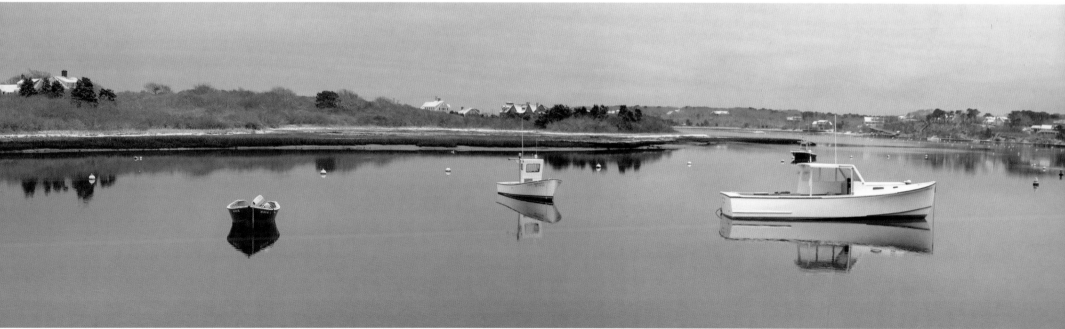

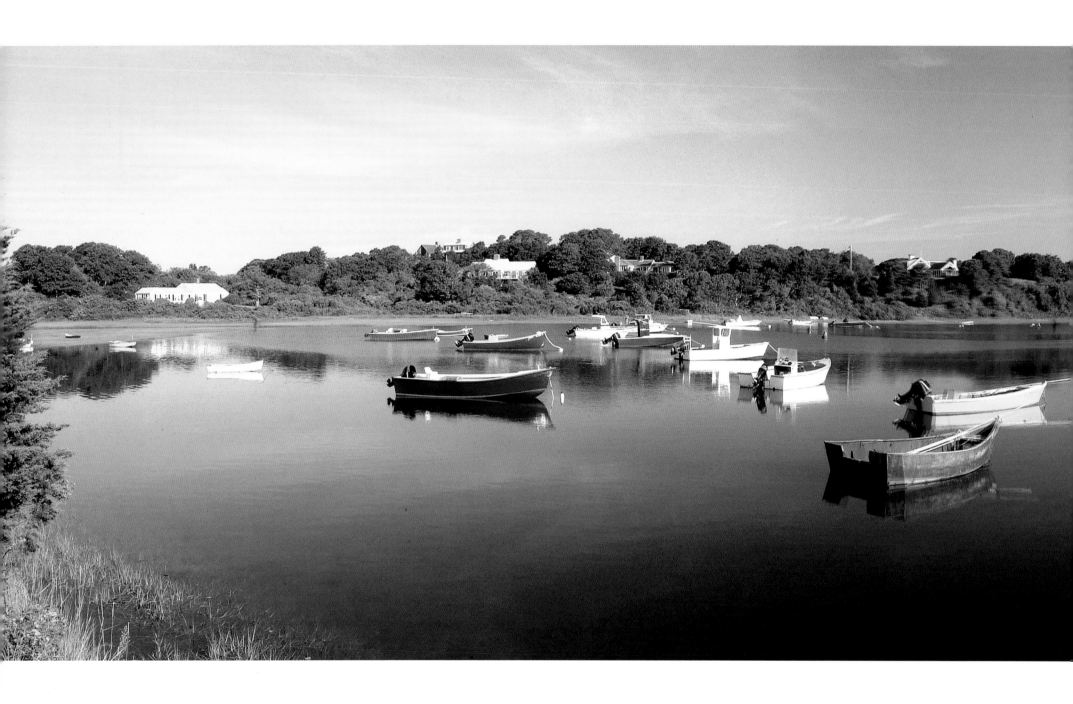

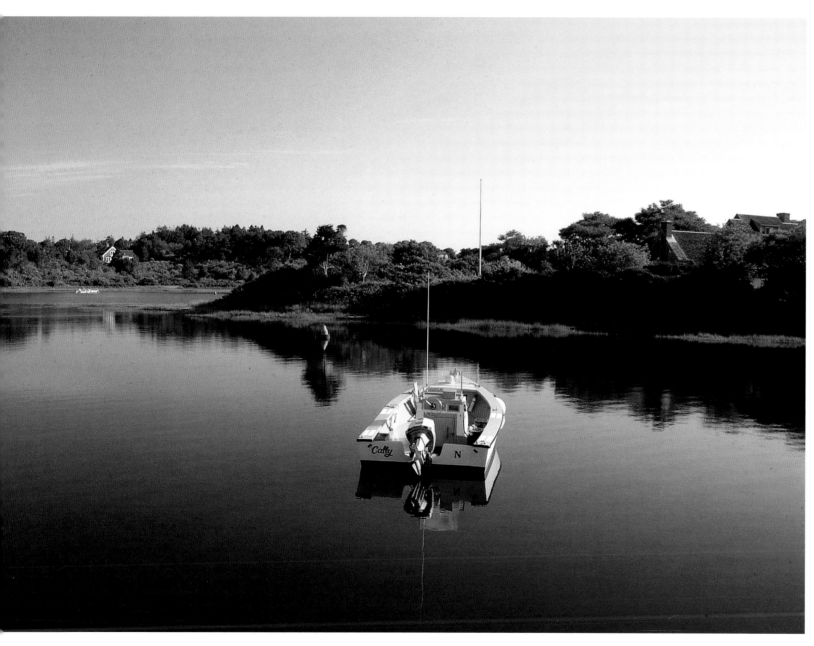

Stage Harbor, Chatham

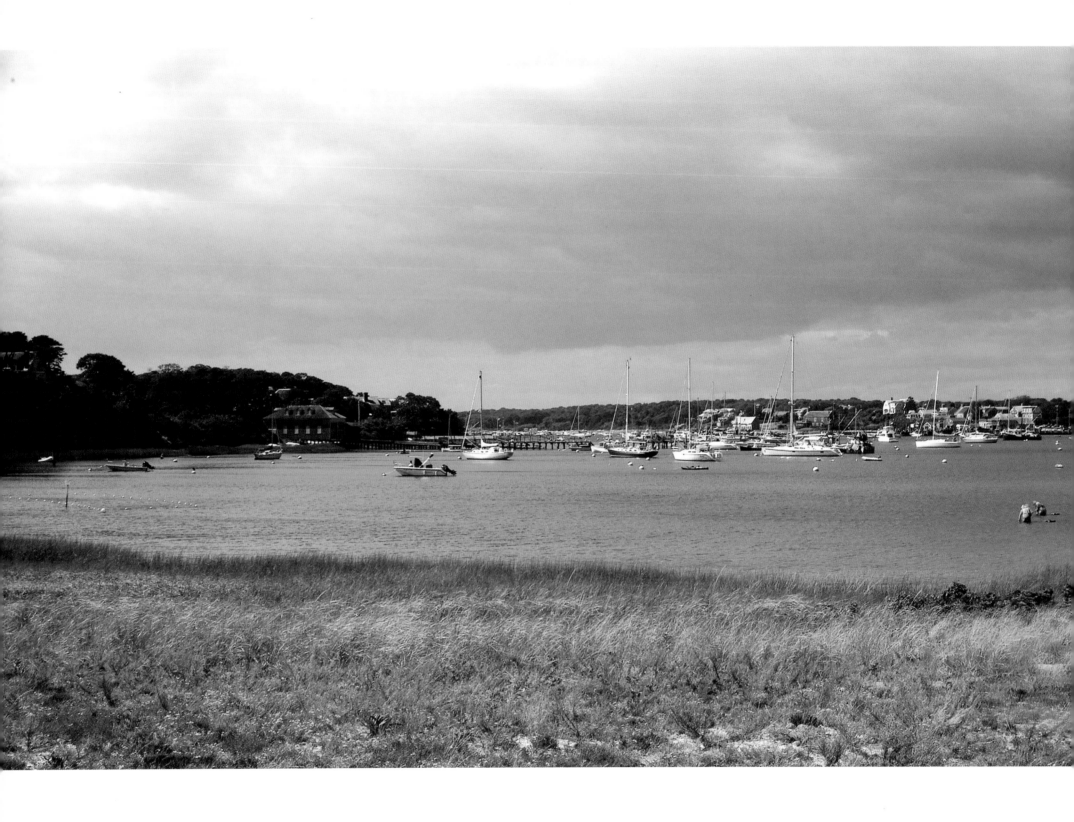

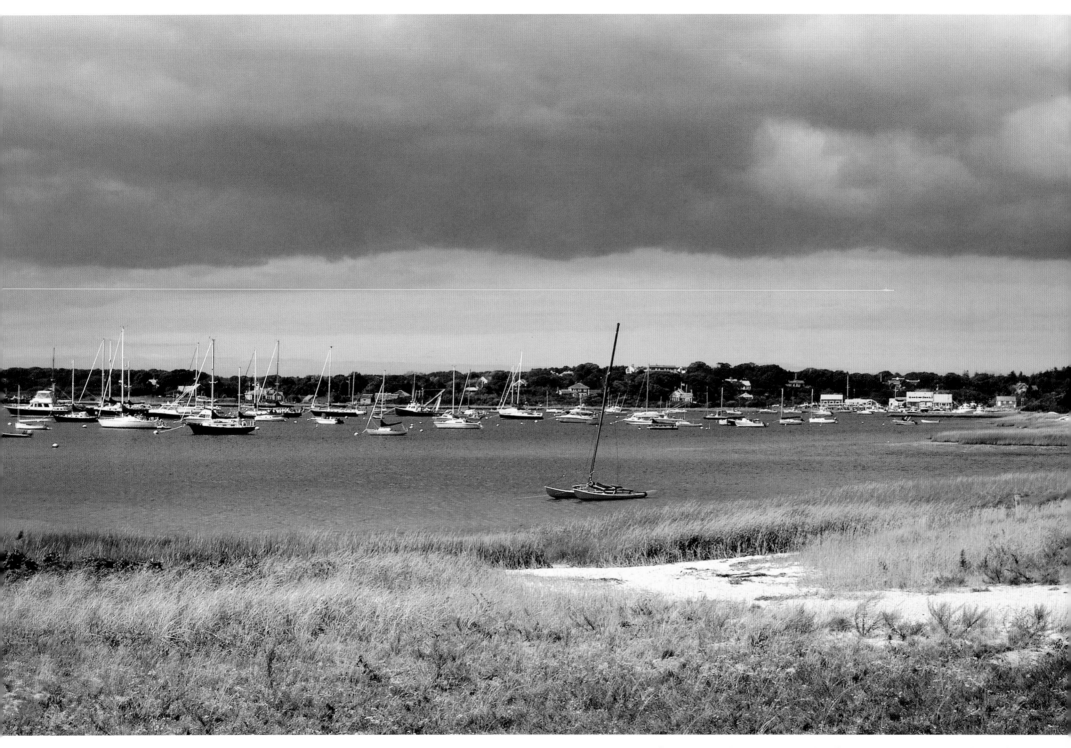

As an approaching storm moves into Stage Harbor, clammers dig for shellfish.

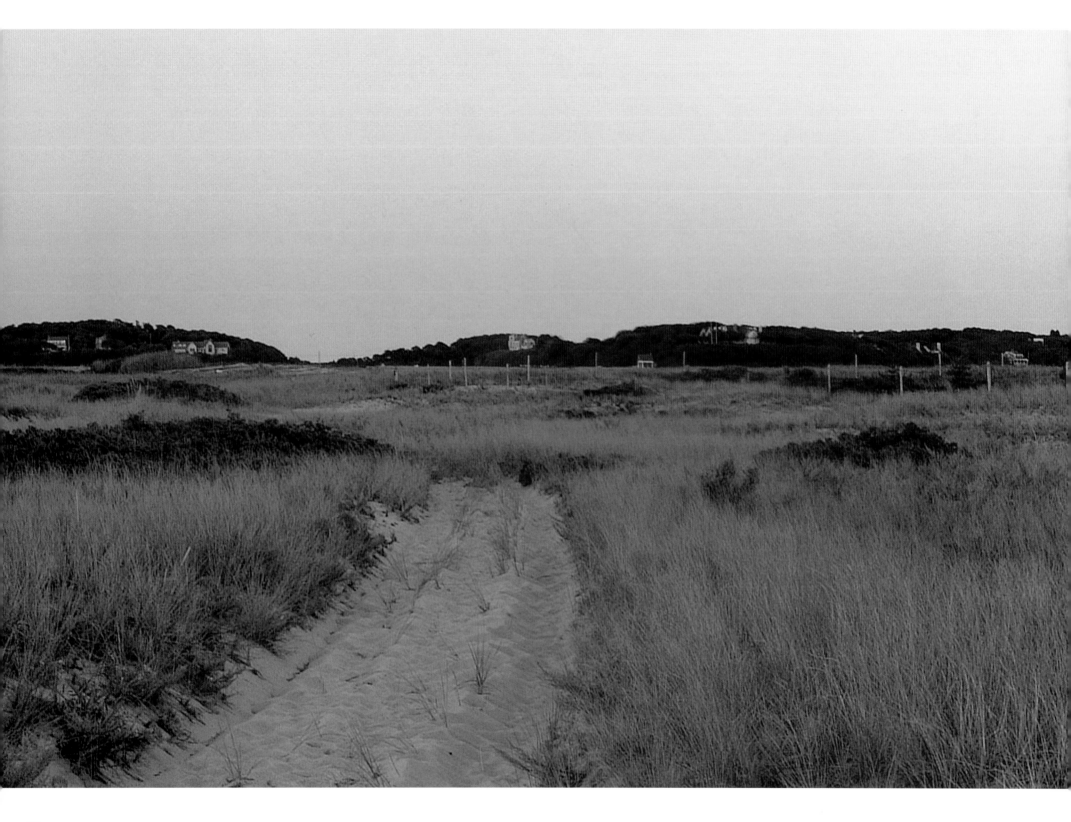

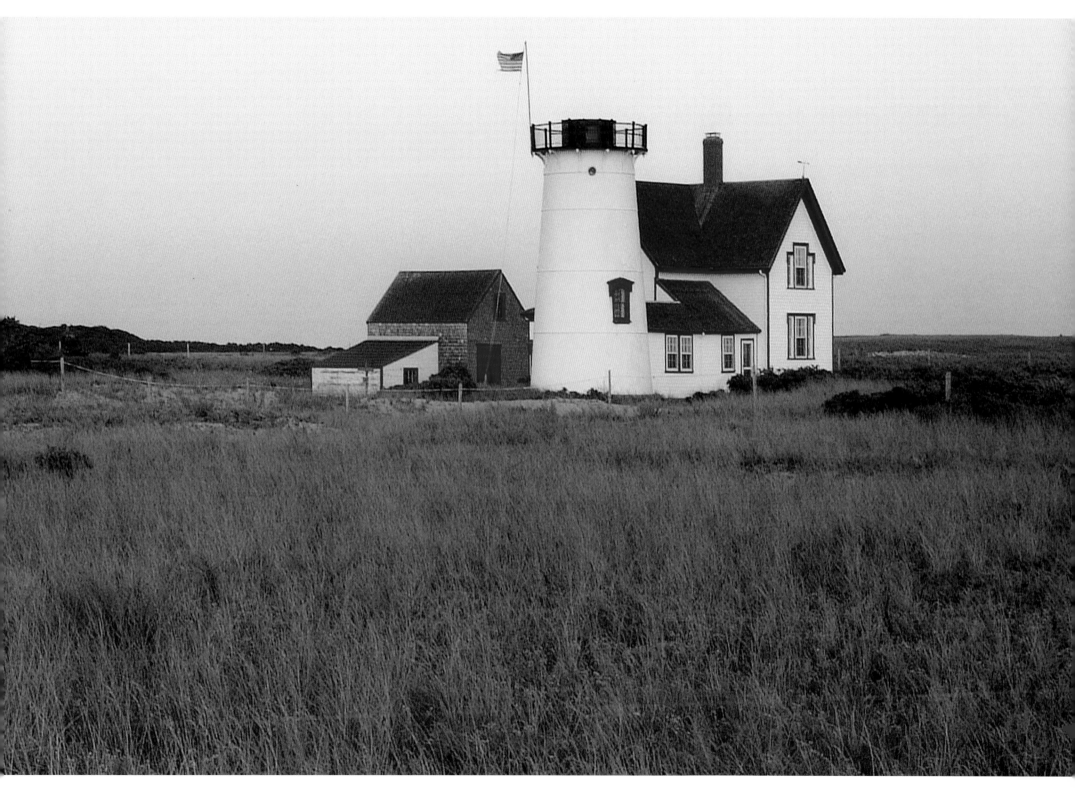

No longer active, Stage Harbor Light once guided mariners into the harbor.

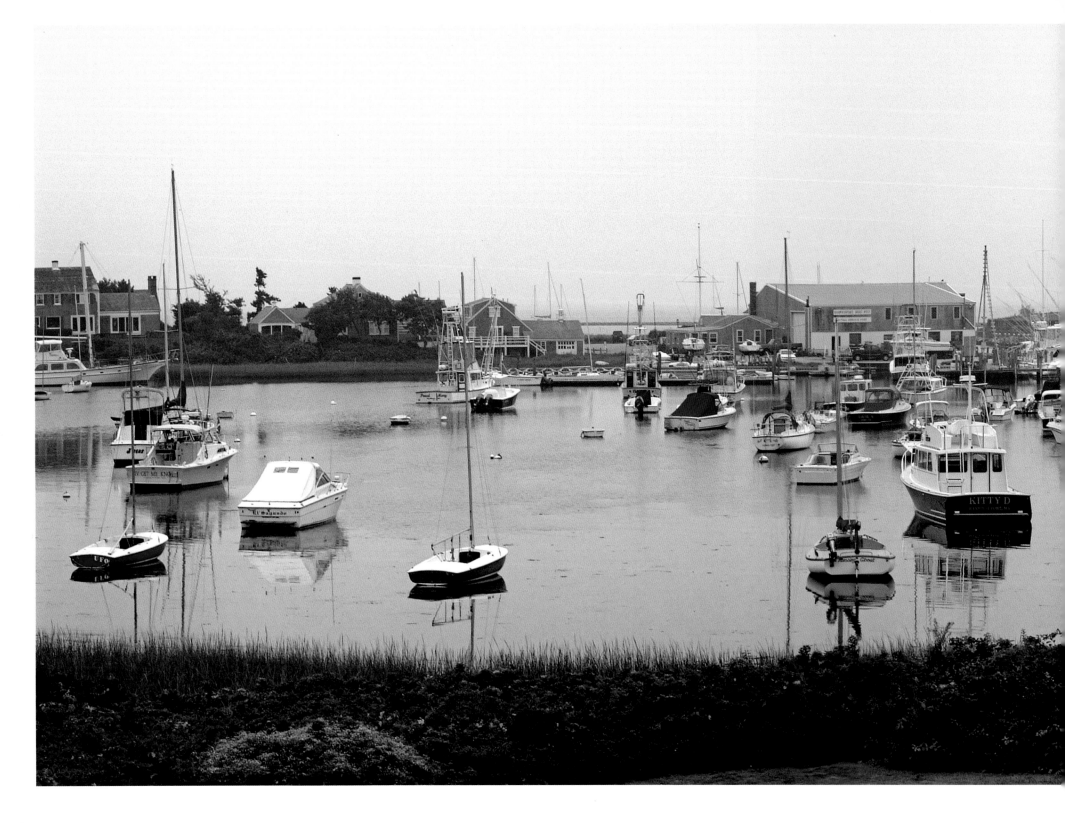

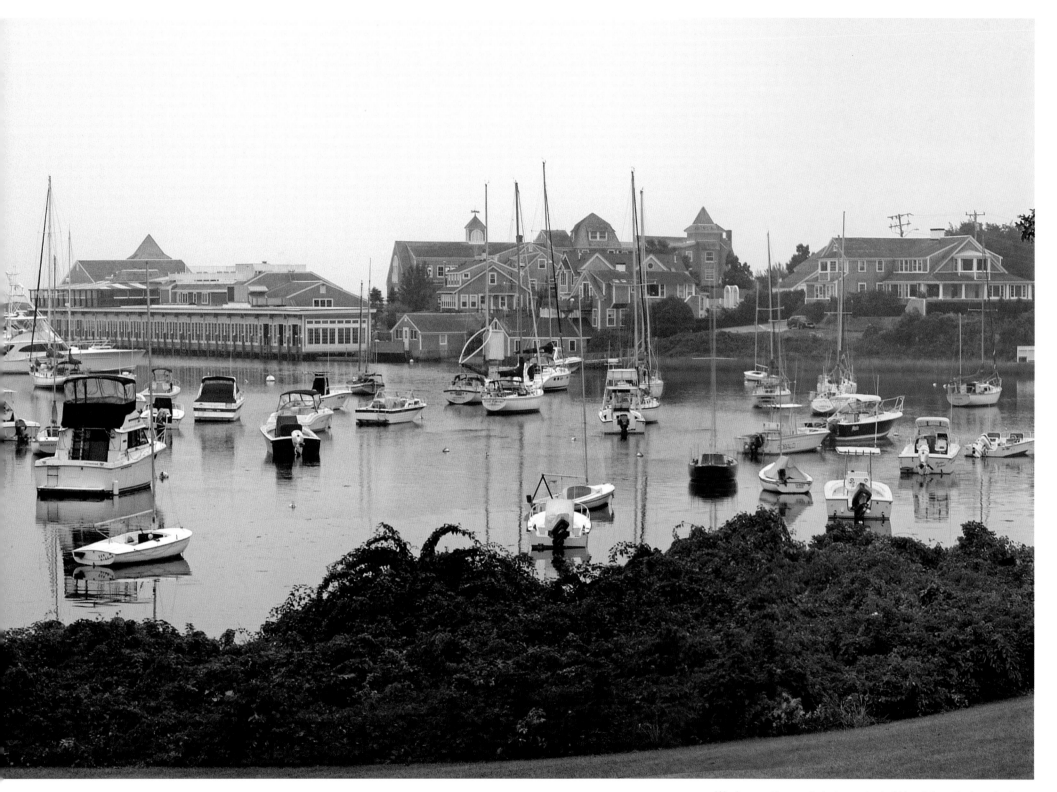

Wychmere, the most photographed of Harwichport's three harbors.

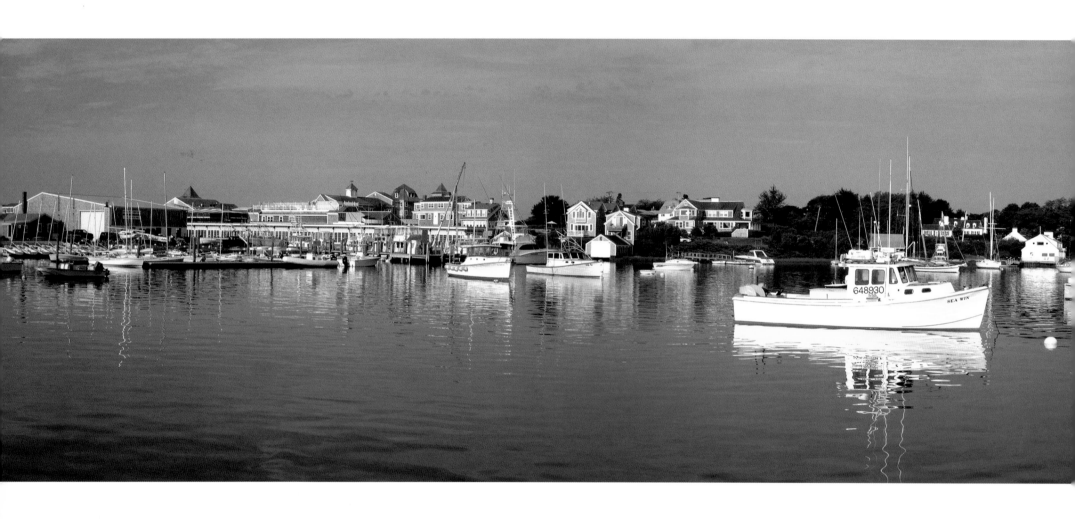

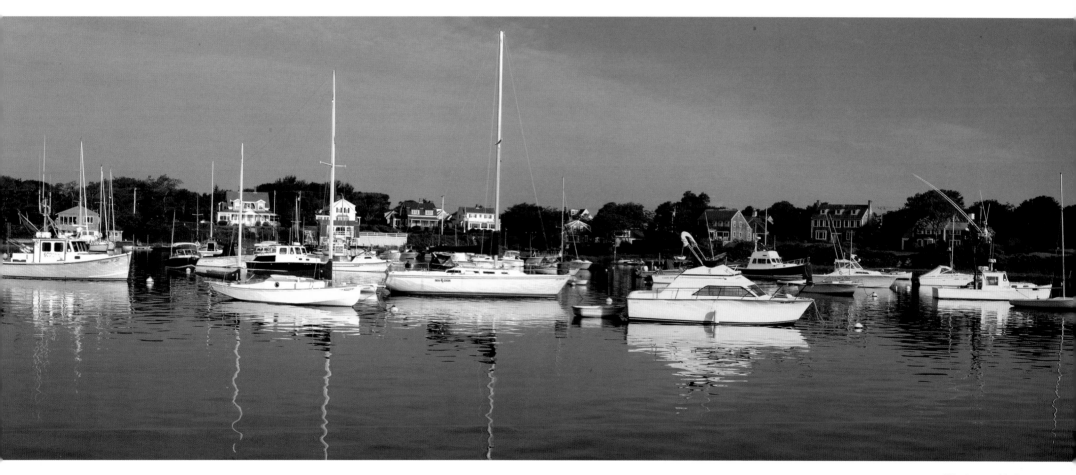

Wychmere Harbor.

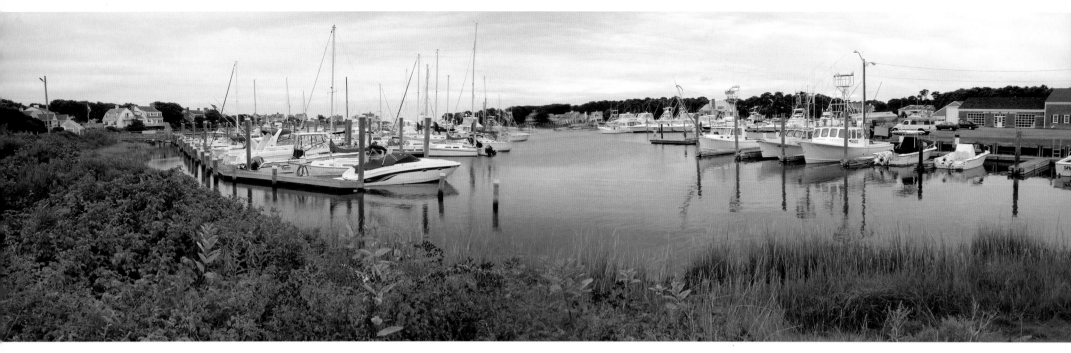

Allen Harbor, Harwichport.

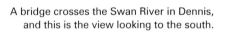

A bridge crosses the Swan River in Dennis, and this is the view looking to the south.

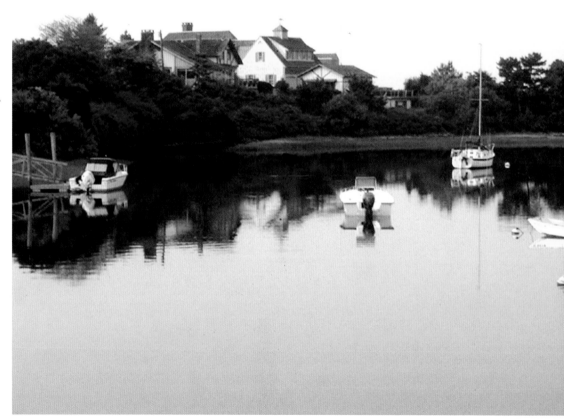

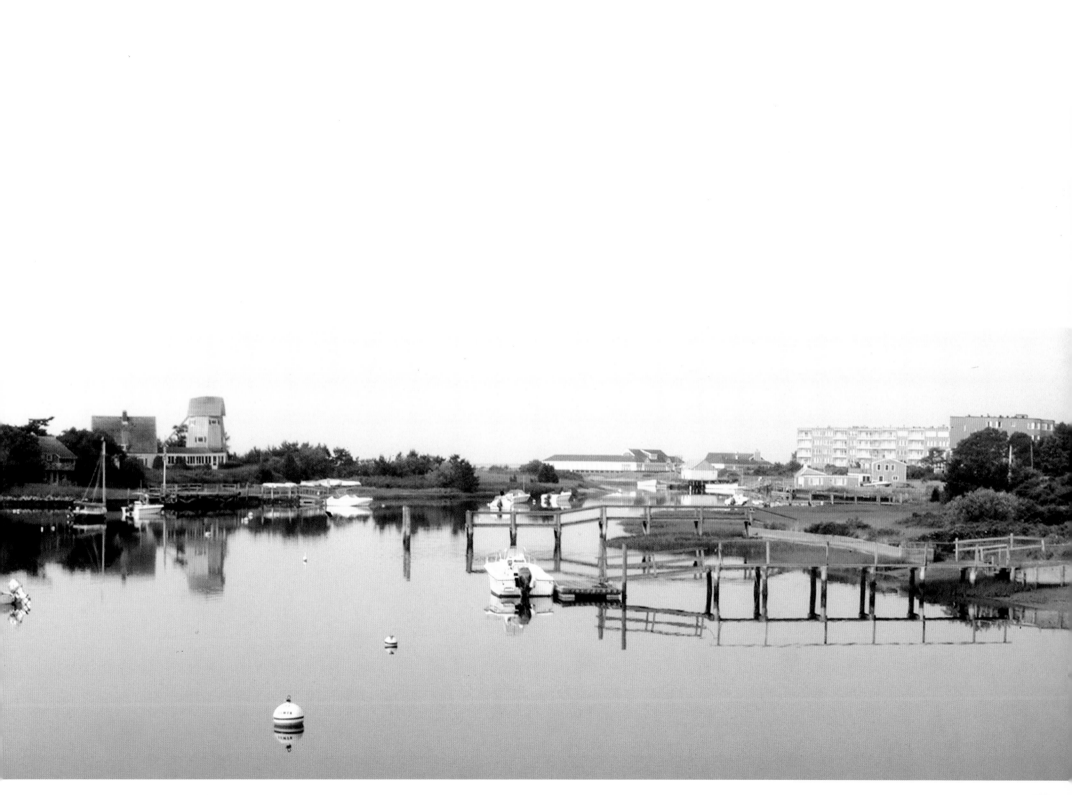

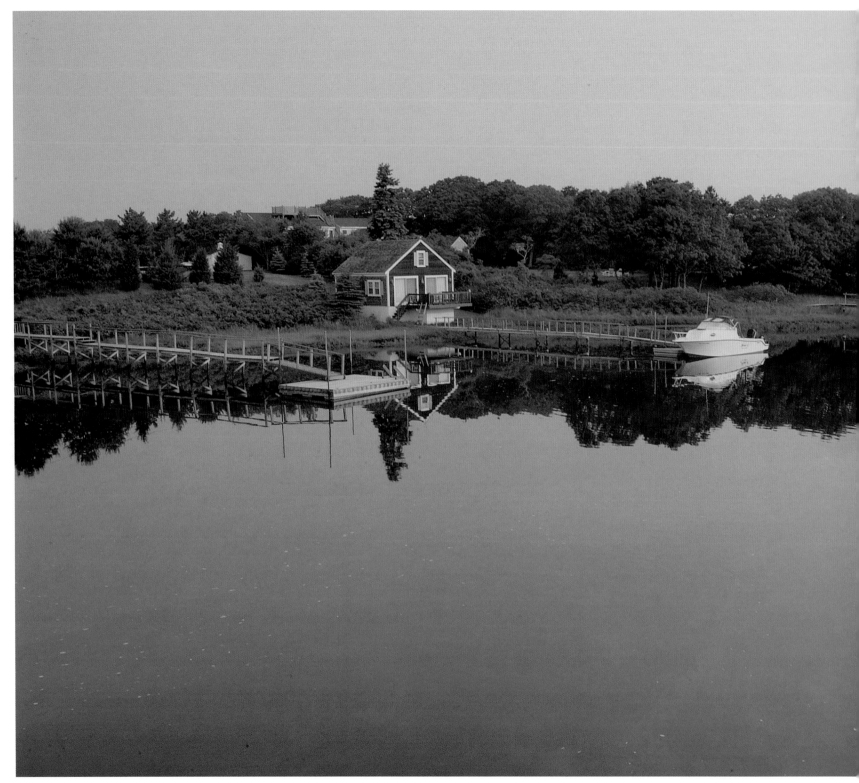

Swan River looking north.

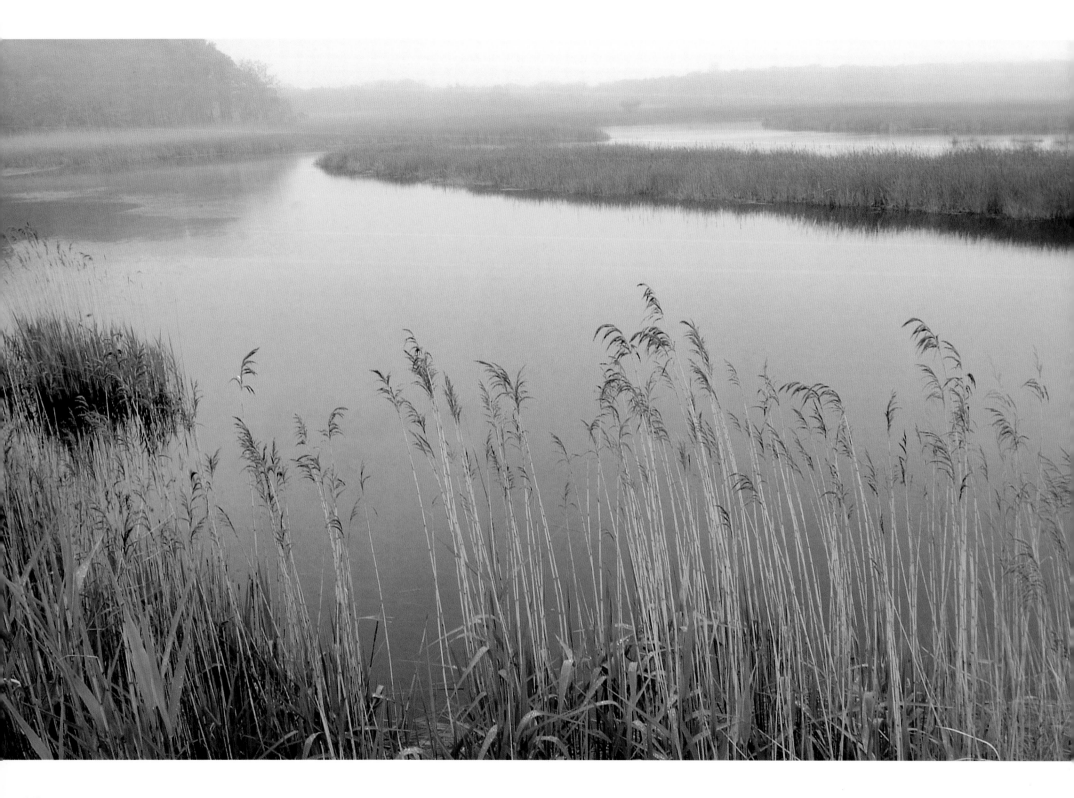

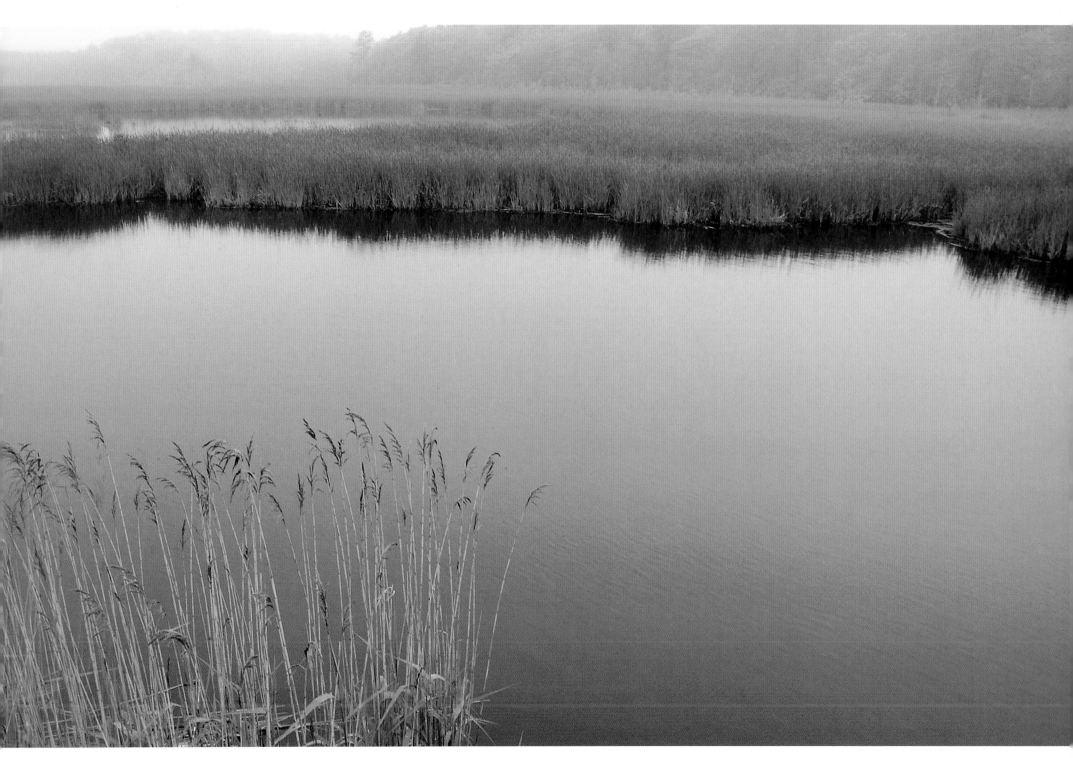

Bell's Neck, Harwich

There are two ways to pick cranberries, dry or wet as here. The fields are flooded in the fall and a machine is used to gently knock the berry off the vine.

On a different bog, the cranberries have been positioned so they can be loaded on to a truck.

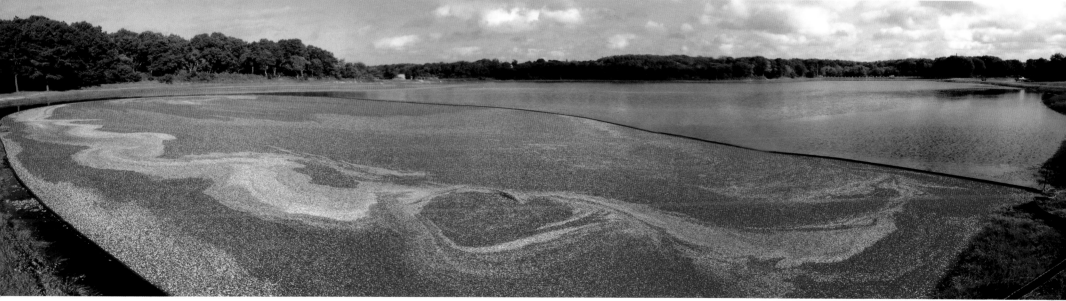

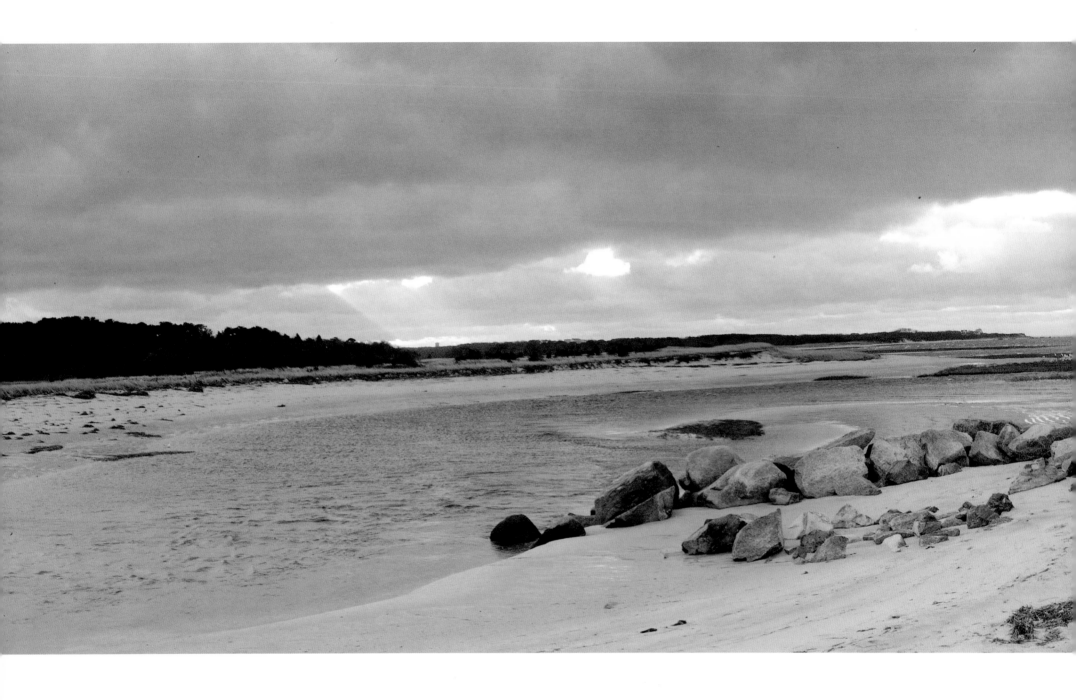

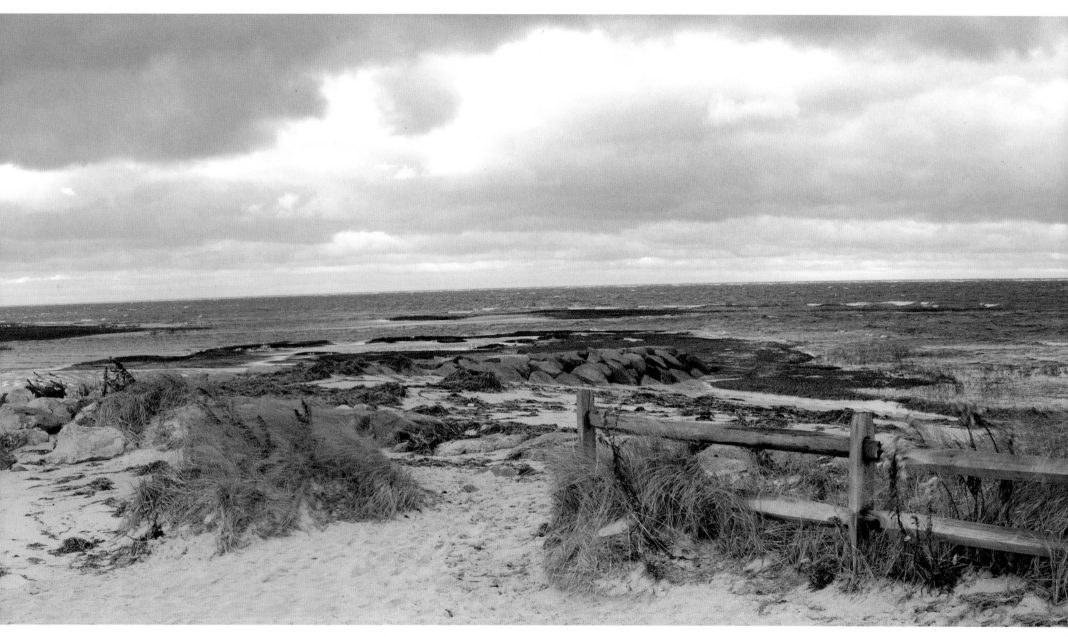

Paine's Creek, Brewster.

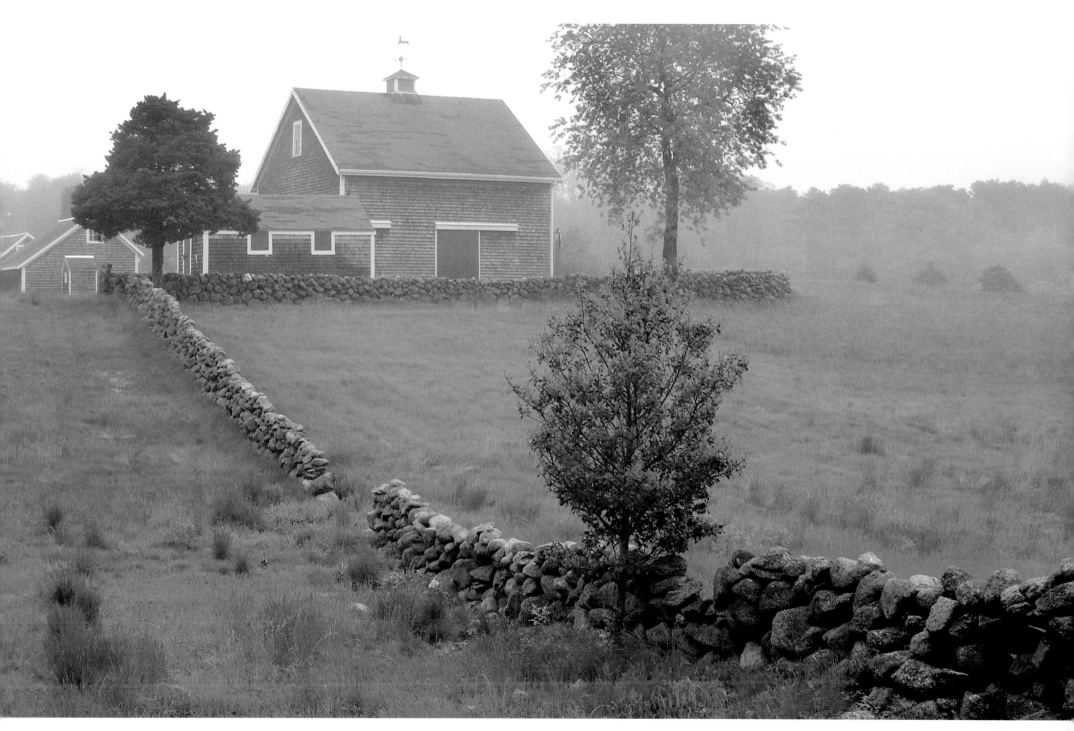

Fields and a barn in Barnstable.

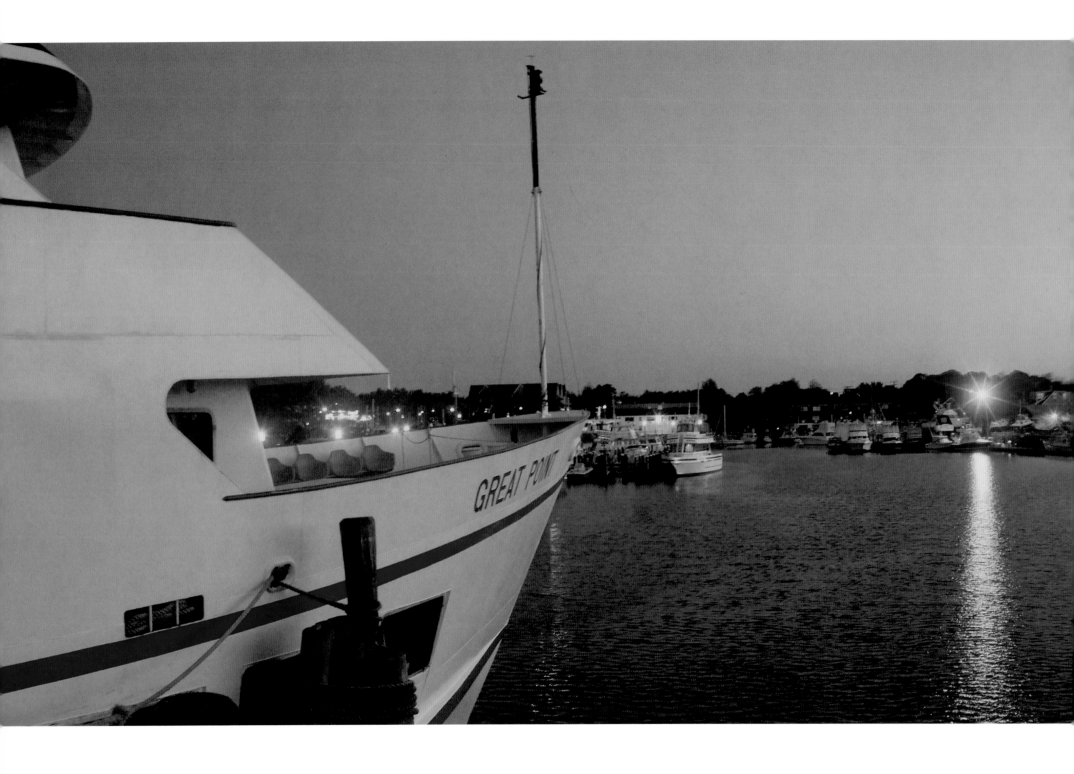

Hyannis Harbor just before daybreak.

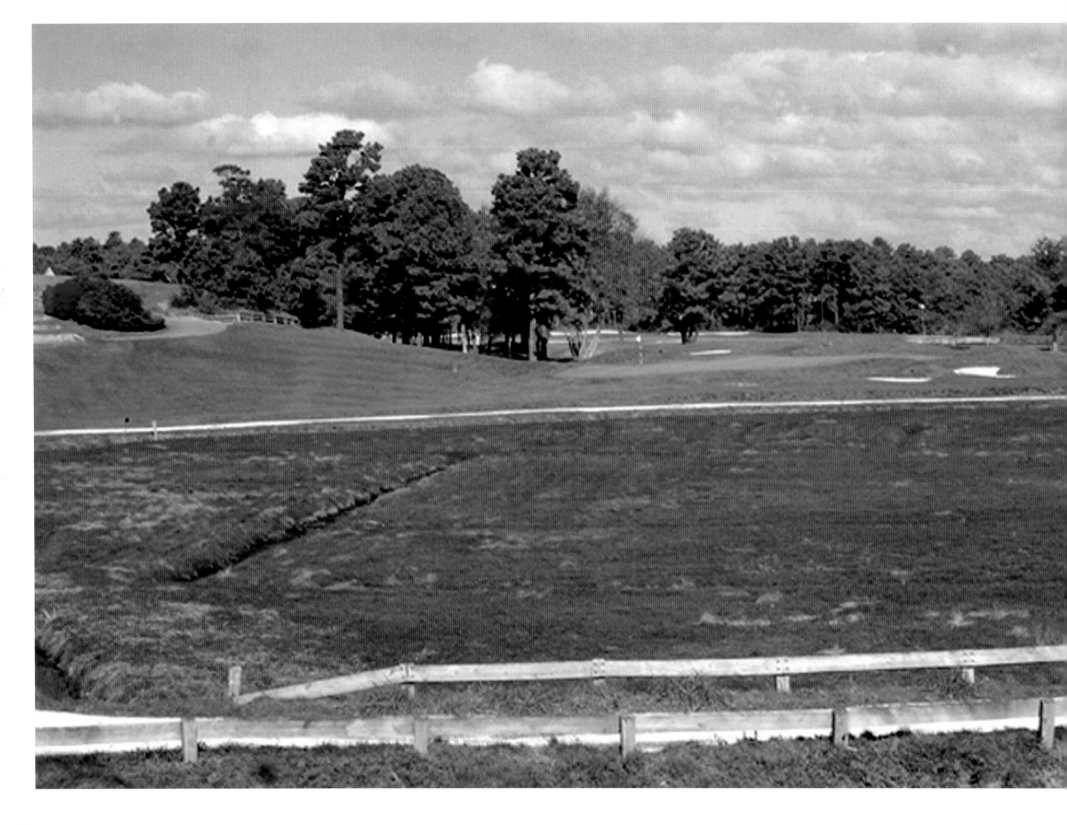

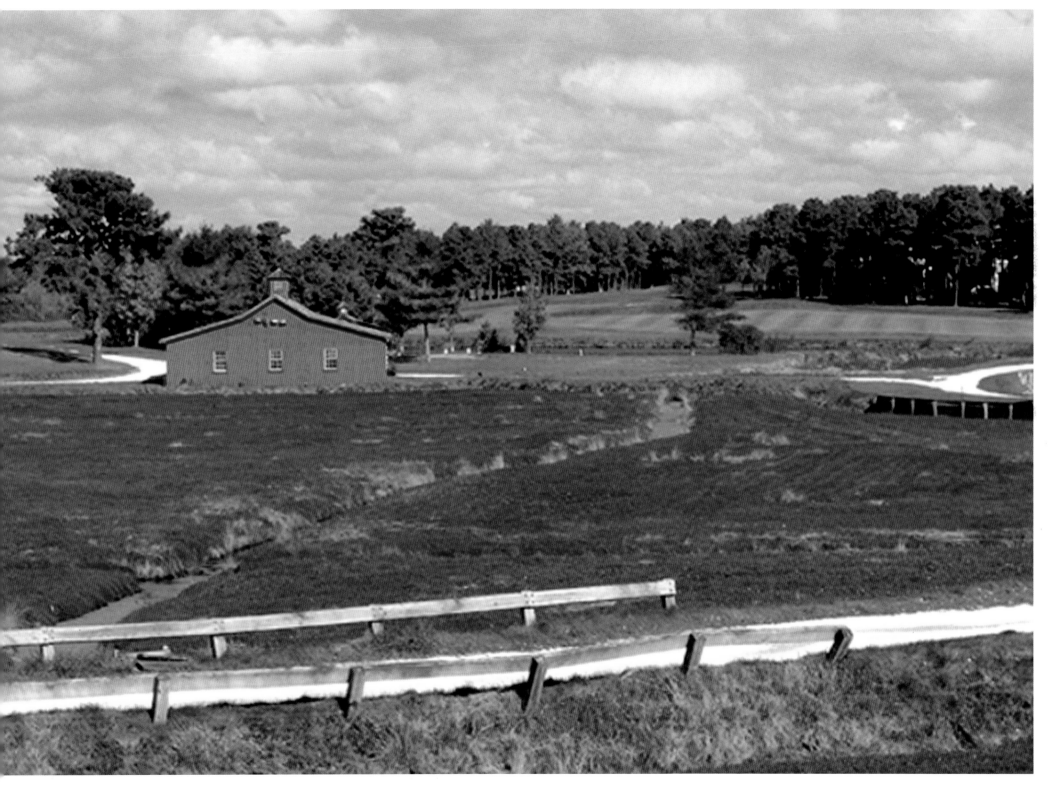

Willowbend Golf Course in Mashpee has an active cranberry bog.

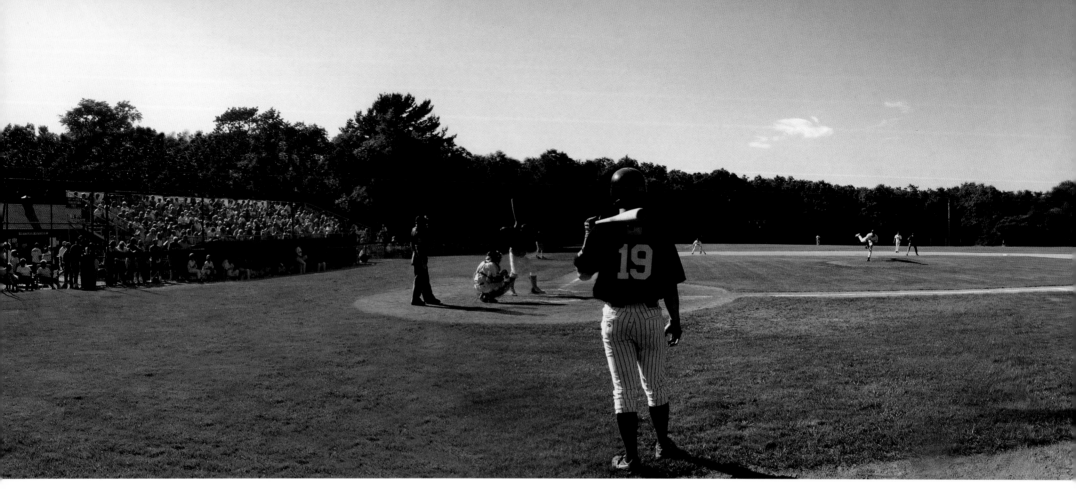

The home team bleachers of the Cotuit Kettler's blend with the trees that surround the park.

The Lowell Field in Cotuit has no lights, so all games are played in the late afternoon.

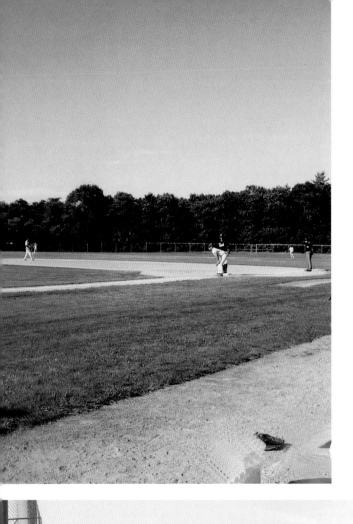

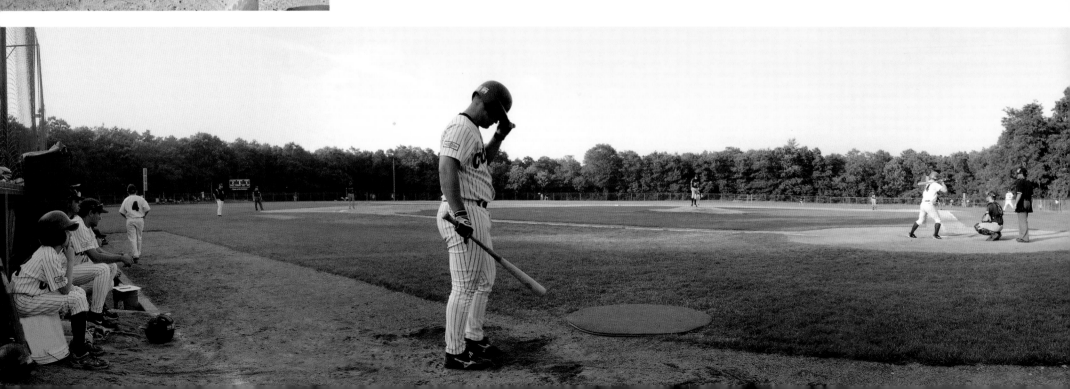

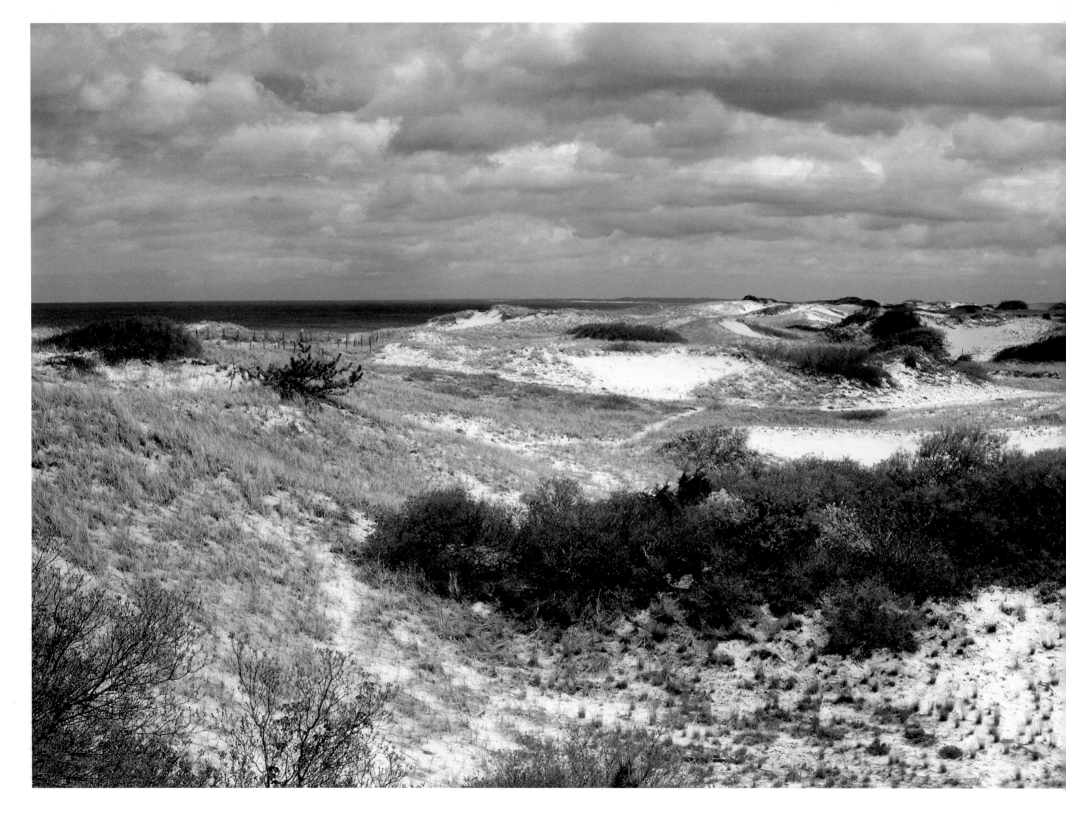

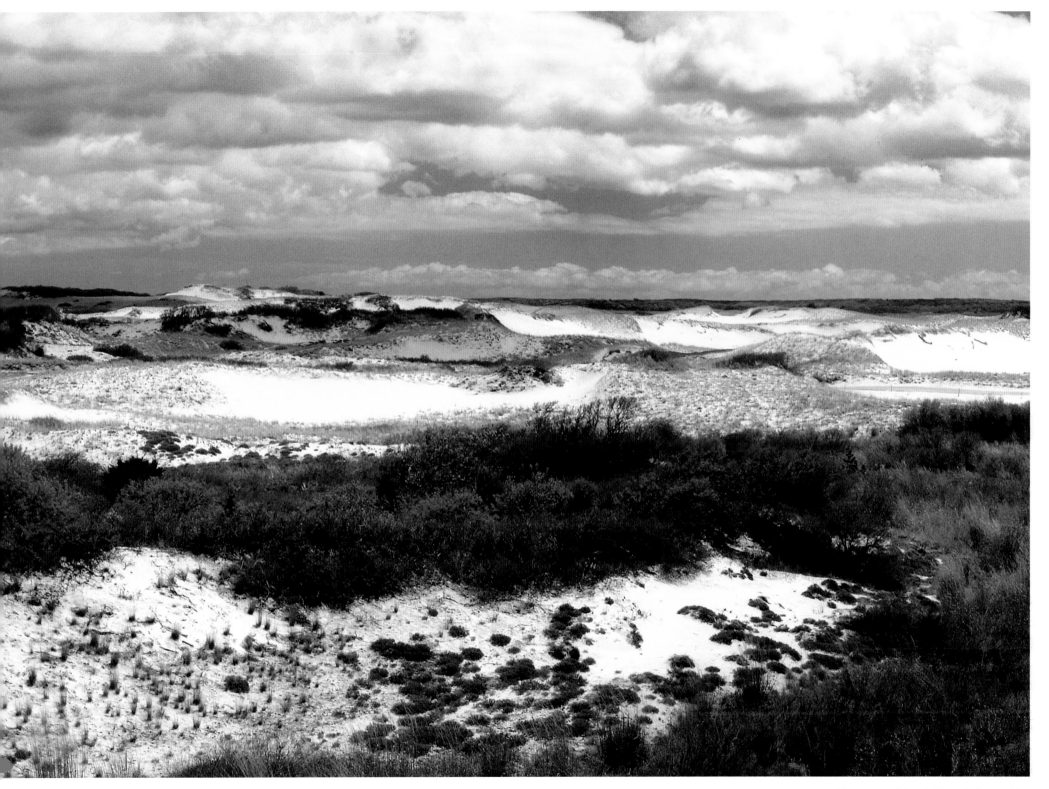

The dunes of Sandy Neck, in Barnstable.

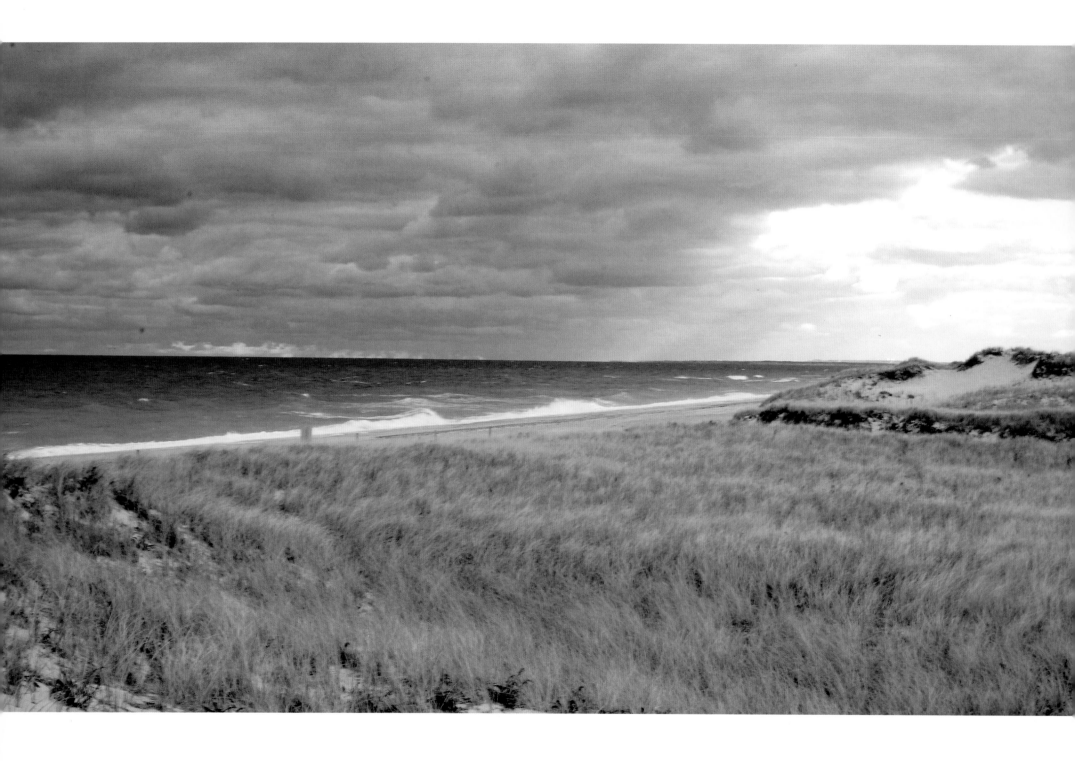

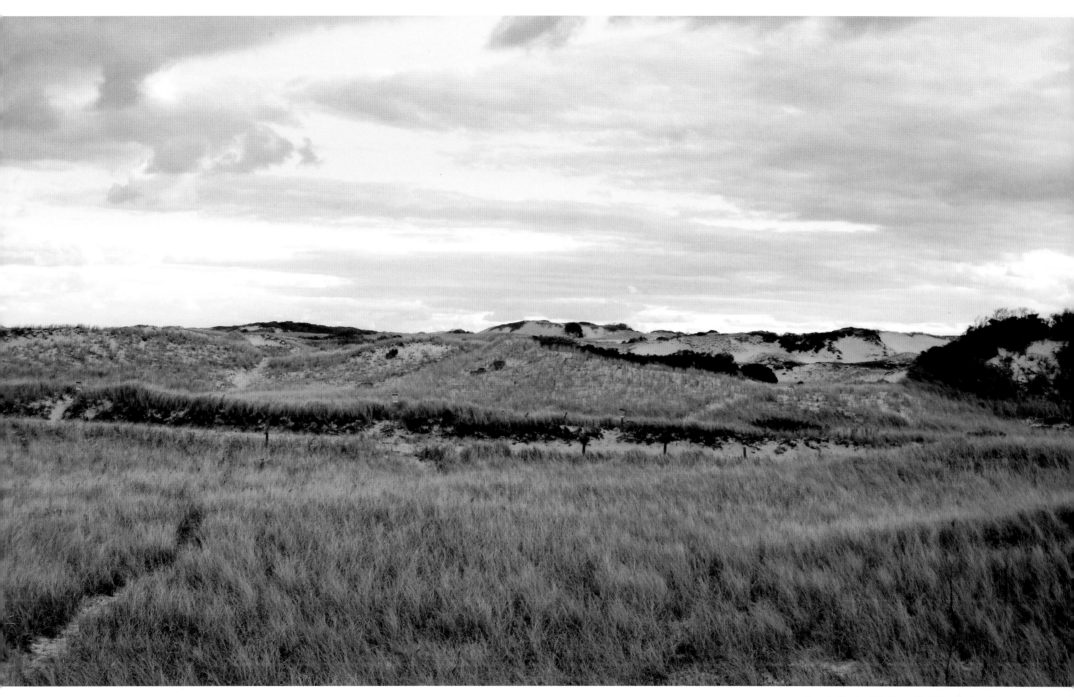

Sandy Neck with Cape Cod Bay in the distance.

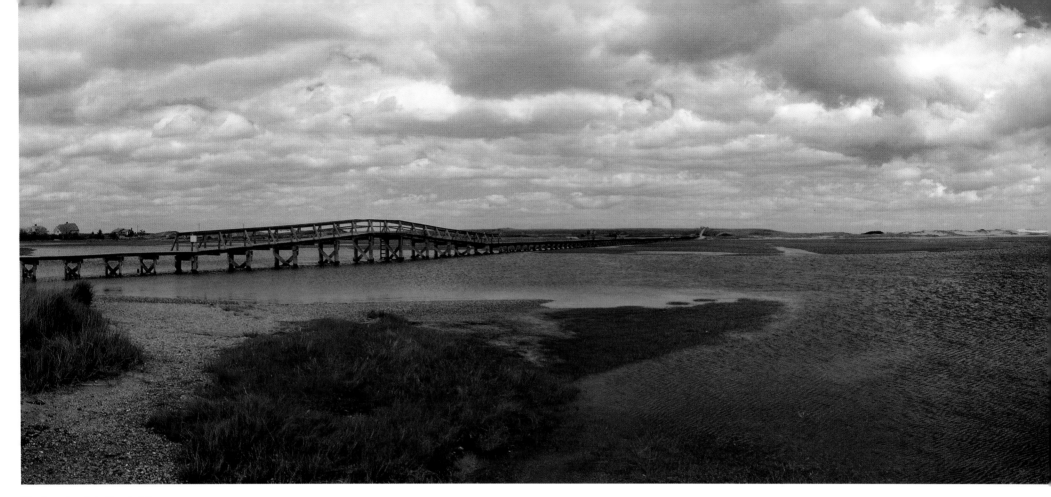

The boardwalk in Sandwich.

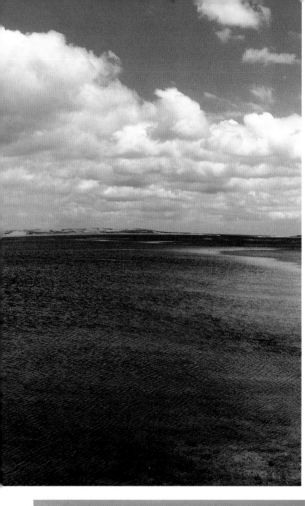

High tide is the best time to shoot the boardwalk, and an approaching storm adds impact.

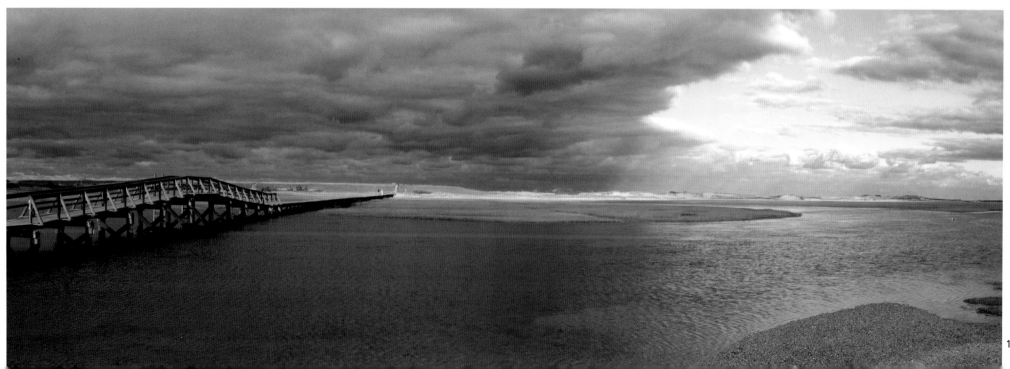

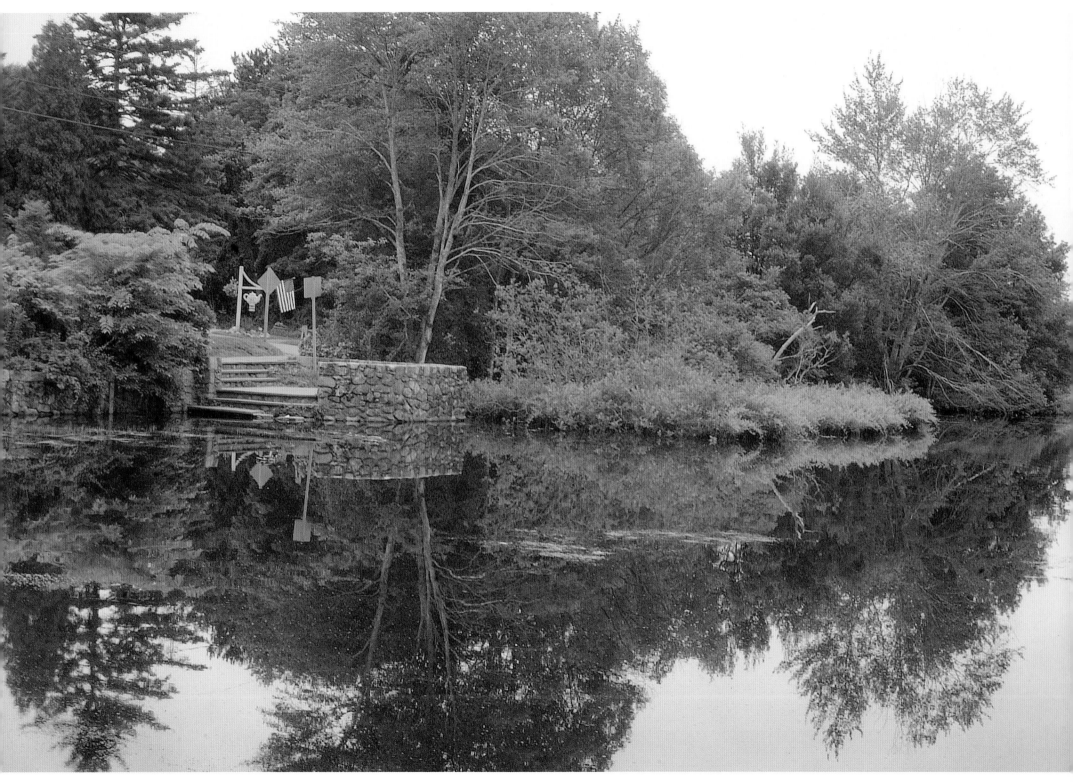

Shawme Lake in Sandwich.

Shawme Lake early on a winter morning.

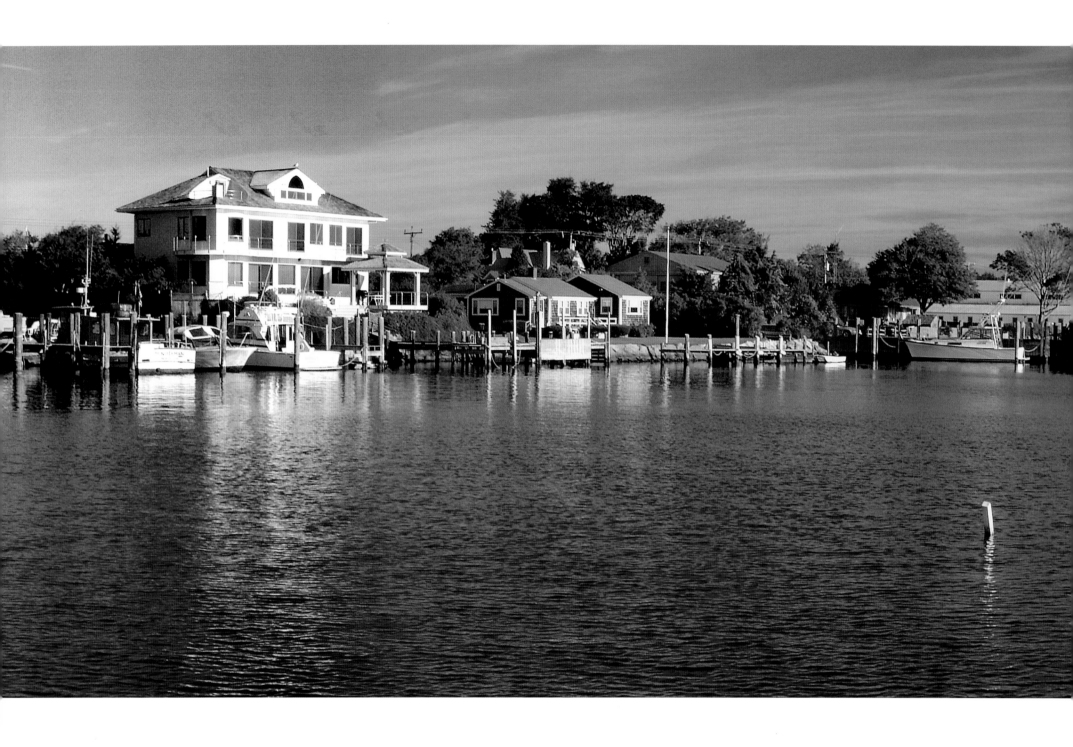

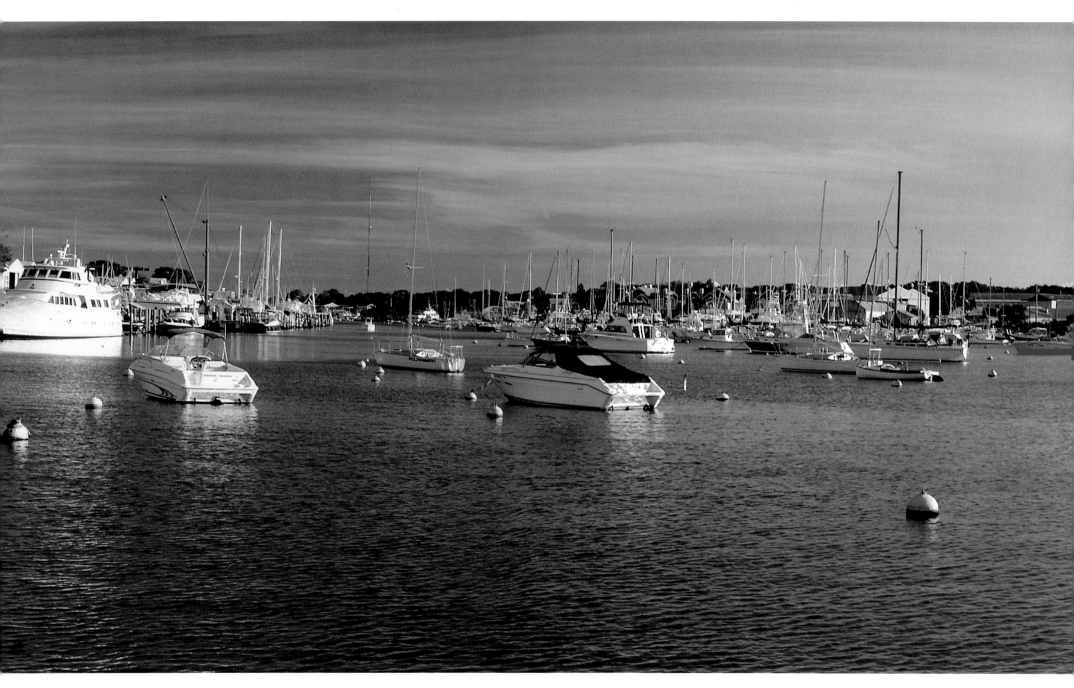

Falmouth Harbor

Green Harbor, Falmouth.

Child's River, Falmouth.

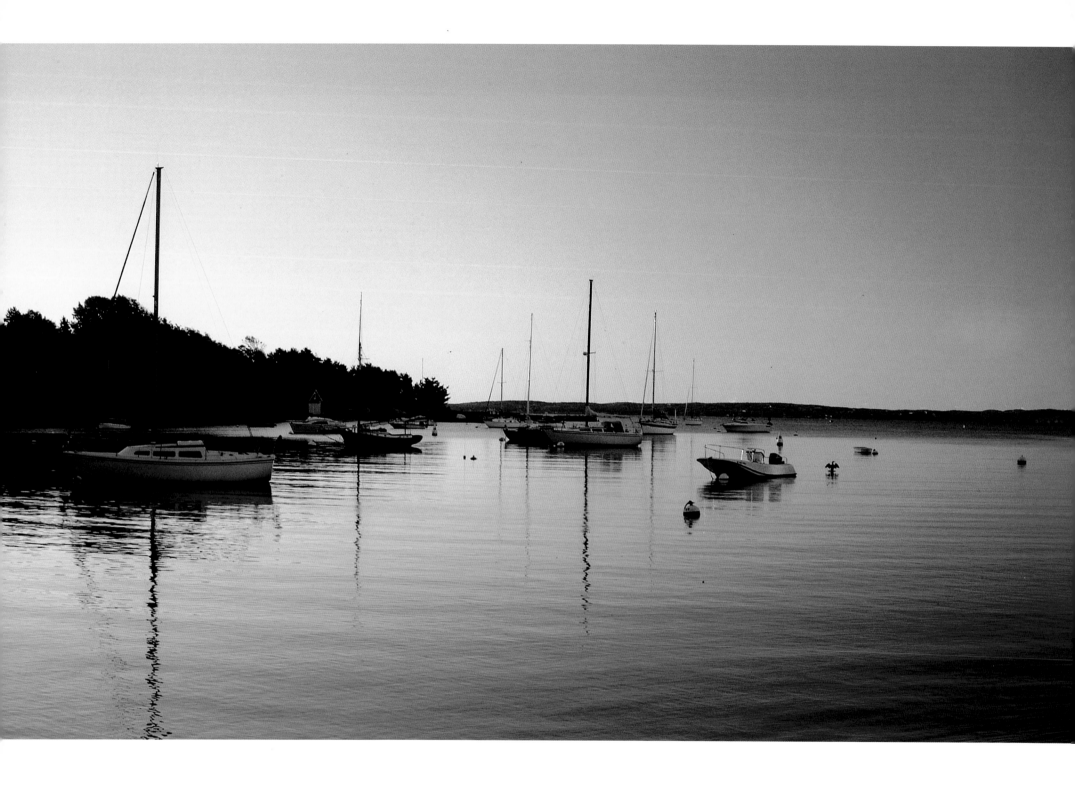

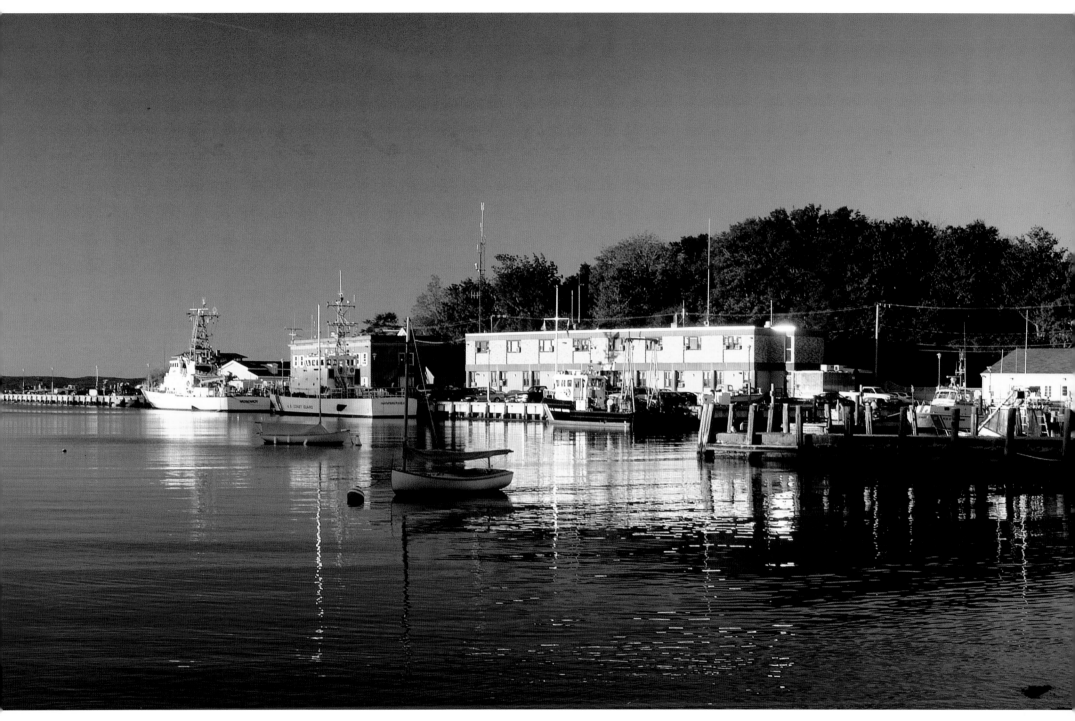

Little Harbor, Woods Hole.

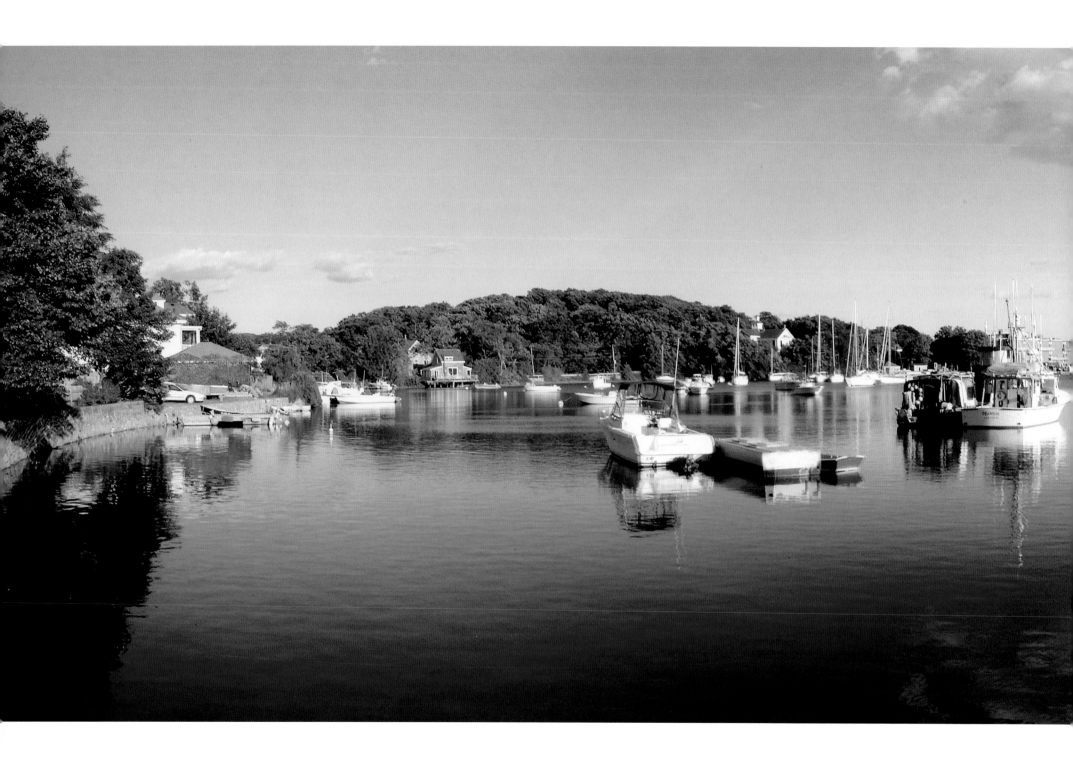

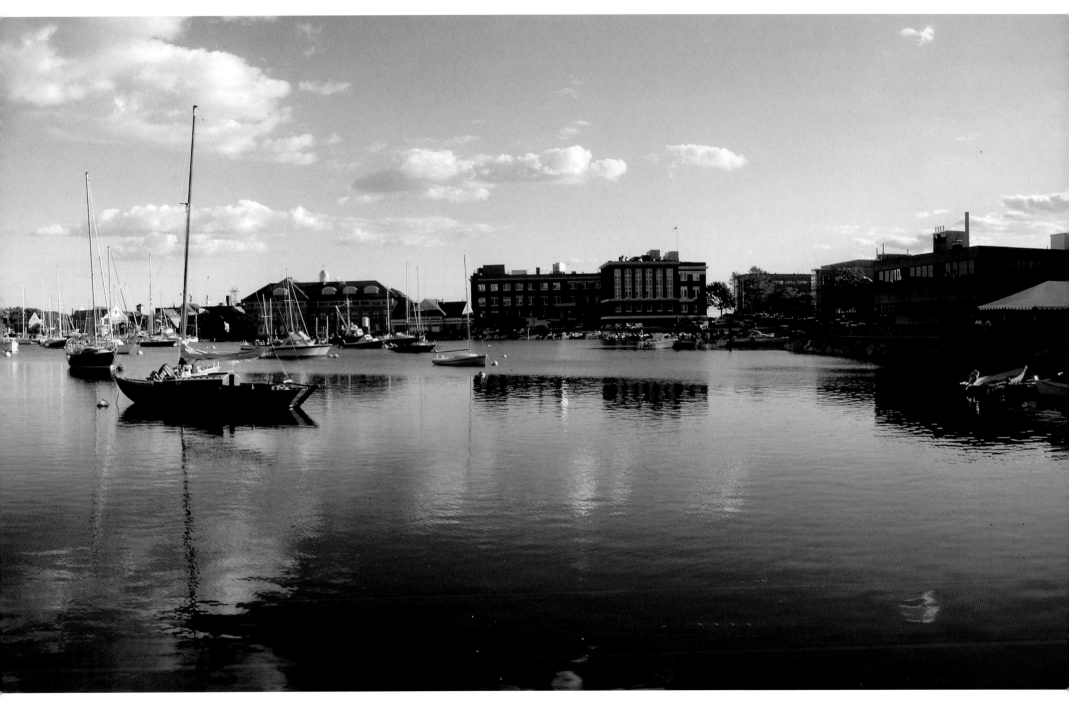

Eel Pond, Woods Hole.

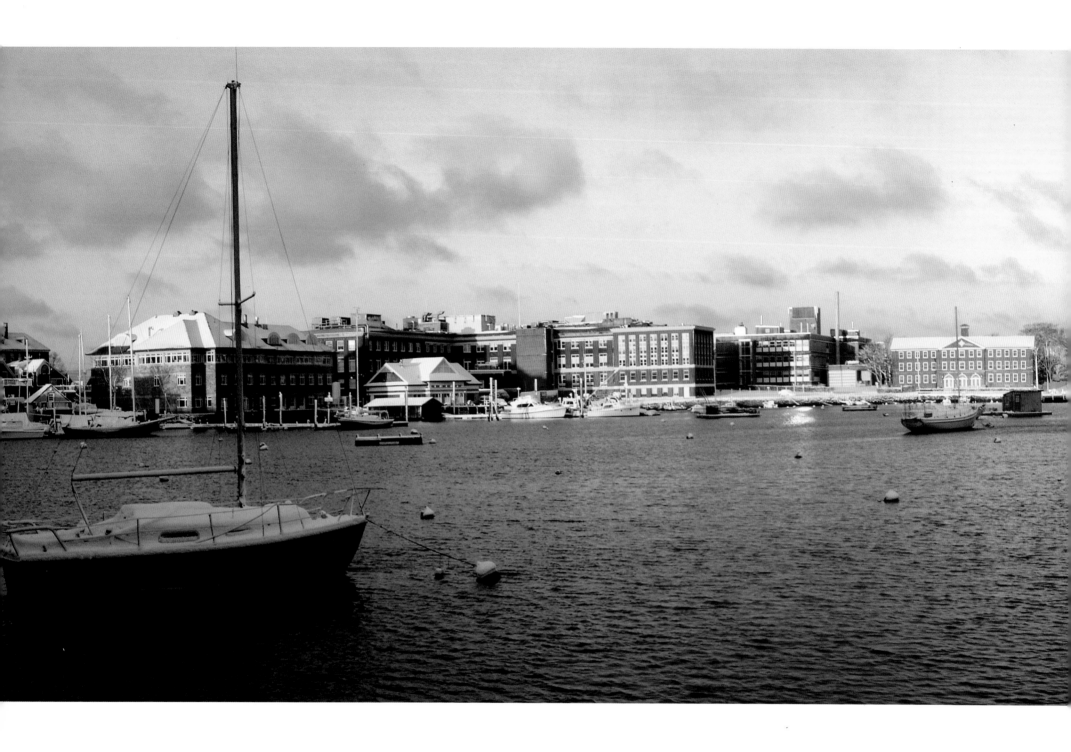

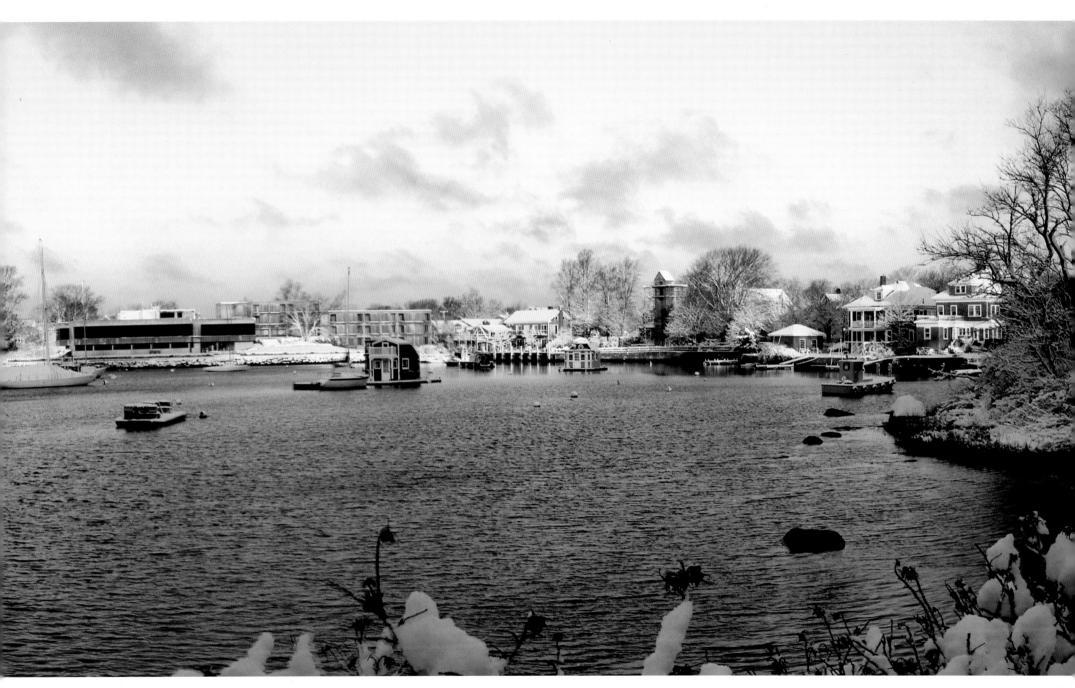

Eel Pond in winter.

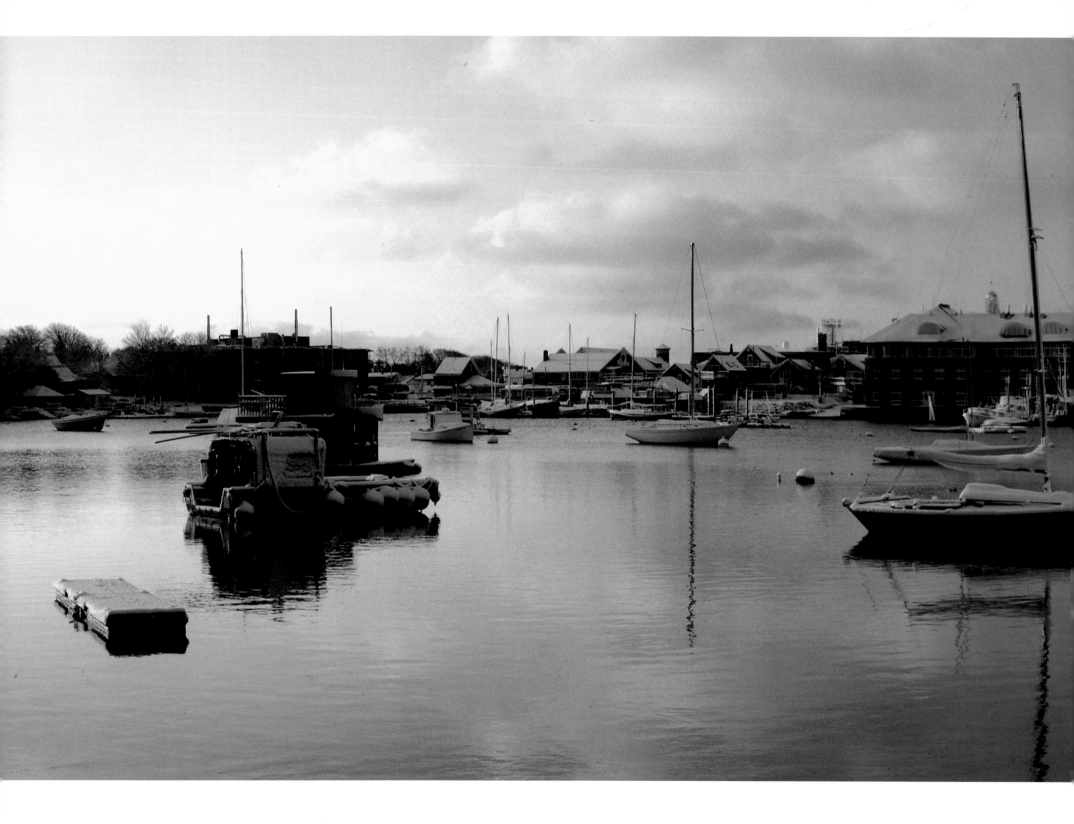

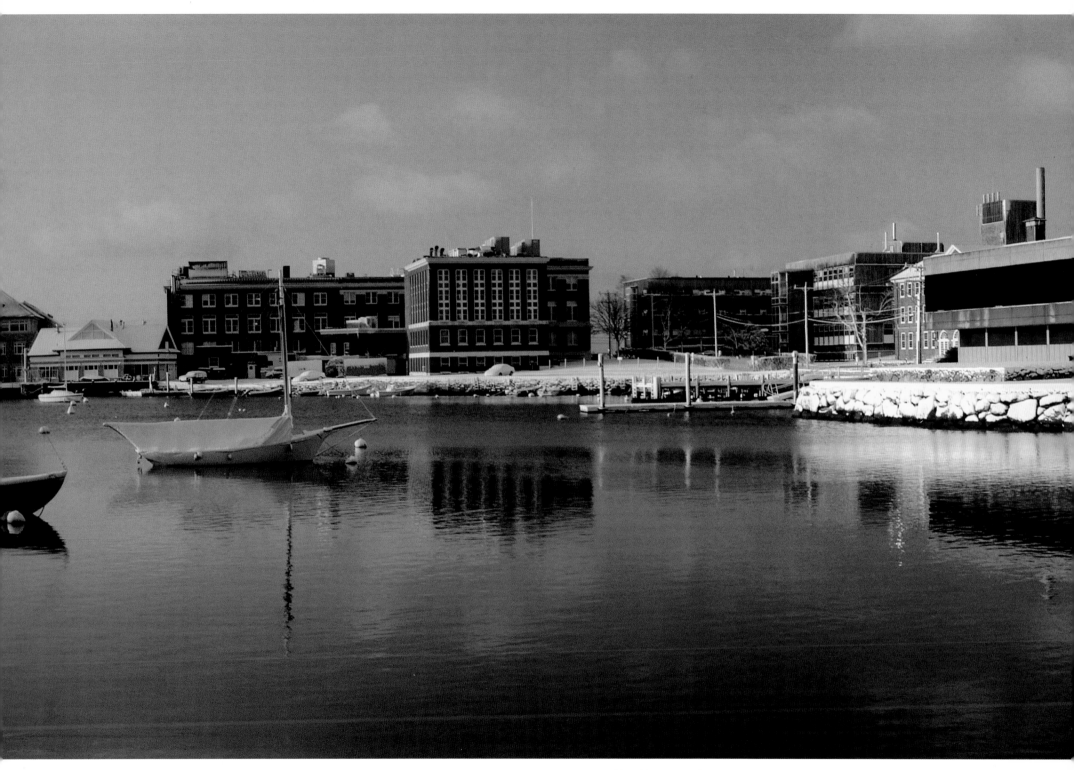

The Woods Hole Oceanographic Institute is on the left and the Marine Biological Lab is on the right of this Eel Pond view.

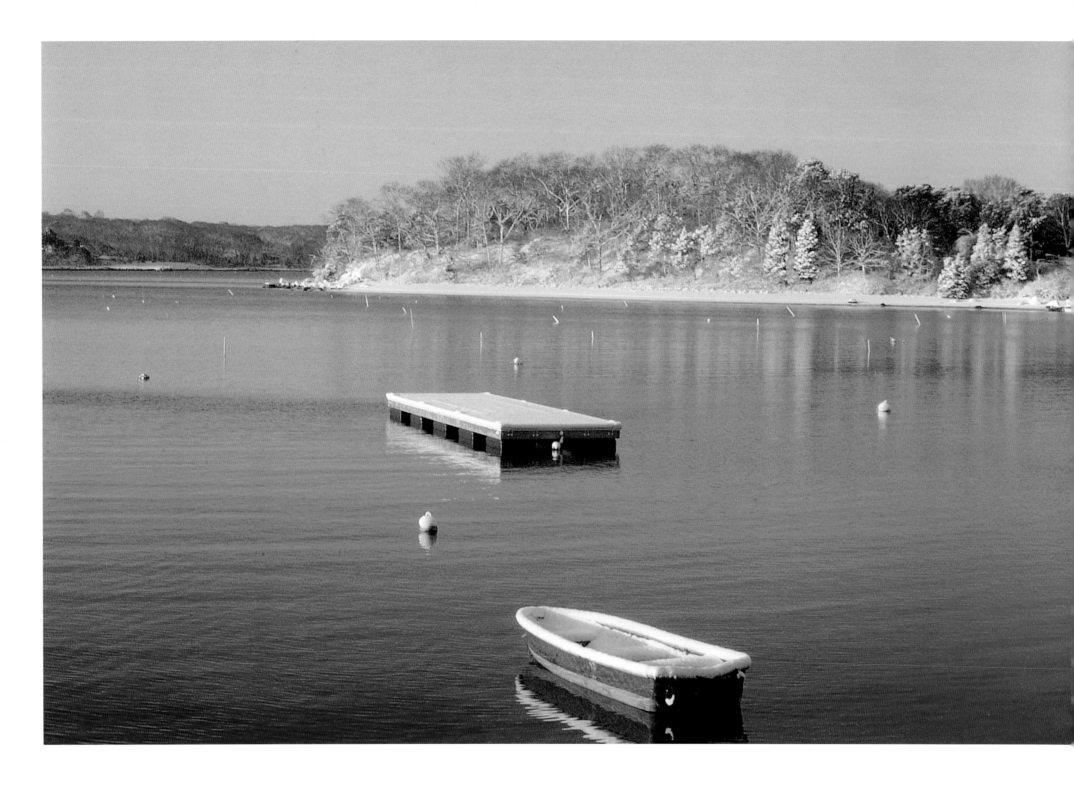

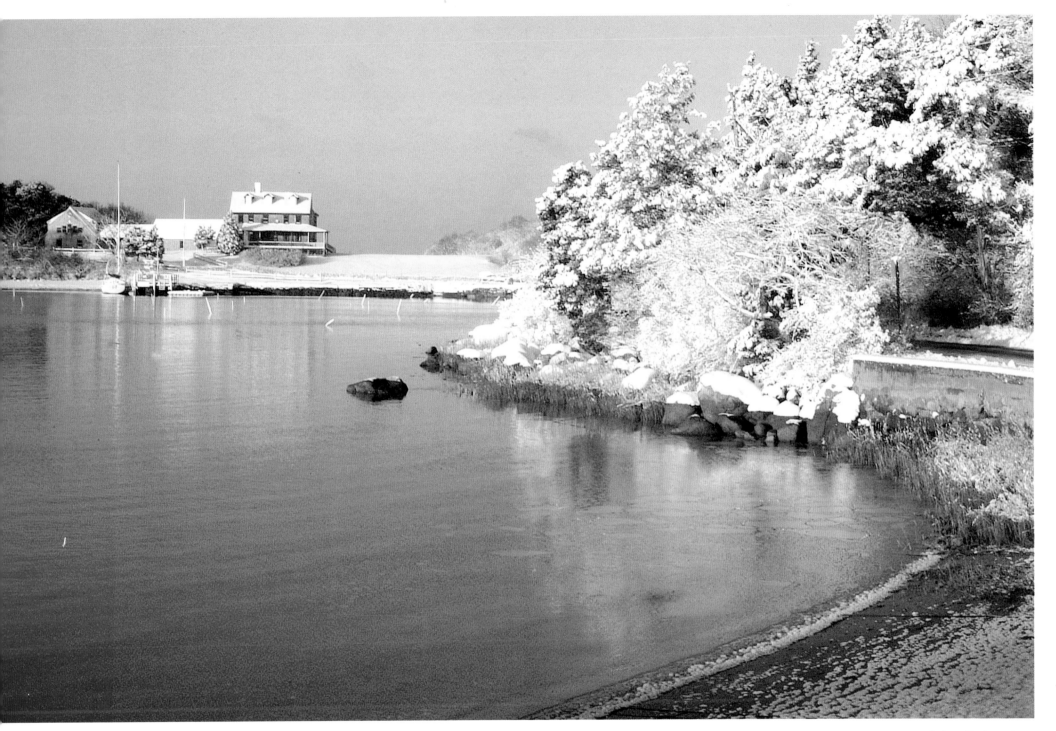

Quisset Harbor, winter.

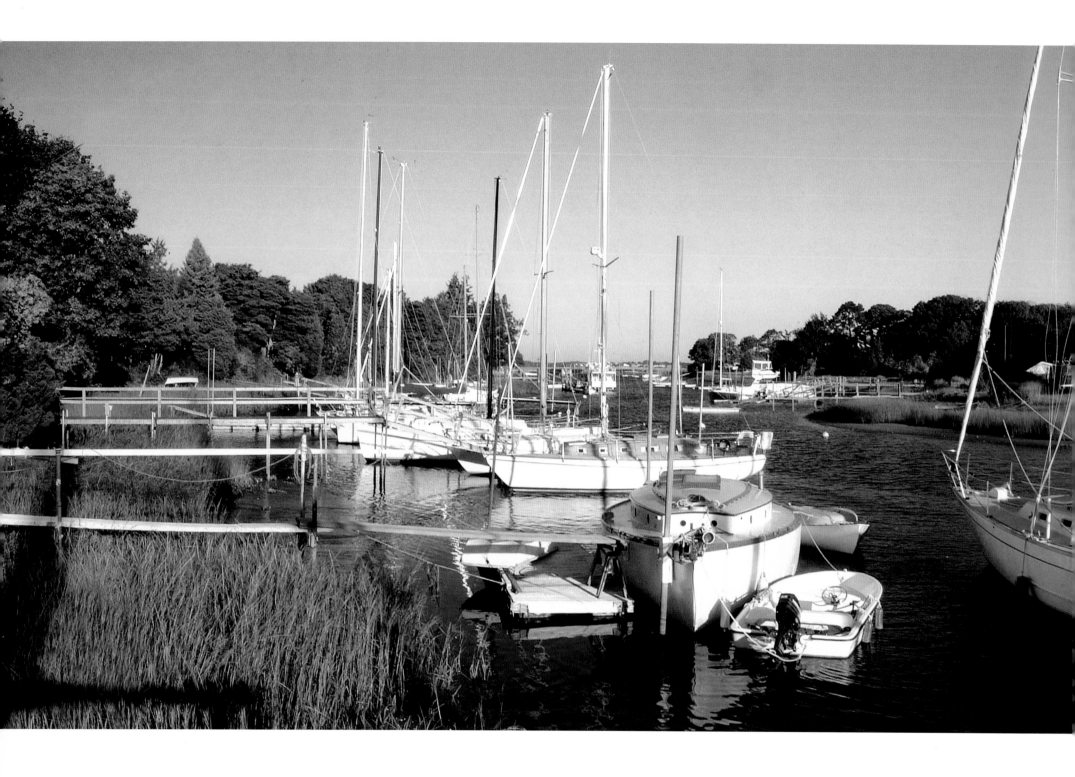

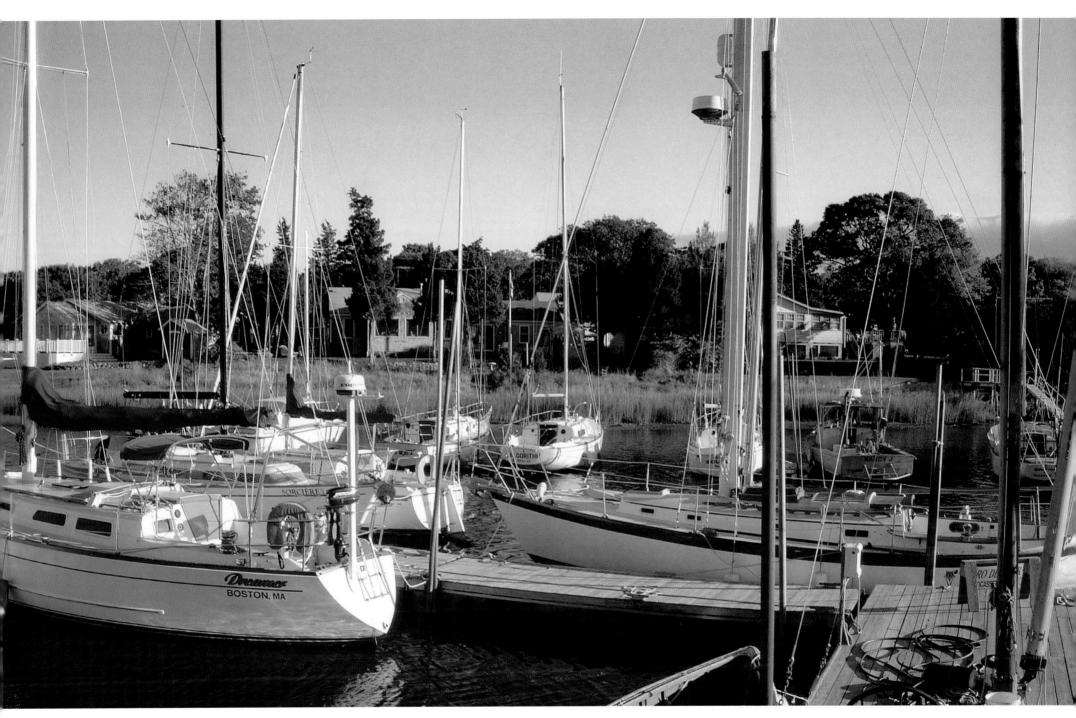

Pocasset River, Bourne.

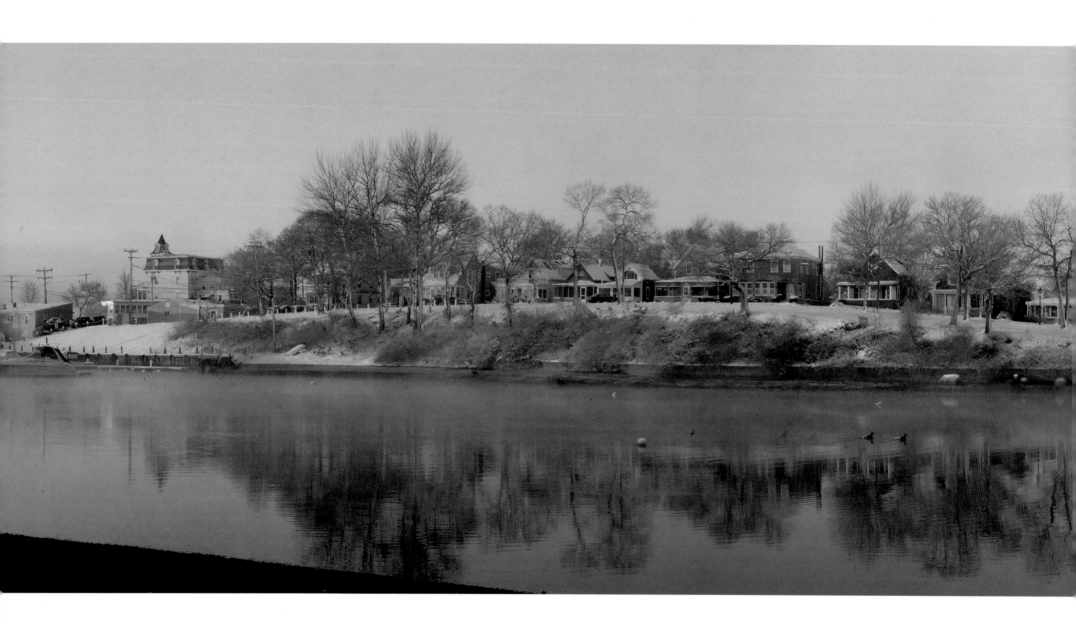

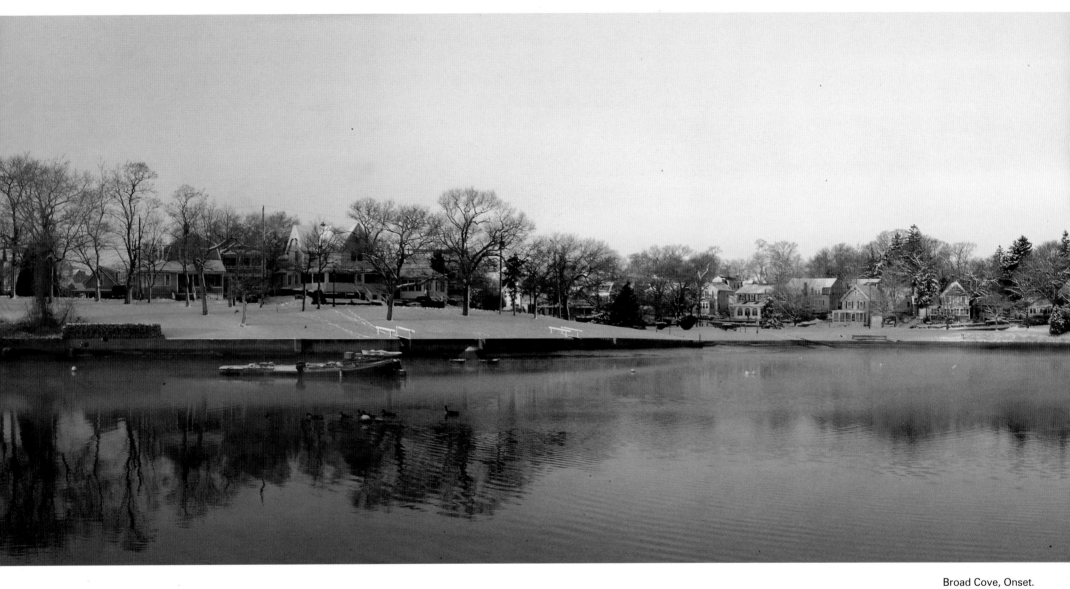

Broad Cove, Onset.

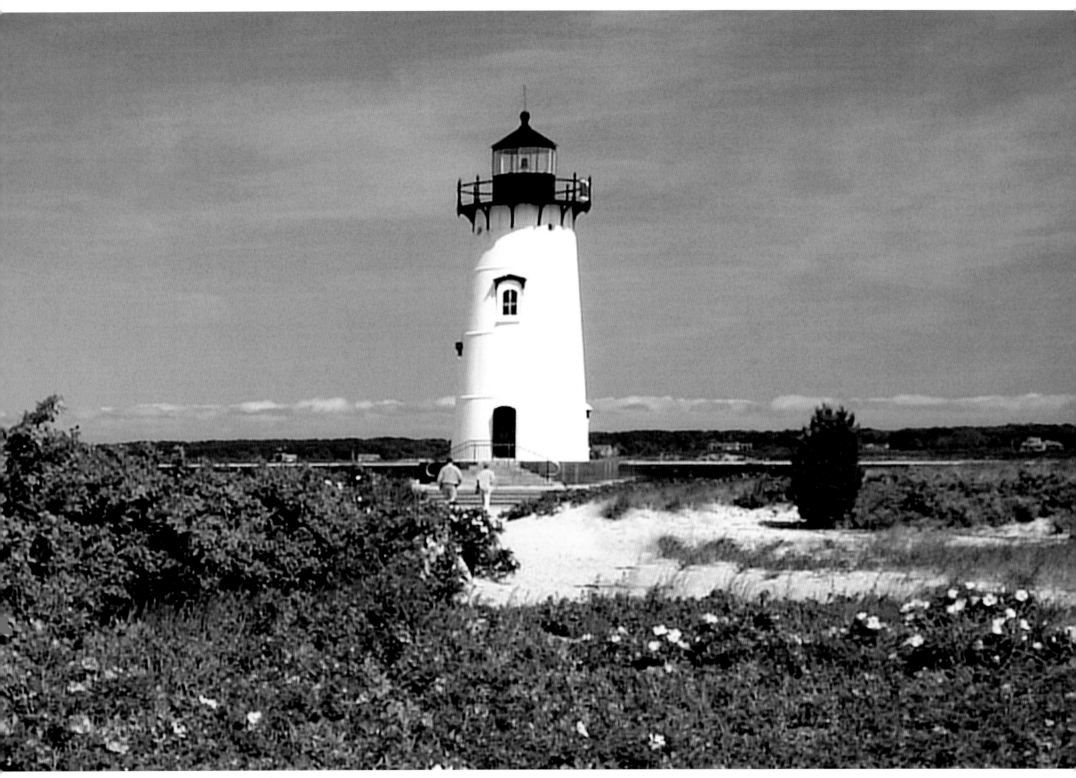

Edgartown Light, Martha's Vineyard.

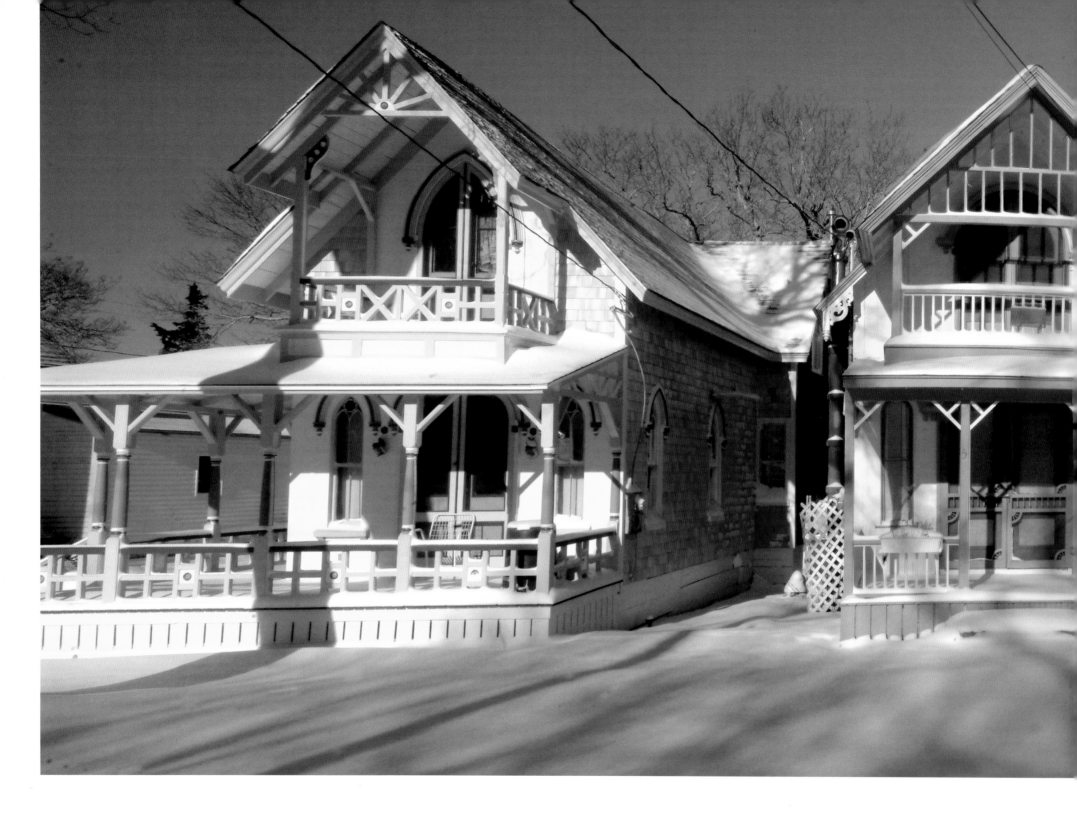

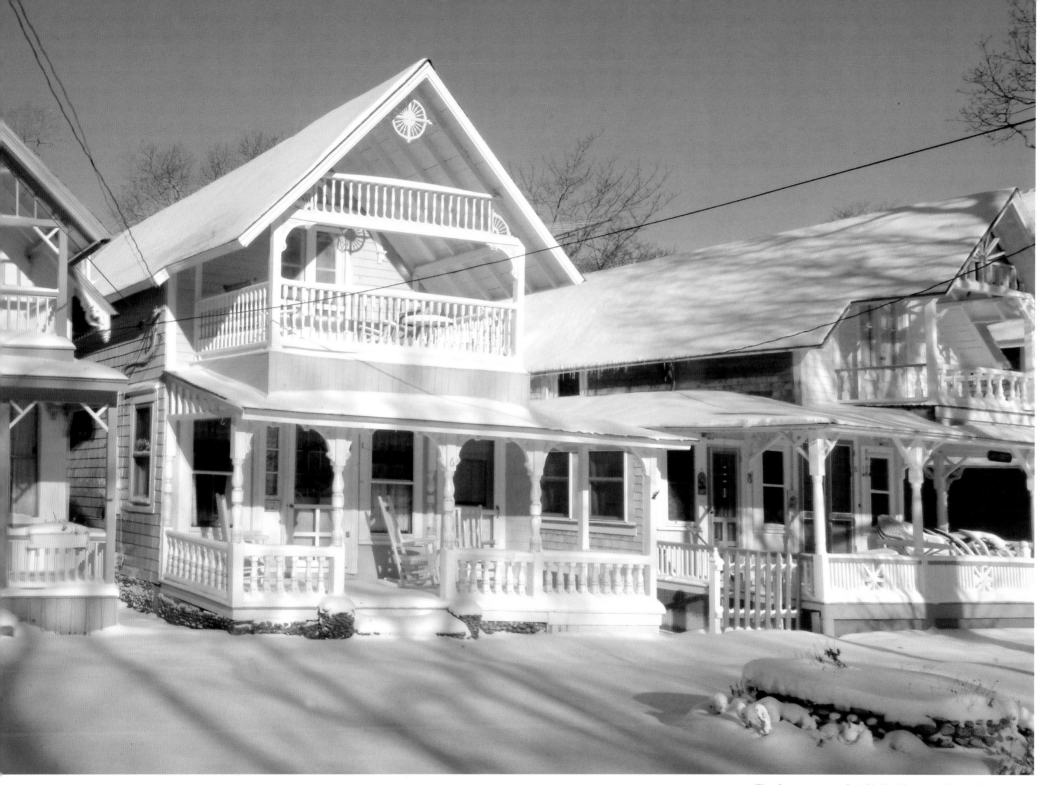

The Campground, Oak Bluffs, Martha's Vineyard, in winter.

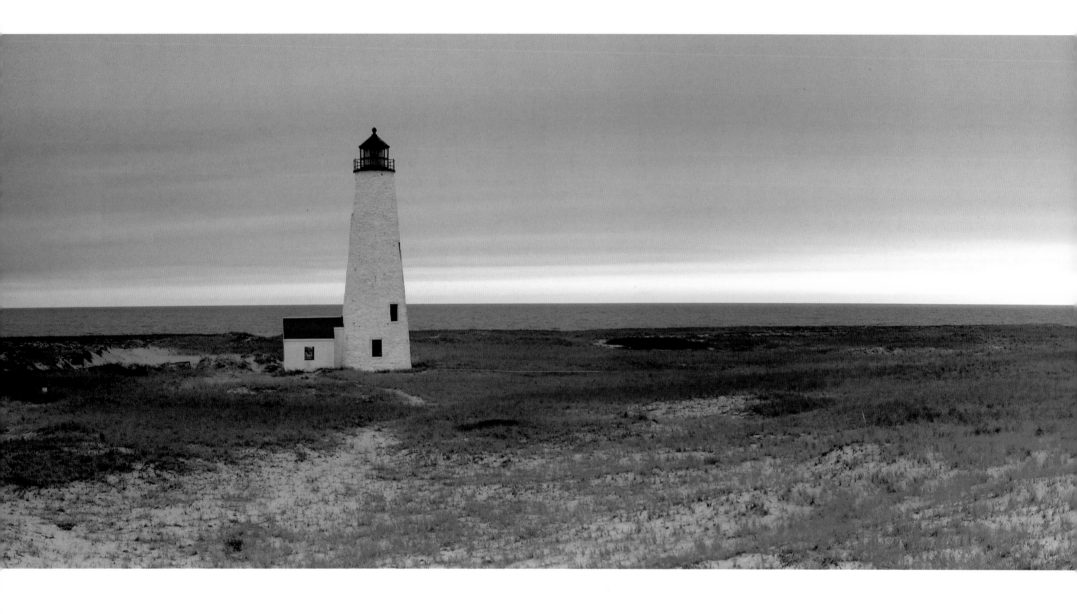

Notes from the Author and Photographer

Arthur Richmond

This book is a product of the digital revolution in photography. It is also the result of computer technology and the ability to process images using dedicated software. The effect of this technology is that we are able to collect images and process them in a way not even considered in the traditional darkroom. For many years, my cameras were 35mm Nikons; I then progressed to medium format using a Pentax 6x7 and a Fuji 6x9. Even using wide-angle lenses, I was not able to capture the scope of a scene that I saw. What I wanted to shoot is what I perceived, what we now refer to as a panorama. I was not interested in shooting a 360-degree image simply because that is not what I observed. My goal in panoramic photography is to depict on paper an image that I perceived and shot just as I observed it. As a full time teacher and part time photographer, I was never able to justify the purchase of a true panoramic film camera, based not only on the cost of its purchase, but also on the frequency that it would be used in my work. All the images in this book were shot with a professional digital SLR camera. The files were then saved to a computer, a panorama was constructed with a stitching program, and the final image was tweaked in photo-editing software. The files were then printed in the desired size on archival paper at a custom lab. The title of this book is a reference to the wide perspective seen in each image. This book will explain how I created these panoramas and hopefully help you to expand your photographic abilities.

The History of Panoramic Photography

Welcome to the world of digital panoramic photography. Explore the possibilities of shooting wide vistas you never thought possible. Expand your picture taking abilities to capture the scenes you see, as I have on beautiful Cape Cod. The potential to shoot and produce outstanding panoramas is now available to any serious photographer who wants to discover an innovative realm of digital photography. It is believed that almost 70% of all sensory receptors in the human body are associated with the eye and vision, so it is extremely important that you learn to see. Not as simple as it sounds, the ability to perceive and process is more important than the equipment you have. All images in this book are mine and were shot with a Fuji (S1, S2, and S3) digital professional camera. This book does not discuss or explain basic photographic techniques. There are numerous volumes available on the subject for the interested photographer. This book does not discuss panoramic film cameras; rather the intention is to explain one potential of the digital revolution: to produce exceptional panoramas.

Great Point Light, Nantucket.

The first panorama was not a photograph but a work of art by Irish painter Robert Barker. He painted Edinburgh, Scotland, on a vertical, circular surface (one actually sat inside the artwork), which was shown in London in 1792 and titled "The Panorama." Numerous other artists painted cities across Europe using the same technique, and these paintings were immensely popular. In America, probably the best-known panorama is the Cyclorama in Atlanta, Georgia, which measures 42 feet high and 358 feet wide and depicts the Civil War battle of Atlanta. Originally displayed in Detroit in 1887, the panorama was part of a traveling circus that went bankrupt while in Atlanta. The circus animals became the basis for the Atlanta Zoo, and the Cyclorama, near the zoo, is still open to visitors. With the development of photography, panoramic paintings no longer held their appeal and fascination.

The history of photography is important to understanding not only the taking and processing of traditional pictures but also the development of panoramas. Even in ancient times, camera obscuras were used to form images on walls in darkened rooms. It was not until 1727 that Professor J. Schulze, through a serendipitous accident created the first photosensitive compound. He was working with nitric acid, silver, and calcium carbonate in a flask when he noticed a darkened area that had been exposed to light. It took another ninety years for Nicephore Niepce to create a permanent image using the camera obscura, but it took as long 30 minutes to expose and create an image. In 1834, Henry Fox Talbot developed a technique to create a permanent negative and then produced a positive using a contact method of printing. He may also have been the first photographer to put more than one frame together to create a panorama. Using silver-plated copper, Louis Daguerre in 1837, was able to create an image in a shorter period of time, which became a daguerreotype after development. By 1851, Frederick Scott Archer had improved the wet plate technique so images could be produced on glass plates with an unlimited number of reprints. Panoramic cameras were being developed that used glass plates and would swing through an arc of up to 120 degrees. Other photographers would take several images and print them side by side with a telltale vertical stripe between the negatives visible on the final print. 150 years ago, panoramic photography was a significant aspect of taking pictures. The first panoramic camera built in 1843 had an 8-inch focal lens that was hand cranked, producing a daguerreotype that was up to 2 feet long. The image had a view of 150 degrees. By 1871, Dr Richard Maddox had created the dry plate process, using gelatin. Images could then be developed relatively quickly with less equipment. George Eastman in 1884 developed

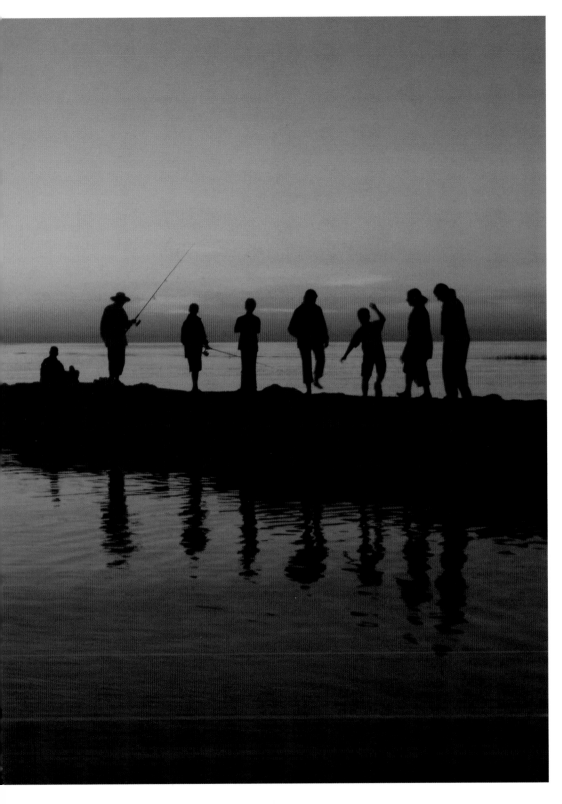

roll film. Four years later, he introduced the Kodak Brownie camera, and everyone could be a photographer. With film, cameras could now be developed to photograph seamless wide vistas previously not possible. Numerous styles and types of panoramic cameras were developed, including flatback (or fixed lens) models, the most common and popular, that produce a wide-angle image with one click of the shutter. The final image is limited to the width of the film that is exposed. Less common are the swing lens models where the lens slit moves from one side of the film to the other. Rotational cameras are the least common type of panoramic camera and require 360 degrees to produce an image. As recently as 1994, panoramic cameras were being introduced that used 120 film to produce 150-degree view with the aid of a rotating lens. Some models of panoramic cameras have cost as much as $70,000 to build. Most serious photographers would explore other ways of creating panoramas.

The first commercial digital camera was produced in the early 1990s, opening a completely new world of panoramic photography to the serious amateur. Now with the development of high-resolution digital SLR cameras with computer-designed lenses, images can now be produced that rival those of traditional panoramic cameras. With the aid of the computer, and specialized software, images can be manipulated to produce unlimited effects. Follow along as I explain the method I use to shoot the panorama, create the panoramic image in a computer, and process the final print.

Shooting the Panorama

If you want to shoot a successful panorama, preparation is of the utmost importance and will pay dividends when you stitch the scene in your computer. Take your time during the middle of the day to scout for prospective vistas that offer possibilities. Allow your creativity to expand because the visual rules and concepts that apply to conventional photography do not apply to panoramic photography. Because you are shooting a wide vista, it is usually not worthwhile to randomly go out and photograph a scene unprepared. Although seeing a panorama takes time and insight, this skill can be developed with practice. There are no rules: allow your imagination and

This view of Rock Harbor taken at high tide and sunset does not provide the photographer with panoramic possibilities as the area to the left is open water and the area to the right behind the jetty is crowded with people. On the other hand, at low tide there are numerous opportunities as can be seen on pages 100-107.

inspiration to be your guide. Principles that you should consider when shooting are foreground interest, leading lines, and dividing the image into thirds both horizontally and vertically. On the lookout for possible sites, scan scenes from side to side rather than focusing on a single dominant subject. As you develop constant awareness of your surroundings, you will soon be taking mental pictures of panoramic possibilities. Just as important as determining what makes a good panorama, it is also imperative that you recognize what subjects and scenes do not have panoramic potential at that time or situation. Compare the image to the left with the Rock Harbor scenes on pages 100-107 and note the difference in tides. On Cape Cod as elsewhere, potential subjects include the beach, harbors, lighthouses, dunes, fields, forests, baseball games, sunrises and sunsets. If you have found a location that you think is suitable, several questions need to be answered before you shoot the panorama.

What is the best time of day?

Since the earth is solar-powered and we receive all our energy from the sun, it is important to know something about the characteristics of this light. Visible light, which makes up only a small portion of the electromagnetic spectrum, is what we see in a rainbow or in a prism. The colors, between infrared and ultra-violet, are red, orange, yellow, green, indigo, blue, and violet; have different wavelengths and frequencies, and what is significant to photographers is to know when the best time is to shoot an image for the light that they want. Most serious photographers avoid the middle of the day, not only for the coolness of the light, but also because the subjects tend to be flat with limited shadows. I prefer the warm golden colors of early morning and late afternoon when the light has to travel further through the atmosphere. The red end of the spectrum with its longer waves is more dominant at these times. Add in particulates found in the air because of human activity and you have the makings of spectacular sunrises and sunsets. Other environmental occurrences such as volcanoes can affect the atmosphere for extended periods of time. If you shoot early in the morning, there is also less chance of having people present in your scenes. More people shoot sunsets than sunrises, probably because they do not like to get out of bed early in the morning, but non-crowded beaches and quiet harbors can produce excellent results. An important aspect of shooting the sun crossing the horizon is to wait until after the sun has set, up to 30 to minutes (or before it rises in the morning). There then might be a glow that will saturate your scene with the warm red colors at that end of the spectrum. An additional benefit is that because the sun is not present, exposure problems are minimized. You should still bracket your

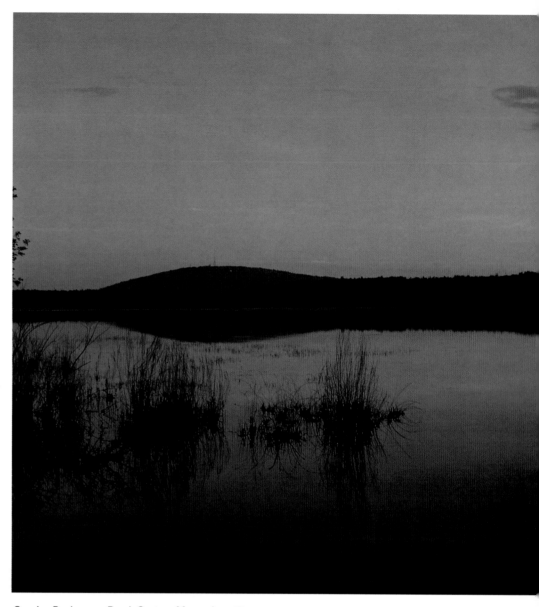

Sunrise Ponkapoag Pond, Canton, Massachusettts

exposures by shooting several stops each way. Many times slightly over-exposed images produce the best results.

What equipment do you need?

First and foremost, is a solid tripod with a level. If you shoot the separate images properly with the horizon straight, there will be very few prob-

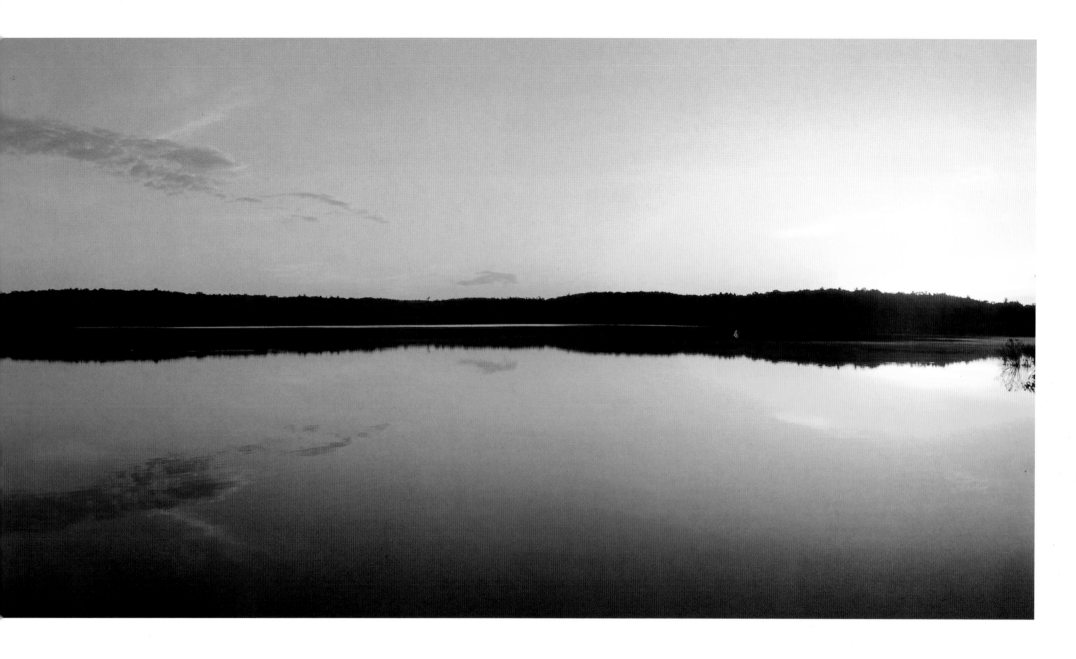

lems when you stitch the panorama. If you are shooting in a marine environment and some of your shots will be in beach sand and mud, a sturdy tripod is a necessity that should be properly maintained. While any digital camera with more than five mega pixels will perform adequately, all the images in this book have been taken with an SLR that allows the photographer to select specific characteristics including pixel dimensions, quality, dynamic range, sharpness and white balance. The camera also allows the photographer to select a variety of lenses and filters.

Panoramas can be taken with any lens but most of the images in this book have been taken with a lens that was between 30mm to 50mm. Try to avoid using super wide-angle lenses as the distortion they create may cause problems when you try to stitch the images together. The one advantage of using a wide-angle lens is that the focus will be constant as you pan through the shots. Telephoto lenses can be used but are not effective for most locations on the Cape. With the ability of modern zooms, these panoramas can be taken with a single lens. Zoom the

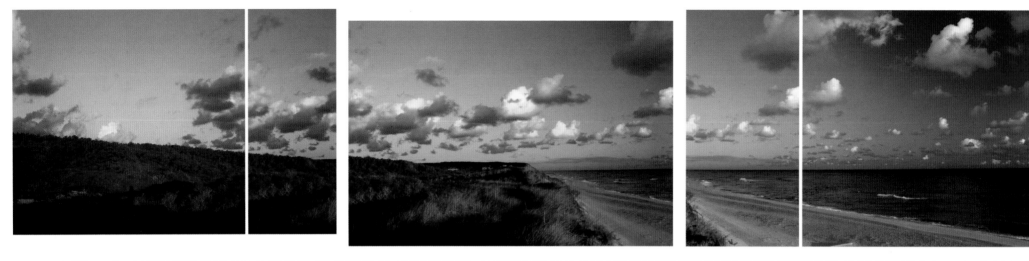

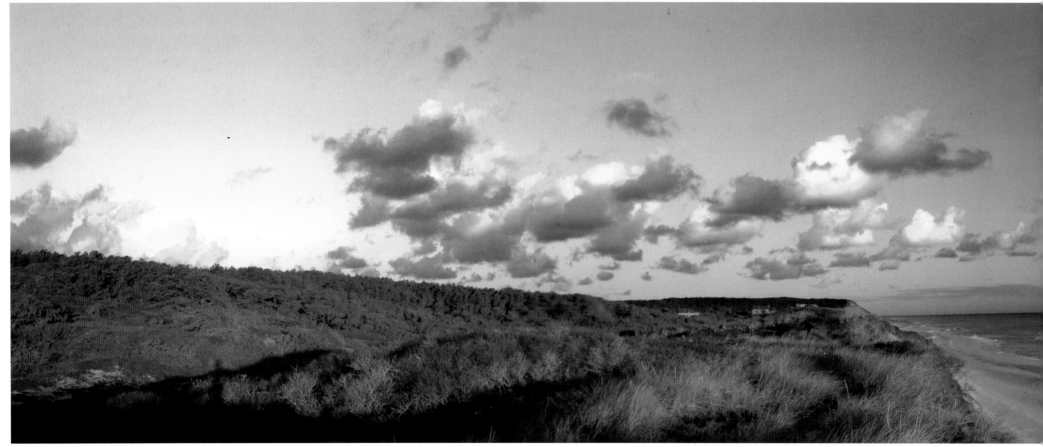

Looking north, the finished panorama of Newcomb Hollow beach in Wellfleet on a fall morning less than an hour after sunrise. After the images were stitched, the panorama was tweaked in Photoshop where minor adjustments were made to the file, and it was then saved as a TIFF document.

Opposite: These three images explain how I shoot a scene: find a stable location for the tripod in the central area. Many times, I will shoot in both directions, but for this example, it will be from dune to sea. Since one needs at least 20% overlap to stitch, the metering ring in the viewfinder of digital SLR's offers a built in gauge to identify landmarks that will coincide from one image to the next. The vertical stripe in the two outside images indicates the overlap that is present in the center image. Practice shooting the scene to determine if you want more dune or more water or even how may frames you may want to include in the panorama. Once you have decided, shoot the first image and rotate the camera until a position that represents the required overlap allows you to shoot the next image in the sequence. Continue shooting until you have completed the frames you require for your panorama. Notice the right image with the distinctive cloud that is a good point for identifying overlap. Another issue that requires attention is the differences that can occur in exposure from one end to the other end of the panorama. If you are shooting in automatic mode, the results may be mixed and not what you expected. I usually shoot in manual mode and alter exposure controls as needed. Depending on the subject, most images are shot at 1/60 sec and the f-stop increased or decreased as the pan moves from one side to the other. The left image was almost three stops different (in this case less light available) from the right image. Stitching software will try to blend the images so there is no exposure gradation in the final pan. but why not attempt to shoot the original files for proper light levels so there will be less difficulties in the computer process.

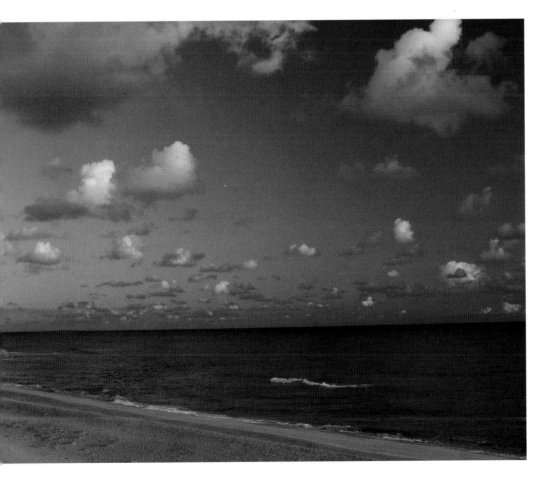

lens so that the subject of the panorama fits the frame to your prerogative. A basic UV/haze filter should be used to protect the lens. Polarizing filters should be used with caution as the greatest effect maybe between frames in your final image. If you shoot with the sun at your back, the polarizer may not be a factor. However, if you are interested in adding greater impact to the sky, use Photoshop after you have stitched the panorama and then you can work on the entire image. A cable release is also a useful tool. A panoramic tripod head may also be useful if your shots include both close and distant objects.

How do I shoot the panorama?

Left to right or right to left? It really makes no difference as long as you have adequate overlap in your images. Since you can see your image results immediately, don't hesitate to photograph the scene as much as possible. Examine the images on to the left for more explanation.

What format, resolution should I use?

Since this depends to some extent on the camera being used, the best format is RAW because the file will contain unprocessed image data. In Photoshop, you can then process the image and save it in a variety of formats including TIFF and JPEG. Most stitching software will not work with RAW files so you will have to convert before using. Since you want to produce the best results, shoot at the highest resolution your camera will allow. Familiarize yourself with your camera and its abilities in order to get the best results.

What is aspect ratio?

The ratio between the length of the panorama and its height is referred to as its aspect ratio and is important, as the number of frames you shoot will increase this ratio. Most images in this book are 3:1 and represent about 120 degrees of view. Because our eyes are set side by side in our head, we are able to see stereoscopically or 3-D in a range of about 110 to 120 degrees horizontally. Our peripheral vision may be as great as 170 degrees, but we do not see 3-D at either extreme end. Vertically, we see about 60 degrees. A panorama, by one definition, is a picture that is greater than 100 degrees so these panoramic images are what you would see in a normal stereo view. If you want to create a panorama of what you see, two or three frames will usually cover that range and have a ratio of 3:1.

What if I don't have a tripod?

No problem, if you are going to shot two or three frames, you can get excellent results if you just remember a few things. To successfully stitch the images in the computer, the film plane in the camera must be in the same relation in each successive shot. That is the camera should be perpendicular to the horizon. If you tip the camera up or down, you will have problems. To avoid this, find something to lean against, hold your breath, and carefully try to minimize camera motion as you shoot. Or if possible sit down, put your elbows on your knees, hold your breath and shoot. Then shoot, some more, if it has the potential to be a great panorama, you can always take the time to manually stitch the images.

CREATING THE PANORAMA

Now that you have photographed the scene and selected the images that you think will produce the best results, it is time to load them into the computer and using dedicated software stitch the files together to create a panorama. The product is sometimes referred to as segmented panorama because it consists of several frames that have been linked together rather than a panorama that is the result of camera using film. Many digital cameras now include in their software the ability to produce panoramas and there are also several stand-alone programs that can be used to stitch images. If you are a serious digital photographer, you probably have Photoshop (either CS2 or Elements) on your computer and that can be used to produce outstanding panoramas. Whatever method or software you choose, the most important factor in producing the panorama is the quality of the files that you are going to use. In addition, it is essential that your computer be capable of performing the tasks required in stitching-speed and memory is of the essence. A typical panorama in this book is a 200MB file at 400DPI in the TIFF format. It is also CMYK rather than RGB because of publishing parameters and requirements. Although you probably will not be using files that large, it is very easy to quickly build up a significant amount of stored memory.

The program I have used and found to be fast, simple and very efficient is Panorama Factory. A trial program can be downloaded off the Internet (www.panoramafactory.com) to practice creating panoramas. Other programs for stitching files are also available on the Internet as shareware. Panorama Factory is very compatible with Photoshop and makes creating the panorama a relatively straightforward process. There are two methods in the program to create panoramas; the first is the wizard interface that is the easiest and the second is the classic interface where you have more control. If the images were taken properly, the Wizard produces excellent results in which I have outlined the basic steps in the process. In the Wizard interface, there are seven steps to construct the panorama:

STEP ONE: Import the images making sure they are orientated from left to right. If there are any difficulties, you can rotate files, reverse order, and add or delete images. Radio buttons with light bulbs at each step provide help and assistance. Relevant information is easily provided in each step. After you have finished, simply click the next button to go to the subsequent step. One advantage of the program is that if you have a problem at any step; simply hit the back button to return to the previous step

STEP TWO: Choose the stitching method of which there are three: fully automatic if the images were taken with a tripod and camera movement (pitch and roll) was negligible; semi-automatic if there was slight camera movement; and manual for the greatest amount of tilt in the files. The last method is the most time consuming. There is also an option to stitch scanned documents.

STEP THREE: Describe the camera used to shoot the images. Identify camera type, make, and model. You are also asked to automatically detect focal length, correct barrel distortion, and correct brightness falloff.

STEP FOUR: Control image quality by automatically fine-tuning, exposure matching and correction, and sharpening the final image. The final image can also be made lighter or darker.

STEP FIVE: Select the panorama type by output format and then if you want a partial or 360 degree image. Most of the images in this book are perspective projection but there is also the option for spherical or cylindrical projection.

Step Six: Create the panorama by determining if it is for the internet or for printing and resolution, printed width or height. By pressing the next button, you will create a panorama.

Step Seven: Save and print the panorama document page gives you a variety of options to save the final image, save the project, page set-up and print choices. I usually save the final image only in a TIFF format and then use Pho-

toshop to tweak the panorama. Since I have saved the original images, I usually don't save the entire project because it increases the number and size of files.

The program, if the images were taken properly, creates quality panoramas very quickly. More time can be spent doing it manually but may not be necessary.

PROCESSING, PRINTING & PRESENTING THE PANORAMA

Now that you have created and saved your panorama, the file has to be fine-tuned and tweaked to produce the final image. The best program to do that is Photoshop, where there are unlimited possibilities to manipulate the saved file. Because no camera can capture the range of light that we are able to see with our eyes, it is necessary to restore that optimum color. Nothing has been done to the images in this book that were not present when the original files were captured. I have tried to create an image on paper as it actually occurred at that point in time. In Photoshop, the most common tools used are image adjustments, with curves, levels, shadow/highlight and hue/saturation the most useful. The clone tool is used to remove distracting artifacts. The final step in making the panorama is the smart sharpen filter to enhance the edges. There are numerous publications, including books, magazines, and the internet that explain Photoshop techniques and photo management. If you want to do something in Photoshop, it is probably written somewhere. In addition, there are usually several different methods or ways to solve the same problem. After you have finished and need to save the panorama, several options should be considered. First, the file should be saved in the size you want to make the final print. For archival purposes, the file should be saved as a TIFF and maintained as a permanent copy. If the file is to be published,

it should be saved as a CMYK file at a higher than normal resolution (400 dpi). If you are going to use your own printer, the file should be saved to meet those parameters. If you are going to have a panorama printed at a custom lab, the file should be saved as a JPEG at 300 dpi. In addition, if you are going to save it for the web, the file should be significantly smaller.

Before you print the panorama, you have to decide what size you want the final image to be. All the panoramas in this book are a minimum of ten by thirty inches print size and are sent to a custom lab for printing. Natural Color Lab (www.naturalcolorlab.com) is able to print a panorama as high as 32 inches and up to 120 inches long. The panorama is printed on Fuji crystal archival paper and will not have a noticeable color change for over 80 years. The lab also provides assistance on a variety of digital processes as well as conducting seminars geared for the photographer. I have had several panoramas printed at larger sizes, one of which was 20" by 60". After printing, the panorama is then dry mounted in a vacuum press so that it will not bubble or wrinkle.

After you have the final print, it is essential that you decide how to show off the panorama. Since the emphasis should be on the print and not on the mat and frame, I have found that it is best to use neutral colors. The mat should be acid-free and two to four inches around the print. It is best to visit a framing store to select mats so that you get the best color match for the print. The frame should not detract from the image and many choices are available on the Internet. If your panorama is large, Plexiglas is an option instead of glass, which is heavier. If you are going to print several panoramas, try to keep them in the same aspect ratio so the mats and frames will be the same size. For my 10x30 prints, the final framed panorama measures 16 by 38 inches.

Now that you can create your own panoramas, family and friends can share the joy in receiving them as presents.

VERTICAL PANORAMAS

Vertical compositions require slightly more preparation than horizontal compositions because we don't tend to see up and down. Our normal range of vision is 60 degrees in the vertical range, so anything more than that is unusual. It is still possible to produce interesting panoramas that consist of two or three frames. On the other hand, if you were in a remarkable forest you could produce a 180-degree panorama from one horizon through the canopy to the other horizon. There are also difficulties in shooting vertically as the tripod may be level in reference to the ground in a typical horizontal panorama but moving the camera in a vertical plane requires the film plane to maintain its perspective in relation to each successive frame. The following image and that on page 208 are made of two frames and were photographed on Cape Cod.

Another interesting possibility is to create a horizontal panorama with images that are shot vertically with the camera and then stitched together. Because a 35 mm frame is about one third greater in the horizontal aspect, if you shoot the camera in the vertical position, you gain that amount in the top to bottom dimension. You also will require more frames to produce a panorama. However, what you see, in this format is probably more accurate in terms of visual representation. No matter how you prefer to shoot your panoramas, remember there are no rules so just expand your creativity.

Left: Meeting House Pond, Orleans, seen horizontally on pages 96-97.
Right: Spectacle Pond, Wellfleet.

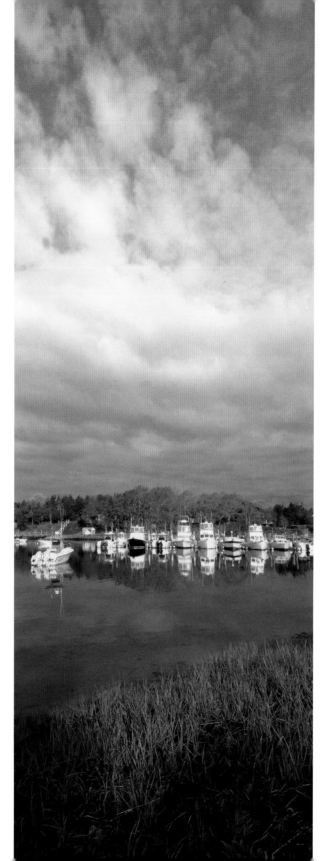

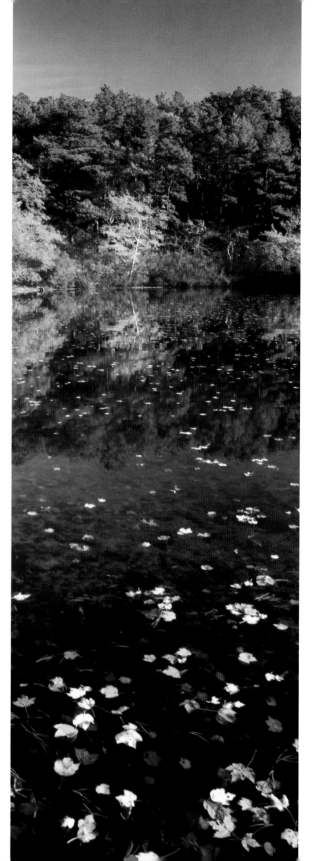

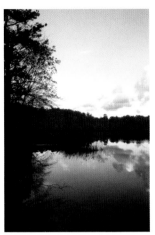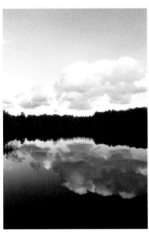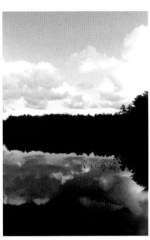

When shooting panoramas in the traditional method, the camera is mounted horizontally on a tripod and the CCD/CMOS (film plane) is perpendicular to the horizon. When shooting vertically it is important to avoid camera motion relative to the CCD. Shot vertically, these are the three frames that make up the panorama, left, center, and right. When shooting this type of panorama, it is extremely important that the camera film plane maintain proper perspective and there is sufficient overlap to stitch the frames together. After stitching, the aspect ratio of the panorama will change because of the difference between the horizontal and vertical dimensions of the film frame.

The completed panorama is composed of three frames. In this example, the aspect ratio is 2:1, because the difference in frame size is vertical not horizontal.

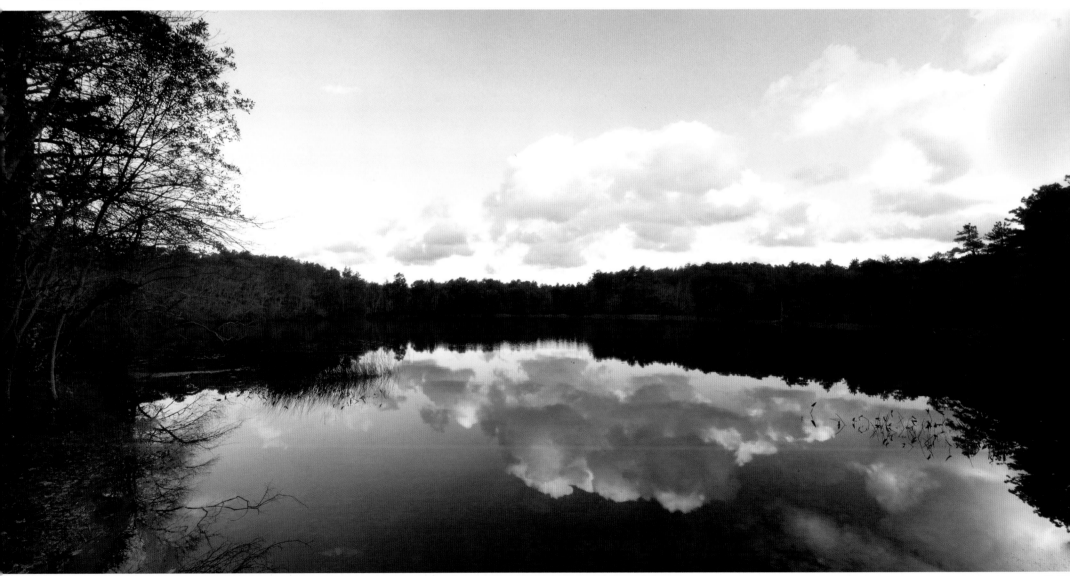

Off Cape

Although this book is primarily panoramas of Cape Cod, the techniques used can be successfully applied anywhere else. The photographer only needs to follow the basic principles shown in these images: make sure there is foreground interest, divide the image into thirds both horizontally and vertically, and try to capture the mood of the environment. Once you learn to visualize panoramas, you will be seeing them without even thinking about it. In addition, you can view a scene and determine that a successful panorama is not possible. Just think that with a little practice, you will be able to capture panoramas no matter where you are. Because we tend to see in the panorama format, images will be available that you never thought possible. Examine the following images and determine if these panoramas meet those requirements.

Conclusion

I have found it interesting and a pleasure to do this book on panoramic photography. At craft and art shows and at galleries, I have sold photographs for over 30 years and have always tried to shoot images that people can hang on the wall with enjoyment and happiness. I have never found more positive comments than those regarding my panoramas. I have tried to capture a point in time that individuals can respond to in their own significant way. I will always remember the young woman who looked at the image of Duck Pond on pages 40 and 41 and exclaimed in a not too subtle voice, "Oh my gosh, I have to have it, that's where I got engaged!" Or the numerous individuals who have ordered larger sizes to fit on a certain wall so they can look out a pseudo-window to see a favorite vista.

Expand your horizons and not only enjoy these images but also, develop your talents to create your own panoramas.

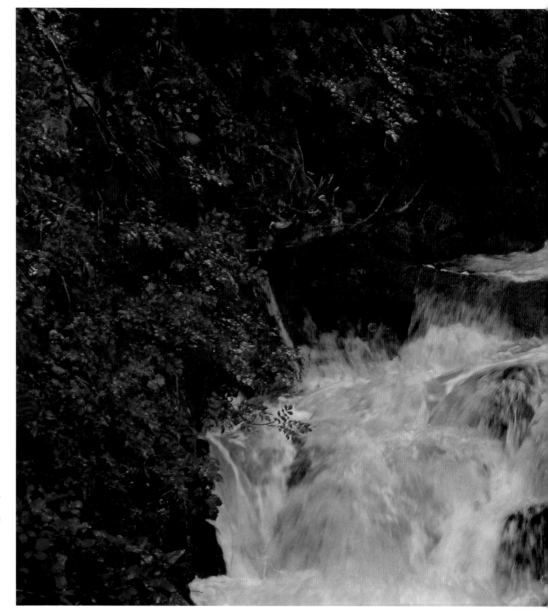

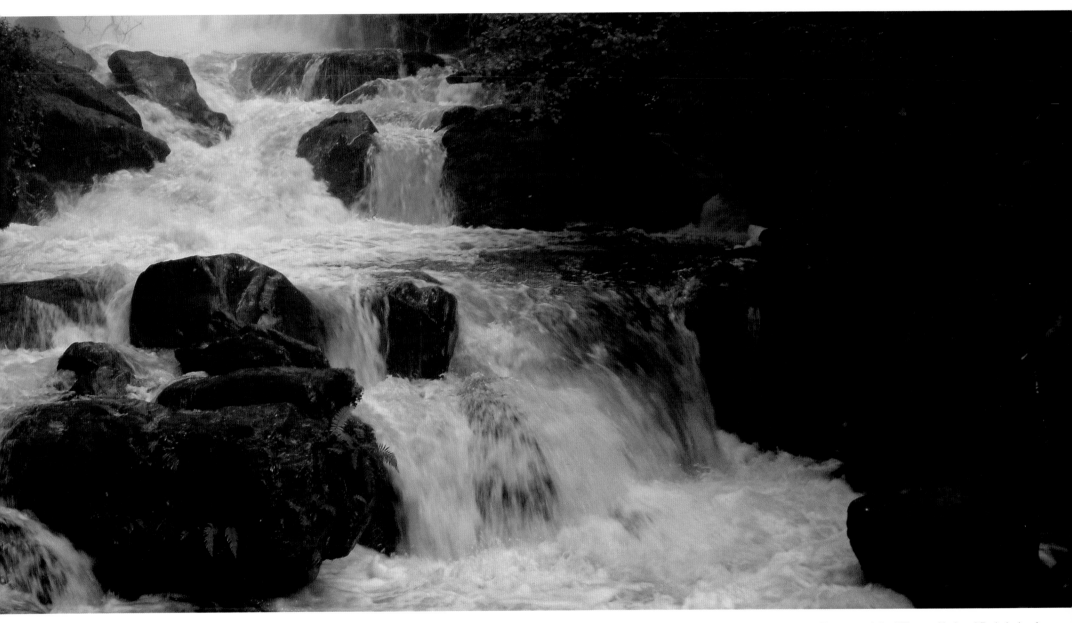

Torc waterfalls, Killarney National Park, Ireland

TECHNICAL COMMENTARY & INDEX TO THE PHOTOGRAPHS

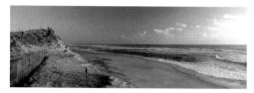

Page 1. Newcomb Hollow Beach in the winter, compare this to the image on pages 194-195.

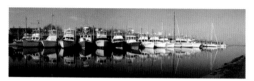

Pages 2-3. Charter boats at Rock Harbor. This shot was taken mid morning at low tide.

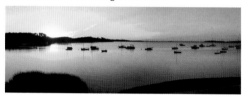

Pages 4-5. Pleasant Bay, Orleans, just after sunrise.

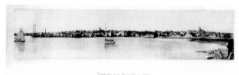

Page 6. This panorama by Henry Sherman Wyer, titled "Nantucket from Brant Point 1895," was printed on a silver printing-out paper and measures 4.5 by 21 inches. This image is one of almost four thousand found in the Panoramic Photograph Collection at the Library of Congress that covers American activities from as early as 1851. Providing an overview of our history, panoramas depicting our cities, landscapes and historical past are important parts that are present in this collection. In looking at this photograph that is over one hundred years old, several basic tenets are present that make it a classic panoramic image. On the right, a dory rests in the sand giving a depth of field and perspective to the image; two sailboats are present creating a visual bridge to the background and the town, and the land area is almost equidistant between the sea and the sky, dividing the scene into thirds. (Courtesy Library of Congress- pan 199300606/PP)

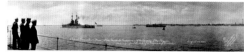

Page 7. The next two images, also from the Library of Congress Panoramic Photograph Collection, were taken in August 1920 in Provincetown Harbor. This panorama, which is a silver gelatin print-measuring 8 by 38 inches, was photographed by Pendleton & Owens of Providence, R. I. on August 29, 1920. Historical information was written on the image: "Visiting ships at Provincetown, Ma, Three Hundredth Anniversary of the Landing of the Pilgrims; photo taken from the English ship 'Constance', August 29, 1920." The photographer had four sailors stand on the deck of the ship to add foreground interest to the image, which is still able to capture most of the harbor. The tower at the right rear is the Pilgrim Monument, built to commemorate the landing of the Pilgrims. Completed in 1910 and dedicated by President William Howard Taft, the cornerstone had been laid by President Theodore Roosevelt in 1907. (Courtesy Library of Congress-pan 1993003921/PP)

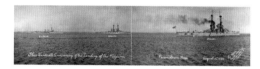

Page 7. This second panorama also by Pendleton and Owens is a significant historical document because it shows the ships present for the anniversary, but it lacks the impact and interest of the previous two panoramas. The characteristic vertical stripe is present in the panorama that indicates that two negatives were used to produce the final image. The writing on this image is important in that it shows the ships present and the magnitude of the event. (Courtesy of Library of Congress pan-1993003920/PP)

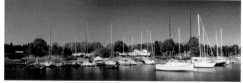

Pages 8-9. Most photographers can look at their images and can describe the circumstances under which the photo was taken. This panorama of Bucky's Boatyard on the Pocasset River was one of my first attempts and it consists of three separate pictures that have been stitched together. You

can shoot the images from left to right or right to left; most people; because we read from left to right probably prefer the former. Which way was this pan shot? Examine the image to find clues that this is not really a static picture. Did you see the rowboat as it moved from the left image to the center image and then was hidden in the right image?

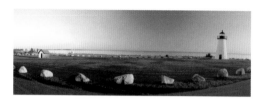

Pages 10-11. Another question photographers have to decide is when is the best time to shoot a panorama at a specific location. On the Cape, in addition to the movement of the sun, tidal conditions must be considered, as well as what environmental conditions would work best. In addition, do you want to have any human interaction? This and the next two pans were taken at Ned's Point Lighthouse in Mattapoisett within a short time of one another. This first image taken in mid afternoon is a nice historical shot of the lighthouse, the oil house, and Buzzard's Bay and Cape Cod beyond. The boulders provide an arc that encloses the buildings and adds foreground interest.

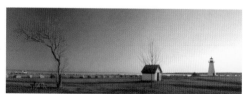

Pages 12-13. This second image taken later in the day just before sunset with its slightly different light spectrum has a different hue. The boulders create a leading line, which ends at the lighthouse. Built in 1888 and with a height of 39', Ned's Point was decommissioned by the Coast Guard in 1952 and purchased by the town in 1958. The light was reactivated in 1961 and is now the focal point of this park.

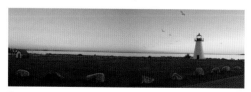

Pages 14-15. With the last rays of sunlight striking

one boulder and the lighthouse, this view, very similar to the first, is very different in the way that it is perceived. With the light on and the herring gulls in motion, this panorama imparts a different perspective and evokes a feeling of tranquility.

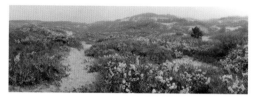

Pages 16-17. In late spring, beach plums bloom in the dunes. This panorama was taken at the end of the bike trail in Provincetown near Herring Cove beach. Ubiquitous and known for its jelly, *Prunus maritimus* is rarely found in such profusion, making this panorama unique.

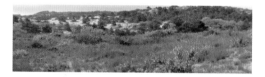

Page 17. Also blooming in the spring, are scotch broom with their small yellow flowers. Shot right next to the road, the dunes extend to Race Point Light and Massachusetts Bay beyond.

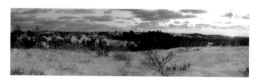

Pages 18-19. Compare this image with the previous one. Many locations that are successful in one season may also produce interesting panoramas at other times of the year.

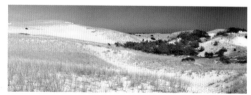

Pages 20-21. This image, made of two files, doesn't convey the vastness and solitude of the same area. Although you would not be able to see it in its entirety, a 360-degree panorama would allow you to visualize the vastness.

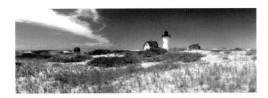

Page 21. The northernmost light house on Cape Cod, Race Point, named for the way the waters raced past this area, is situated in the dunes and guides mariners into Provincetown Harbor. Numerous compositions can be produced that show the lighthouse in a variety of settings. In this distant scene, the oil house is to the left, the keeper's house, available for summer rental, is next to the lighthouse, and a marine science education center is on the right. Does the cloud bring your eyes towards the lighthouse?

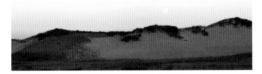

Pages 22-23. With the last rays of the sun still shining on the dunes, the moonrise can be seen in the distance.

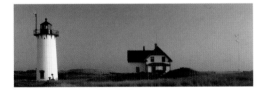

Pages 24-25. This view of Race Point Light and the keeper's house was taken at sunset and shows greater detail than the previous image. Trying to photograph the light before the sun went down, I had to include people getting into the vehicle. I could have tweaked them out on the computer; but they do not distract from the picture.

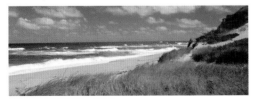

Pages 26-27. Probably one of the best beaches to shoot surf and dunes on Cape Cod is Head of the Meadow in Truro. The dunes are low, the water can reach the beach grass, and it's right next to the parking lot. After a storm, check the time for high tide and try to arrive at least an hour before. When shooting the panorama, try to time the surf so it is in the same position; even if it is not exactly the same, the rough water will mask any overlapping ghosts.

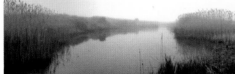

Pages 28-29. This foggy morning creek leads into Pilgrim Lake on the Truro/Provincetown line.

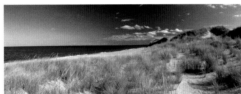

Pages 30-31. Dunes and the beach offer many opportunities for panoramas.

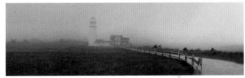

Pages 32-33. Highland Light, like Race Point, allows one to photograph the scene from almost 360 degrees. With the ocean at my back, the fence guides the viewer to the light.

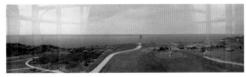

Page 33. Highland Lighthouse is open to the public, and 69 steps lead to the lantern room where this panorama was taken. Originally shot as multiple single images with a super wide-angle lens, this shot needed manual stitching to produce a panorama overlooking the golf course and the Atlantic Ocean.

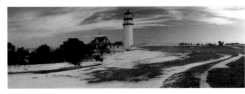

Pages 34-35. Moved in 1996, Highland Light still remains close to the ocean and is an active aid to navigation. In any season, in this case early spring, the light provides excellent opportunities for photographers.

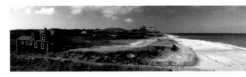

Pages 36-37. Ballston Beach, Truro, looking north. The building in the foreground may have been associated with the life saving station located here. The white building in the background, which is now an environmental education center, was originally a Coast Guard installation.

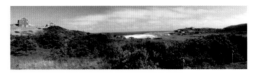

Pages 38-39. Photographed from the old Coast Guard Station, Ballston Beach looking south.

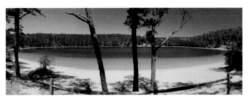

Pages 40-41. Almost a perfect circle, Duck Pond, hidden in the woods in Wellfleet, is a product of the glaciers that formed Cape Cod. Huge blocks of ice remained when the glaciers retreated and formed the numerous kettle ponds.

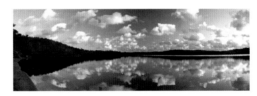

Pages 42-43. Gull Pond is another kettle pond in Wellfleet.

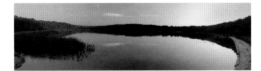

Pages 44-45. Horseleech Pond, Wellfleet, in the early morning.

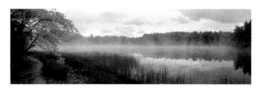

Pages 46-47. In the fall, a morning fog hangs over Snow Pond, Truro.

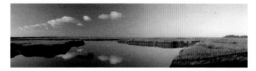

Pages 48-49. Photographed from the Lieutenant Island bridge in Wellfleet, this creek leads into Cape Cod Bay.

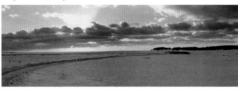

Pages 50-51. The road in this winter scene leads to the bridge where the previous image was captured, with Lieutenant Island in the background.

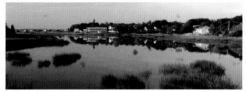

Pages 52-53. Three conditions were required to record this image of Duck Creek: early morning with the sun to the left, high tide, and no wind. Later in the day, you would be shooting into the sun; and with any possible wind and ripples on the water, you would not get the reflections; and at low tide, the area is mud.

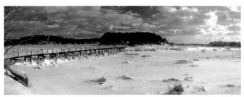

Pages 54-55. Snow covered, the same scene in winter but now I have included Uncle Tim's bridge to provide a leading line into the image. The red art gallery in the previous panorama is in the distance.

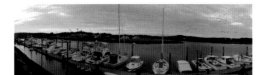

Pages 56-57. Wellfleet Harbor.

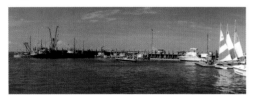

Pages 58-59. Wellfleet Harbor has both commercial craft as well as recreational vessels.

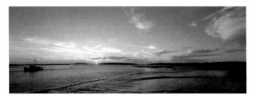

Pages 60-61. At low tide, a dragger returns to harbor while clam diggers work the flats.

Pages 62-63. Sunrise at Marconi Beach. Lens flare can be a problem, but in this instance without the sun present in the picture, it provides a context for the image.

Pages 64-65. A peaceful sunrise on the outer beach.

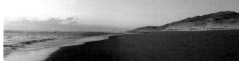

Pages 66-67. Winter storms at Lecount Hollow have swept the beach clean. This was shot from as low as possible withsout getting wet to give this panorama a leading line from bottom left to upper right.

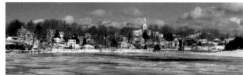

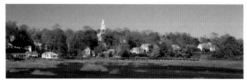

Pages 68-69. Compare these two panoramas taken from almost the same spot, the red art gallery in the image on pages 52 and 53. The winter view, although not having a distinct foreground, is divided into three bands; the ice, the houses, and the sky, and has more visual impact than the fall panorama.

Pages 70-71. Downtown Wellfleet after a storm.

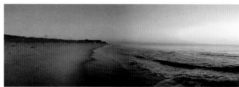

Pages 72-73. Low tide at Coast Guard Beach in Eastham.

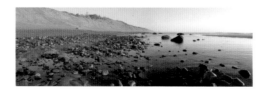

Pages 74-75. Low tide at Nauset Light Beach.

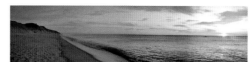

Pages 76-77. High tide at Nauset Light Beach.

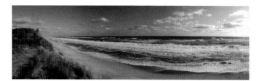

Pages 78-79. High tide at Nauset Light Beach from the top of the dunes.

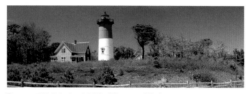

Pages 80-81. In 1996, Nauset Light was moved to its present location before it fell into the sea.

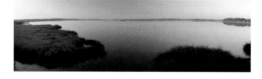

Pages 82-83. Early morning at a Nauset marsh; the air is clear and still. Dawn provides opportunities for tranquil scenes with no ripples on the water.

Pages 84-85. Fort Hill overlooking Nauset marsh on a fall morning.

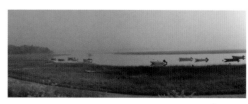

Pages 86-87. Hemmingway Landing, looking out on Nauset Marsh

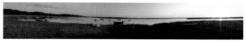

Pages 88-89. This panorama of Hemmingway Landing consists of four frames and includes the sun just rising.

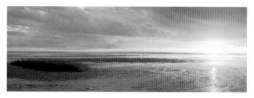

Pages 90-91. Low tide and a bayside sunset. Arrive early, plan your panorama and shoot before the sun sets.

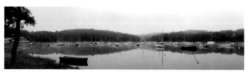

Pages 92-93. Arey's Pond in South Orleans is a safe haven for sailboats.

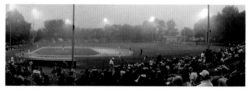

Pages 94-95. The Orleans Cardinals play in the ten team Cape Cod Baseball League. Eldridge Park is one of the premier amateur baseball fields in America. Shooting as fast as possible, try to capture the scene with little movement from the fans to prevent ghosting during stitching.

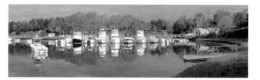

Pages 96-97. Meeting House Pond, East Orleans. Compare this horizontal panorama to the one on page 198.

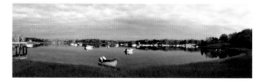

Page 97. Meeting House Pond, East Orleans, from a different perspective.

Pages 98-99. Skaket Beach, Orleans. Early morning and this popular beach is unoccupied except for the photographer.

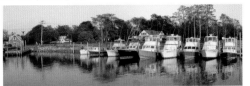

Pages 100-101. Rock Harbor at the inside elbow of Cape Cod, is without a doubt one of the most popular photographic spots to visit. There are opportunities for the photographer almost all day long. Check the tide tables and plan your activities accordingly. At low tide, you can explore the mud flats and surrounding areas. This view of some of the charter boats was taken before the sun went behind a dune. The golden glow highlights the boats and the restaurant beyond.

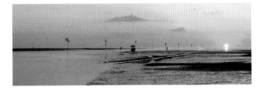

Pages 102-103. Low tide at Rock Harbor and this boater missed the tide. This panorama would not have had the impact without the stranded boat and boater. The channel outside the harbor is marked with trees to guide the charter boats. The best time to photograph the area is at sunset at low tide. There are numerous possibilities and a variety of compositions because every sunset is different. During the summer, you can also enjoy a local steel band that provides music to celebrate the setting sun.

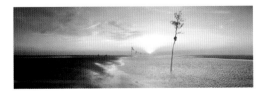

Pages 104-105. The row of trees marking the channel can be seen leading into deep water. It is not unusual to find traffic signs nailed to the trees.

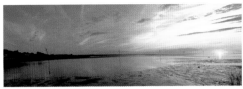

Pages 106-107. Another panorama of Rock Harbor showing the land and houses to the left.

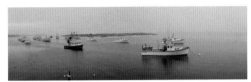

Pages 108-109. Aunt Lydia's Cove in Chatham is home to a commercial fishing fleet.

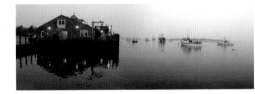

Pages 110-111. The Chatham fishing pier on an early foggy morning. Compare the fishing boats in the previous panorama; on this day, it was an outgoing tide.

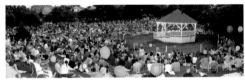

Pages 112-113. On summer Friday nights in Chatham, the band concert attracts families and friends to the musical experience.

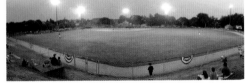

Pages 114-115. Veteran's Field is the home park of the Chatham A's in the Cape Cod Baseball League.

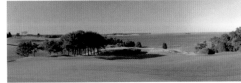

Pages 116-117. Eastward Ho golf course overlooks Pleasant Bay in Chatham.

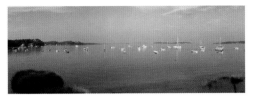

Pages 118-119. Pleasant Bay, Orleans, on a peaceful late afternoon.

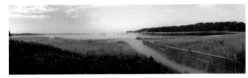

Pages 120-111 Also on Pleasant Bay, this path leads to the beach.

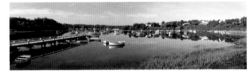

Pages 122-123. Mill Pond in Chatham.

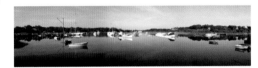

Pages 124-125. Another panorama of Mill Pond.

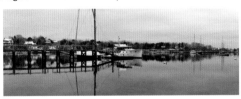

Pages 126-127. Mill Pond in the winter.

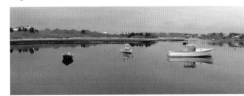

Page 127. Stage Harbor in winter.

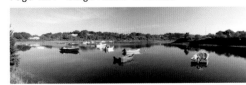

Pages 128-129. Stage Harbor, Chatham.

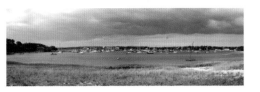

Pages 134-135. As an approaching storm moves into Stage Harbor, clammers dig for shellfish.

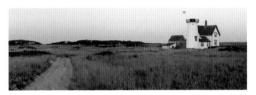

Pages 132-133. No longer active, Stage Harbor Light used to guide mariners into the harbor.

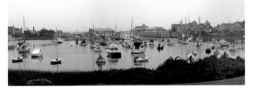

Pages 134-135. Harwichport has three harbors and the most photographed is this one, Wychmere. A viewing area and a small park permit access to this vista. Facing south in this panorama, the best opportunities to photograph are early morning and late afternoon.

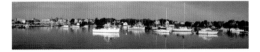

Pages 136-137. This pan of Wychmere was taken near the commercial fishing dock on the east side of the harbor. Compare the location of the buildings in the previous picture. Images can also be captured on the west side of the harbor.

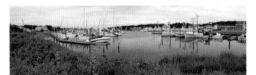

Page 138. Allen Harbor is also in Harwichport.

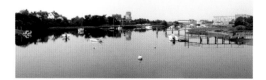

Pages 138-139. A bridge crosses the Swan River in Dennis, and this is the view south.

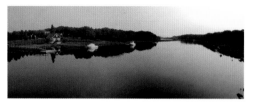

Pages 140-141. Swan River looking north.

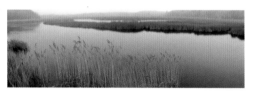

Pages 142-143. Bell's Neck, Harwich.

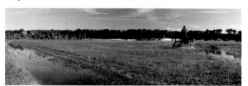

Page 144-145. There are two ways to pick cranberries, dry or wet as seen in this photograph. The fields are flooded in the fall and a machine is used to gently knock the berry off the vine.

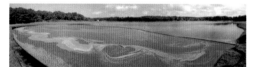

Page 145. On a different bog, the cranberries have been positioned so they can be loaded onto a truck.

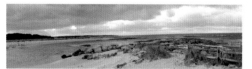

Pages 146-147. Paine's Creek in Brewster.

Pages 148-149. Fields and barn in Barnstable.

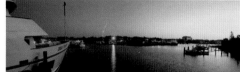

Pages 150-151. Hyannis Harbor just before daybreak.

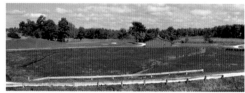

Pages 152-153. Willowbend Golf Course in Mashpee has an active cranberry bog.

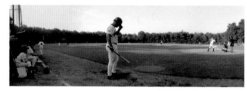

Pages 154-155. The Lowell Field in Cotuit has no lights, so all games are played in the late afternoon.

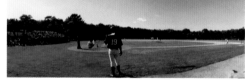

Page 155. The home team bleachers of the Cotuit Kettler's blend with the trees that surround the park.

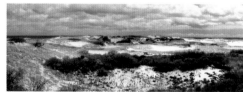

Pages 156-157. The dunes of Sandy Neck, in Barnstable.

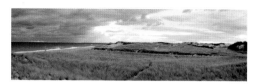

Pages 158-159. Sandy Neck with Cape Cod Bay in the distance.

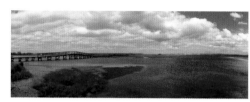

Pages 160-161. The boardwalk in Sandwich.

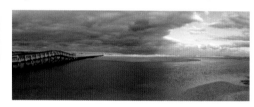

Page 161. High tide is the best time to shoot the boardwalk, and an approaching storm adds impact.

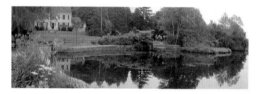

Pages 162-163. Shawme Lake in Sandwich.

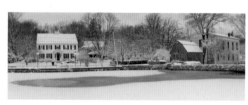

Pages 164-165. Shawme Lake early on a winter morning.

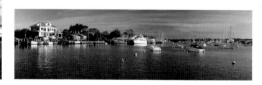

Pages 166-167. Falmouth Harbor.

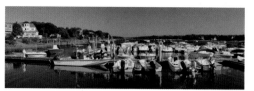

Pages 168-169. Green Harbor, Falmouth.

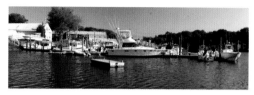

Page 169. Child's River, Falmouth.

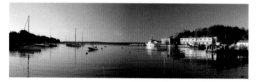

Pages 170-171. Little Harbor, Woods Hole.

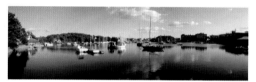

Pages 172-173. Eel Pond, Woods Hole.

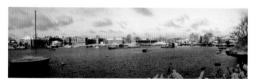

Pages 174-175. Eel Pond in winter.

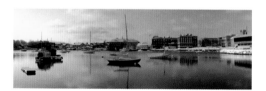

Pages 176-177. The Woods Hole Oceanographic Institute is on the left and the Marine Biological Lab is on the right of this Eel Pond view.

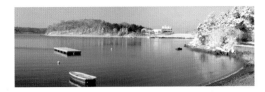

Pages 178-179. Quisset Harbor.

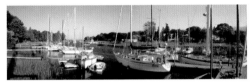

Pages 180-181. Pocasset River, Bourne.

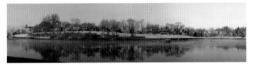

Pages 182-183. Broad Cove, Onset.

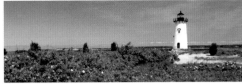

Pages 184-185. Edgartown Light, Martha's Vineyard. Like Race Point Light, this light allows numerous panoramic compositions depending on the time.

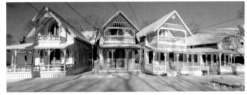

Pages 186-187. The Campground, Oak Bluffs, Martha's Vineyard, in winter.

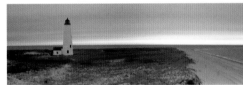

Pages 188-189. Great Point Light, Nantucket.

ACKNOWLEDGMENTS

This book would not have been possible without the aid and assistance of friends and family who have supported me in the search for the next image

To Doug and Jared, who have had numerous adventures with Dad capturing images.

To Tony Pane, for apt guidance and willing participant on many treks.

To Charles Poole of Natural Color Lab, for opening the window to digital photography and always being a resource.

To John Strait of Panorama Factory, for his assistance and guidance.

To all the now anonymous viewers who have expressed their enthusiasm for the panoramas and numerous suggestions for where to shoot more.

To Carol, this book would not have been possible.

Others, some famous, some not, who have been an inspiration and incentive to my photographic career; I would like to thank them for their motivation and encouragement.

To Ansel Adams whose name is synonymous with fine photography; Stanley Baumann who gave me my first job in photography; Eliot Porter who shook my hand and expressed enthusiasm in evaluating some of my images; Rene Houde and Myles Marcus who taught me about learning and teaching; Roger Everett, thanks for opening new doors; The Artisans who have provided support and a format for discussion; and George Smith and Willard Boyle who invented the CCD and opened the world to digital photography.

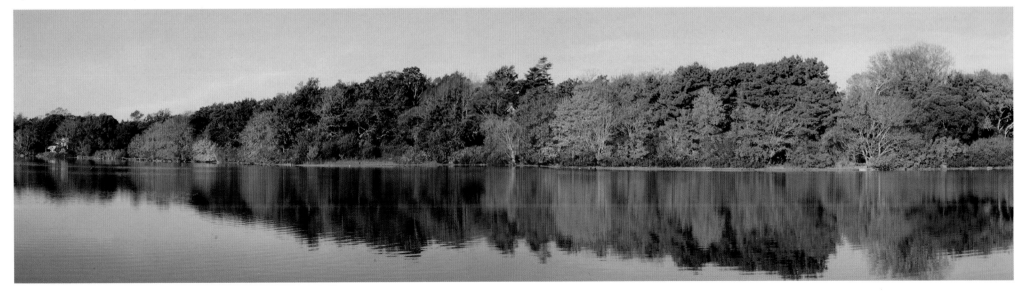

Scargo Lake in autumn.

BIBLIOGRAPHY

Resources for this book not only include traditional manuscripts and publications but also web addresses that provide information and knowledge about the digital revolution.

INTERNET

www.adobe.com Photo-editing software
www.fujifilm.com Digital cameras
www.naturalcolorlab.com Custom printing lab.
www.panoguide.com Web site explaining panoramic photography
www.panphoto.com Web site for international association of panoramic photographers. They also print the magazine, Panorama.
www.panoramafactory.com Photo stitching software.
www.loc.gov Library of Congress with over 4,000 panoramas from mid 1800's to 1951.

BOOKS

Photographers are probably some of the best visual learners. The following books have numerous panoramas for study and evaluation.

Frost, Lee. Panoramic Photography, David & Charles Book, United Kingdom, 2005.

Harmon, Carole. Canadian Rockies Panorama Viewbook Altitude Publishing Ltd, Alberta, Canada. 1989.

Meehan, Joseph. Panoramic Photography Revised and Updated, AMPHOTO BOOKS, New York City.

Meers, Nick. Stretch The World of Panoramic Photography. Rotovision, Switzerland 2003.

Ronck,Ronn. Photographs by Jack Rankin, Bill Lair. Panorama California, Scenic Views of the Golden State. Signature Publishing, Honolulu, Hawaii. 1988.

The following books I have found helpful in learning Photoshop. Many more titles are available that will meet the photographer's requirements. Many books are also updated as newer versions of the software are introduced.

User Guide, Adobe Photoshop CS2, Adobe Systems Inc, 2005.

Classroom in a Book, Adobe Photoshop CS2, Adobe Systems Inc 2005

Gartside, Tim. Digital Night and Low Light Photography, Thomson Course Technology, Boston, MA 2006. An impressive series of books dealing with digital cameras and how to shoot great pictures. This is just one of the title's available from the publisher.

Haynes, Barry; Crumpler, Wendy. Photoshop CS Artistry, Mastering the Digital Image. New Riders Publishing, Berkeley, CA. 2004. This book is used as a text in many Photoshop courses.

Kelby, Scott. The Photoshop CS2 Book for Digital Photographers. New Riders Publishing, Berkeley, CA. 2005 Excellent book that is clear, concise and illustrates step-by-step process to solve numerous problems with images. Also, have sections that deal with Adobe bridge and camera RAW files.

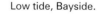

Low tide, Bayside.

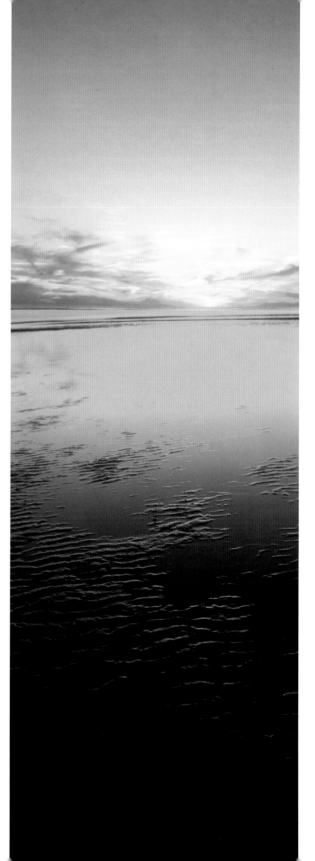

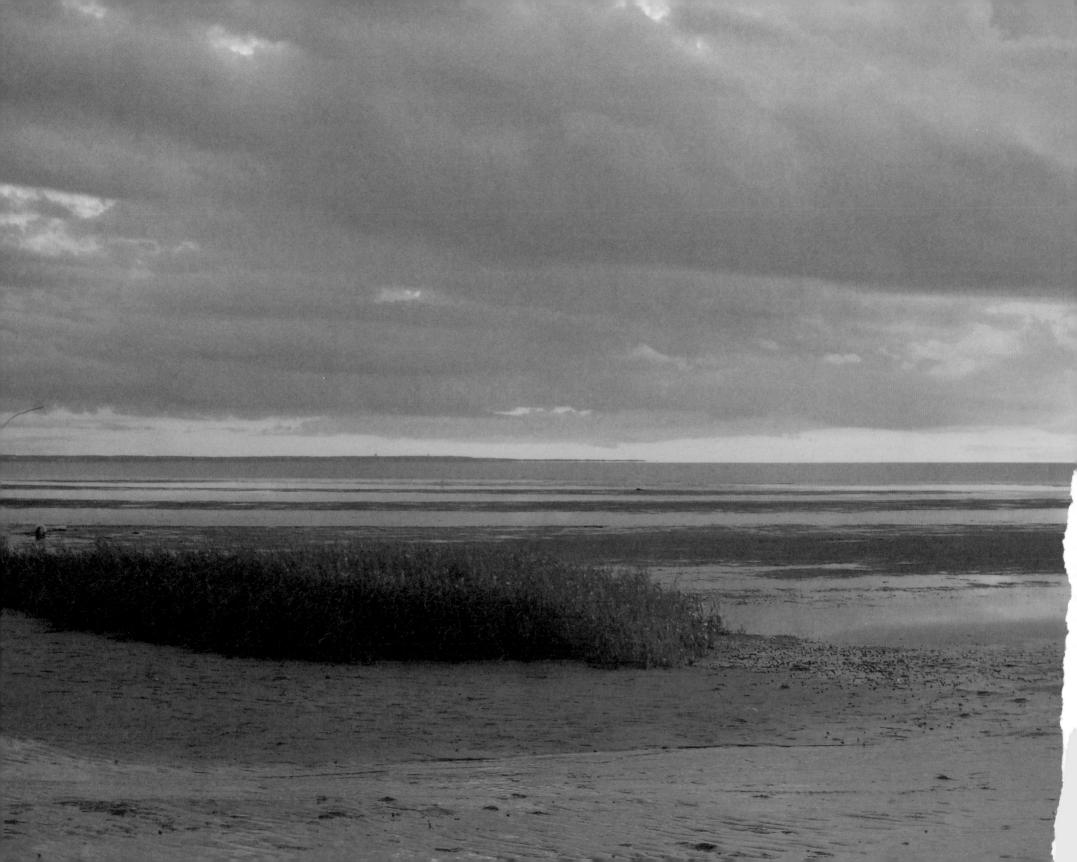